Harold Rosenberg was born in New York in 1906 and graduated from St Lawrence University in 1927. One of the most influential critics at work in the United States, he has been Regents Lecturer, University of California, at Berkeley (1962), Lecturer, Christian Gauss Seminars in Criticism, Princeton University (1963), Visiting Professor of Sociology, Illinois University (1965) and is currently at the University of Chicago.

Harold Rosenberg has been the art critic of *The New Yorker* magazine, and contributed essays to periodicals such as *Kenyon Review*, *Commentary*, *Partisan Review*, *Encounter* and *Les Temps Modernes*. His books include *Trance Above the Streets* (1962), *The Anxious Object* (1964) and, most recently, *Artworks and Packages*.

The

Harold Rosenberg

Tradition of the New

Paladin

Granada Publishing Ltd., 3 Upper James Street, London W1

First published in Great Britain by Thames & Hudson Ltd.
 1962
Published by *Paladin* 1970
Copyright © Harold Rosenberg 1959, 1960, 1970
Made and printed in Great Britain by
Hazell Watson & Viney Ltd.,
Aylesbury, Bucks
Set in Monotype Bembo

To Maynatalie

ACKNOWLEDGEMENTS

Acknowledgements are made to the magazines in which the essays in this book have appeared, some in an earlier form: *Art News*, *Commentary*, *Dissent*, *Encounter*, *Midstream*, *Partisan Review*, *Prospectus*, *View*, *The Symposium*. Also to Wittenborn & Company for the piece, 'French Silence and American Poetry', written as an Introduction to the American edition of *From Baudelaire to Surrealism* by Marcel Raymond.

Contents

Preface

'You cannot hang an event on the wall, only a picture,' Mary McCarthy admonished us in her generous review of this book. One or two other friendly critics sounded related objections. In approving certain happenings in art and literature, these essays had, it seems, neglected aesthetic values, a lack particularly evident in the section, 'American Painting Today'. The Action Painter, whom we had presented, may not intend, the argument ran, to produce an art object but 'to abolish art' in favour of the meaningful gesture. Painting, however, is in the 'realm' of things made, not of deeds done; and art wins against the painter by changing his 'act' back into a picture. Hence once a painting is finished, the criticism ought to tell us whether it is good or bad.

In reply, I should like to point out that in dealing with *new* things there is a question that precedes that of good or bad. I refer to the question, 'What is it?' – the question of identity. To answer this question in such a way as to distinguish between a real novelty and a fake one *is itself an evaluation*, perhaps the primary one for criticism in this revolutionary epoch when art, ideas, mass movements, keep changing their nature, so that their most familiar features are often the most misleading.

For example, in evoking the irony that turns a creative 'event' into a picture, Miss McCarthy draws an apt analogy with the Marxist revolution that seeks to 'bring history to an end' but winds up by producing an authoritarian state. Here is a 'law' that would seem to oblige us to judge acts of overturn, whether in art or in politics, according to established categories of value.

9

Yes, if you are speaking of a revolution that is ended. But to judge an event within the process of the revolution, you must first identify what is happening, in order to decide if at that moment you are hearing the voice of insurrection or the voice of the police; since except to one opposed to all revolutions it will matter in judging how good or bad the action is. Also, you must be able to recognize the difference between a genuine uprising and a simulated uprising, that is, one fabricated according to the revolutionary 'craft' by professionals who deliberately design it to resemble a spontaneous upheaval. Is this act of recognition one of aesthetic judgement? Be that as it may, ordinary concepts of good or bad government will not help towards a decision, any more than commonly accepted aesthetic principles will help in deciding which new works are worth while and which are poor precisely because they have copied what is aesthetically valid in the new.

In other words, in regard to creation there are two ironies in operation, not just one: the mortal irony that changes a living event into a 'picture on the wall', and the tragic and comic irony that causes a masquerade to expose itself, to the surprise of those who have been taken in by appearances. To criticize art and events *in the course of their development*, as many of these chapters do, requires finding a footing in both these ironies. If criticism, under the illusion that only one irony is at work, waits for aesthetics and history to reassert themselves, it avoids the adventure of playing a part in events and gives credence to the superstition that intelligence kills or deals only with the dead.

But a painting hangs on the wall. It reminds me of the old joke about the herring: 'you can hang it on the wall.' Is its occupancy of the wall the function by which painting today is to be defined, so that the idea of its 'activity' results in what Miss McCarthy calls 'a weird contradiction'? Only if, through the habit of looking back to other times, we forget the multiple existence which a painting now enjoys in separation from its physical body: its ghostly presence through reproduction in books and magazines that carry it *as picture* far from its durable being of paint and canvas; the intellectual character it takes on from the interpretations irremovably tacked to it by critics,

art historians, psychiatrists, philosophers of culture; its role in the political rivalry of states and factions and in the educational activities of international institutions; the power of transformation it wields over its own creator through the energy it accumulates on its passage through the social orbit. Is this proper behaviour for an object of aesthetic contemplation? Is the work of art still a *thing*, or an image of a thing, waiting for the spectator's taste to respond to it? Or is it rather a quantity of energy released into the whole configuration or arena of a contending world? And if the latter, must an Action Painting, which reflects a consciousness of the changed nature of the work of art in our time, inevitably lose its character as an event in the interval following its creation? Will it not rather augment its activity the moment it leaves the studio? Are not even the 'quiet' paintings of the past more and more being precipitated into motion and compelled to catch up with contemporary requirements?

If art in our time has been completing a transformation with respect to its objective nature as well as its interests, to apply to it canons derived from craftsmanship, as if perfection in making were still the essence of the work, is bound to show everything in reverse. Making for whom? Yet a poverty of terminology forces art critics and art faculties to interpret American abstract art of the past twenty years as if, in abolishing figuration, it were merely engaged in an arbitrary reduction in the number of 'pictorial elements' – a streamlining of the manufacture of treasures.

Perhaps you cannot hang an event on the wall, only a picture. But this is a problem for the picture more than it is for events. For a wall implies a space in which to stand next to it. This space is now lacking. The Bolshevik Revolution may have turned into a picture on the wall, but it was a picture that pulled the entire globe into it, and even outer space. No room was left for the spectator who merely looks, as there was in the days when the earth had empty spots and the heavens were full.

East Hampton, New York
August, 1960

Foreword: After Ten Years

THE central concepts of each of the four sections of *The Tradition of the New* can be extended to the present day along lines more or less visible ten years ago and even earlier when most of the chapters of this book originally appeared. Ideas in Section 1, 'American Painting Today', have been especial objects of controversy since the book first appeared in 1959. One reason may be that painting and sculpture have been forced to undergo a more stringent self-scrutiny than literature, politics or intellectual life generally. The sense that these mediums are threatened with extinction or, what amounts to the same thing for the individual practitioner, transformation into something entirely different from what they have been, is never entirely absent from the consciousness of artists and critics.

For the latter, my statement in the Introduction that 'criticism cannot divide itself into literary criticism, art criticism, social criticism, but must begin in establishing the terms of the conflict between the actual work and its illusory context' seemed like an open act of sabotage. To demand that criticism be based on principles derived from a broad consideration of the modern epoch amounts to insisting that the special difficulties, already all but unmanageable, of judging works of art be compounded by efforts to judge the quality and direction of contemporary life as a whole. In order to review an art Exhibition one must qualify as a Philosopher of History. Is it not wiser to segregate painting and sculpture and study them in terms of their own development and their own problems – and the more thorough the segregation the better? Art

criticism in the sixties has for the main part chosen this safer alternative. The results have not persuaded me that criticism gains by disentangling its interests from those that make art itself significant.

Conventional art values presuppose an encounter between a painting and a spectator whose speciality is aesthetically discriminating looking. That artists might have lost their enthusiam for bringing about this encounter is inconceivable to those for whom works of art belong to the category of treasures to be traded in or acquired. The contention in this book that art has been in the process of abandoning its age-old object-making in favour of acts of transformation and self-transformation has been confirmed by a decade of battles. The issue of the art object has been the foremost one in the art of the sixties. Movements have appeared which in order to achieve an art object in the strictest sense – that is, as existing only for itself and not as a carrier of illusory effects – reduce painting and sculpture to their rudimentary physical properties: for example, bands of colour that parallel the shape of the stretcher to which the canvas is attached. These affirmations of the art work as object have been met by counter-movements, from Happenings to conceptual art, which discard the art object entirely as inessential to the art act or the art idea.

Efforts to reconstitute the art object seem to me futile in that they ignore the changed situation of the spectator. The wars and revolutions of the twentieth century, including its cultural revolutions, have left no space for detached contemplation. As Valéry said in *M. Teste*, '*Personne ne medite.*' Today, everyone is *in* the act, and cannot avoid the consciousness that the painting and its public are in motion together toward an uncertain future. The drama of history, formerly reserved for heroes and their anxious and awestruck onlookers, has spread out to encompass the entire human race. In contemporary life there are no spectators, only actors – winners and losers. Though watching occurs on a scale never before imagined, the living room is an extension of the field in which tanks crash across borders and living robots descend upon the moon. As broadcasters like to remind their audiences, 'You are there!' Every

watcher has interests at stake, whether he is aware of it or not. Today's spectator looks with a purpose, at least that of assuring himself that he is keeping up with the pace of change. Among professionals of the art world – art historians, curators, dealers – looking is a polemical act, designed to promote or to destroy.

Modern social science has conceived the 'participant observer,' a species of investigator or spy who joins in changing the community that he observes. All the arts endeavour to key their forms to 'audience participation,' which is a kind of recruiting. Being *in* the act calls for different operations of the intelligence than those characteristic of the detached observer, operations which, as indicated in the chapter on 'The American Action Painters,' are not consistent with conventional art criticism. The critic-connoisseur distinguishes between subject and object, separates image from reality, matches what he sees with what he remembers. His aim is to arrive at a concept that will encompass particulars within an order of ideal models selected from the masterpieces of the past. In contrast, the spectator caught in the act responds to a work as to an incident. It is important to him not with regard to art but with regard to life.

Art today has aspects as distant from 1959 as from 1859. Most of these differences are effects of the increased size of the art public. What were ten years ago seemingly invulnerable assumptions of advanced art – for example, that a work of art presupposes an artist – can be denied and even forgotten in the presence of the contemporary mass audience. The bohemian spirit on which intellectual creation fed for a hundred years has been pushed into the background by disciplines conforming to the art ideals of institutionalized education, entertainment and marketing. At the same time the social foes of advanced art have weakened – the Community and its representatives have moved over to the side of innovation. As avant-garde art has ceased to be 'controversial' it has ceased to be avant-garde. The tradition of the new has become the accepted tradition, taken for granted and no longer an object of thought.

Social history has, however, taken an opposite course from

the pacification of the art world. As art has cooled down, politics has heated up. The 'quiet generation' of the late fifties, with its ambition for financial security and fitting in, dealt with in the chapter 'Death In The Wilderness,' has sunk out of sight beneath the mooings of drug cop-outs and the war cries of yippies and draft protestors. The generation-consciousness of postwar youth, expressed in the passion for costumes and togetherness, has survived, but their consciousness is today one of collective grievance and rebelliousness.

While 'Death In The Wilderness' is thus out of date, except for its observations on masquerade, another chapter, 'The Orgamerican Fantasy,' succeeded in penetrating the façade of supermarket conformity, affluence and quiescence that observers in the fifties mistook for the substance of the new American mass society, and the argument these presented that the drama of history had not ended in 'an electrified Eden set out on porcelain grass' is confirmed by today's collapsing cities and violated landscapes.

The chapter on 'The American Action Painters' raised the issue of 'Modern Art? Or an Art of the Modern.' It suggested a distinction between the professional practice of avant-garde styles and efforts of the creative imagination to seize the dramatic note of the present historical interval in order to embody in art what Baudelaire called 'the heroism of modern life.' Needless to say, the mass of artists opted for Modern Art, or what one art historian has called 'the formalist experience of the twentieth century.' What has been unusual in the sixties is not that the artist as individual searcher has been repudiated but the fervour with which art-historical painters and sculptors have pushed Modern Art styles to exhausting conclusions. As for the art of modern life, it has been represented chiefly by Pop formalizations of the output of advertising-agency workshops, by clichés regarding the aesthetic potentialities of laser beams, kinetics and systems, and by the disastrous collaborations of artists and engineers.

For a portion of the sixties, the creations of the mass media became of ascendant interest owing to the emergence of Pop art and the writings and oral pronouncements of Marshall McLuhan. The chapter, 'Pop Culture: Kitsch Criticism',

originally published in *Dissent* several years before the appearance of the Pop art movement, discussed the relationship between the commercial crafts and the experience of individuals and it concluded that in the United States 'life and Kitsch have become inseparable.'

Item: (page 45): 'Everyone knows that the label Modern Art no longer has any relation to the words that compose it. To be Modern Art a work need not be either modern or art; it need not even be a work.'

Error: 'Everyone' does not know this. On the contrary, Modern Art becomes increasingly real to the crowd as this art sheds its last vestige of intellectual and emotional substance. It is on the basis of the formal implications of Modern Art that the vast, dull, principle-demonstrating canvases of the sixties have gained acceptance. Were the vacuity of the term Modern Art recognized, these museum-sponsored mastodons would collapse into raw art supplies. That the phrase Modern Art now includes ghosts of ideas that 'need not even be a work' has been dramatized by contrivers of Happenings and, more recently, by art that consists of verbal concepts which no one has bothered to realize, or of photos and ground plans of distant operations, or of materials unchanged except by removal from one site to another. By the end of the 1960's, Modern Art exists basically as a tradition of discourse that can be manipulated to confer value on objects singled out for institutional promotion.

Item (page 72): 'Thus with regard to such work, criticism becomes in essence polemical and has little to do with "appreciation"; the critic either approves of or opposes the direction in which the work is pulling the profession.'

Battles among critics have pre-empted the foreground in both the creation and exhibition of paintings and sculptures. Artists who remain aloof from these conflicts are likely to find themselves ignored by major galleries and museum surveys. Since what is at stake is the power to determine the direction of art, criticism has taken on a thoroughly political character. The concealment by criticism of its political element, e.g., as by formalists, is itself a political tactic.

'Everyman A Professional' (page 62): 'Outside each pro-

fession there is no social body to talk to, and apart from the forms in which the thought of the profession is embodied there is nothing to say.'

Processes arising from the division of labour make jargon inevitable. The trend toward the self-isolation of all professions, whether in the arts and sciences or in industry and the armed forces, has been carried to new extremes in the past 10 years. For example, military 'special forces' detachments have succeeded in wresting themselves not only from under social control but even from control by the defence structure. Jargon is part of the process of collective self-separation and autonomy; it provides an ever-thickening barrier between ideas and practices in related fields of interest. A primary moral issue for intellectuals is whether to take advantage of professionalization and its mental splitting in order to promote their own careers, or to combat mental structures through which activities become manageable and empty of meaning. Formalist and methodological thinking in the sixties reflect the influences within cultural institutions of the nihilistic principle inherent in the growing bureaucratic fragmentation of society.

Item (page 75): 'In the twentieth century, the world of art and the world of revolutionary politics, both of the Right and the Left, have been thoroughly mixed together. The same Words are at their centre.'

The traditional mixture of new aesthetic perceptions and ideas aimed at changing the world has been disintegrating into its components. Art today lacks a metaphysical impulse, and radical politics is devoid of a new sensibility. For the first time, avant-garde art has been under attack by Leftwing youth. The de-socialization of art has been accomplished by means of a quantitative vocabulary that measures works in terms of size, shape, materials and technical data. In following these leads painting and sculpture have reached the point of liquidating themselves into the crafts. They await rescue by a new naivete and disorder.

Item: Two essays on Marxism and 'Politics As Dancing.'

It is difficult to say whether the prestige of Marxism as a system for changing society, or as a set of clues for under-

standing events, or as a critical approach to social issues, or as a source for slogans and clichés has risen or declined. Certainly, the reactionary and deadening influence of the Soviet Union has been appreciated as never before in the decade of the invasion of Czechoslovakia and the trials of Sinyavsky and Daniel. At the same time, anti-Communism as a mirror version of Communism used, especially in the United States, to interpret domestic and world events has weakened under the impact of the Civil Rights movement, the disasters of American foreign policy and the uprisings of students and anti-war demonstrators. The ugly confessions of ex-Communist anti-Communists (the subject of the chapter 'Couch Liberalism and the Guilty Past') have, happily, dried up, and intellectuals no longer make headlines through recounting the history of their earlier idiocies. Having been exposed as a sponsor of literary journals and trans-oceanic free trips to literary conferences, the CIA has retreated into the shadows – and has even grown so sensitive as to deny that it ordered the assassination of a Vietnamese double agent. The Congressman who won notice through taking Whittaker Chambers at his word is now President of the United States and beyond the need to save his country by fingering conspirators in government agencies. The welding of industry, the military, the trade unions and Administration intellectuals has made it difficult to imagine that the American 'system' is about to be tipped over by a doctrine.

In the midst of these confusions the question of possible riches still to be mined from the writings of the great Marxists seems to me to be very much on the order of the day. Marx's drama of history has failed to resolve itself into the anticipated denouement of the classless society brought into being by proletarian revolution. Moreover, the two major characters of the Marxian drama – the bourgeoisie and the proletarian – have been altered beyond recognition. Events since World War I have made it clear beyond dispute that 'man has not acquired the capacity for the historical,' (page 152) a capacity which for a moment seemed to be lodged in the leaders of the Third International. Instead of a locomotive carrying man-the-maker full speed to a higher destiny, history has come to

resemble a broken down Roman palazzo inhabited by aged arthritics.

Nonetheless, we do live within conflicts generated by mass actors – blacks against whites, technically armed squads against native guerrillas, nations against nations, cults against cults, students against the Establishment – and even our inaction does not relieve us from participation. Marx, pioneer theoretician and dramatist of the wars among modern collective entities, remains one of our few guides in apprehending this fateful and least illuminated portion of the human situation.

'The mind has no means for determining the origins of a mass act.' (Page 152) The paranoiac conviction that every uprising, rebellion, riot or even peaceful demonstration is the work of 'outside agitators' may, in any given instance, represent the actual state of affairs. Perhaps man in the mass is hopelessly passive, and history is a melodrama or spy thriller. It seems likely, however, that the view of Marx is more profound and that the formation and struggles for self-affirmation of mass 'characters' are the modern equivalents of classical tragedy and farce into which all public meanings are concentrated.

Human affairs have not been raised to the realm of reason through the elimination of classes. – 'History is still at the mercy of the poetry of the past. Everywhere the presence of crisis is recognized. The demand for "the new" has become the standard chant of the chorus of political "independents"' (page 153).

In the sixties this chant has swelled to a roar heard from Berkeley to Chicago, Nanterre, Prague, Tokyo. The statement made in the chapter 'The Fall of Paris' that with the onslaught of the Nazis 'the scuttling of middle-class conservative values became a physical fact' pointed to the cause of the deepening social and intellectual crisis by which all free societies are affected today. Ideologies have been torn to bits, and the debris of Anarchism, Nihilism, Marxism, Surrealism, Dada and Fascism float on the puddles left by the high-pressure hoses of the riot police. What is called in this book 'politics as dancing' has become the common resort

against the infamy of powers that betray the principles on which they were founded. History has emerged as a drama seen from within by a spectator who, willy nilly, is also an actor and in some indefinable sense an author. No wonder that the paradigm of modern man is the artist – and that the paradigm of modern art is the painting complete in each gesture and never finished.

The Tradition of the New

THE 'latest' styles in art have been with us from birth; for many, their manifestations have become part of Nature. There are people who are made nostalgic, if at all, by the sight of the Modern: a 'Bonnard' lawn through a window, 'Surrealist' signs on Broadway, the 'Neo-plasticism' of a partly torn-down building.

In the arts an appetite for a new look is now a professional requirement, as in Russia to be accredited as a revolutionist is to qualify for privileges.

The famous 'modern break with tradition' has lasted long enough to have produced its own tradition. Exactly one hundred years have passed since Baudelaire invited fugitives from the too-small world of memory to come aboard for his voyage in search of the new.

Since then there have come into being an art whose history, regardless of the credos of its practitioners, has consisted of leaps from vanguard to vanguard, and political mass movements whose aim has been the total renovation not only of social institutions but of man himself.

The new cannot become a tradition without giving rise to unique contradictions, myths, absurdities – often, creative absurdities.

Under the slogan, FOR A NEW ART, FOR A NEW REALITY, the most ancient superstitions have been exhumed, the most primitive rites re-enacted: the rummage for generative forces has set African demon-masks in the temple of the Muses and introduced the fables of Zen and Hasidism into the dialogue of philosophy. Through such dislocations of

time and geography the first truly universal tradition has come to light, with world history as its past and requiring a world stage on which to flourish.

Whoever undertakes to create soon finds himself engaged in creating himself. Self-transformation and the transformation of others have constituted the radical interest of our century, whether in painting, psychiatry or political action. Quite ordinary people have been tempted to assume the risk of deciding whether to continue to be what they have been or to exchange themselves to fit a more intriguing role; others have had self-substitution forced upon them.

Metamorphosis involves the mechanisms of comedy and tragedy. Never before has there been such wholesale participation in the secrets of the ridiculous, the morbid and the idyllic. It is through these, however, that the physiognomy of an epoch must be recognized.

In such circumstances, criticism cannot divide itself into literary criticism, art criticism, social criticism, but must begin in establishing the terms of the conflict between the actual work or event and its illusory context.

Part 1

American Painting Today

1 Parable of American Painting

The American is a new man who acts on new principles: he must therefore entertain new ideas and form new opinions. J. HECTOR ST JOHN DE CRÈVECOEUR

Cursed be that mortal inter-debtedness . . . I would be as free as air: and I'm down in the whole world's books. HERMAN MELVILLE

PEOPLE carry their landscapes with them, the way travellers used to cart along their porcelain chamber pots. The stronger their sense of form the more reluctant they are to part with either.

Since the eye sees through a gridiron of style and memory, it is not so easy for a man to be 'new' as Crèvecoeur implies.

Braddock's Defeat

For me the most dramatic example of the newcomer's illusion of being elsewhere is Braddock's Defeat. I recall in my grammar-school history book a linecut illustration which shows the Redcoats marching abreast through the woods, while from behind trees and rocks naked Indians and coon-skinned trappers pick them off with musket balls. Maybe it wasn't Braddock's Defeat but some ambush of the Revolutionary War. In any case, the Redcoats march in file through the New World wilderness, with its disorder of rocks, underbrush and sharpshooters, as if they were on a parade ground or on the meadows of a classical European battlefield and one by one they fall and die.

I was never satisfied with the explanation that the Redcoats

were simply stupid or stubborn, wooden copies of King George III. In my opinion what defeated them was their skill. They were such extreme European professionals, even the Colonials among them, they did not *see* the American trees. Their too highly perfected technique forbade them to acknowledge such chance topographical phenomena. According to the assumptions of their military art, by which their senses were controlled, a battlefield had to have a certain appearance and structure, that is to say, a style. Failing to qualify, these American trees and rocks from which come such deadly but meaningless stings are overlooked. The Redcoats fall, expecting at any moment to enter upon the true battlefield, the soft rolling greenswards prescribed by the canons of their craft and presupposed by every principle that makes warfare intelligible to the soldier of the eighteenth century.

The difficulty of the Redcoats was that they were in the wrong place. The dream-world of a style always moves ahead of the actual world and overlays it; unless one is of the unblinking wilderness like those Coonskinners behind the trees.

In honour of the dream-defeated Braddock, I call the hallucination of the displaced terrain, originating in style, Redcoatism. In America it is an experience of the first importance. If Crèvecoeur were right and the American were a 'new man acting on new principles', Redcoatism as a mental condition should have ceased to exist with the departure of Cornwallis. The fact is, however, that the art-entranced Redcoat, in a succession of different national uniforms, dominates the history of American art. Like Braddock, painting in this country has behaved as if it were elsewhere – to the point where artists have often emigrated physically in order to join their minds in some foreign country. What has counted with the art corps has been the Look, from the British Look of Colonial portraiture, through the Düsseldorf Look, the Neoclassic Look, down to the Last-Word Look of abstract art today. The uniforms change, Redcoatism endures.

Of course the sharpshooting individuals – we shall speak of them later – have the last word. But granted that what counts in the art of any nation, since the Renaissance, at any rate, is

primarily the works of its individual masters, American art has differed in this respect: that the triumphs of individuals have been achieved against the prevailing style or apart from it, rather than within it or through it.

The issue is not that American painting is influenced by Europe; the painting of all European countries has also been influenced. The issue is Redcoatism, the difficulty for the artist of finding here a spot on which to begin. But a starting point in experience is indispensable if the artist is to prevail against the image of Great Painting that slides between him and the canvas he is working on.

The first American playwrights could think of nothing less to compose than Shakespearean tragedies in blank verse. Had it not been for a will to bad art in order to satisfy the appetites of the street, the American theatre would never have come into being.

What marks the paintings of America's past as provincial is not their inferior general level – the low quality of Dutch poetry or British music in a given period does not make it provincial – but the absence in them of any continuing visual experience that demands recognition. Copley's later canvases did enter as a force into the continuity of *British* historical painting. But until very recently no American painter, or assumption put into practice about painting, has had the power of emanating into world art as Whitman or Poe did into literature, so that it became possible to say that Nietszche or Tolstoy was a Whitmanite, that Gide and Lorca Whitmanize and that through Baudelaire the cue to modern poetry was given by Poe.

To be legitimate, a style in art must connect itself with a style outside of art, whether in palaces or dance halls or in the dreams of saints and courtesans. Physically, America has been moving away from style (more exactly, from styles). Eighteenth-century Boston, Philadelphia, Richmond, are 'works of art' in the British mode, L'Enfant's Washington in the mode of the incredible. The frontier, however, is not a 'landscape' – Gainsborough could not have painted it. Nor are the later cities. They are raw *scene*.

No wonder that the edges of the canvas meant nothing to the Hudson River panoramists. Geography (history, too) becomes in America an endless roll of uncomposed appearances, as in the cycloramas depicting famous Indian battles and the Civil War. Or if an attempt at composition is made, it is by arbitrary means, with the result that the form becomes mechanical, as in the Currier & Ives street scenes whose parts are articulated like a fire engine of those days.

America's steady backing away from style explains why British portrait painting in Colonial Philadelphia is better painting than German Expressionism in twentieth-century Texas, which does not justify any style.

The discovery of *modern* art by Americans in the first decades of this century did not rid them of their old habit of misplacing themselves; in the mirror of post-Impressionism they mistook their cultural environment instead of their physical one. By the twenties, under the banner of Experiment, everyone had learned how to manipulate a Look, sometimes three or four, developed out of the crisis of French, German or Italian painting. The profusion of codes to obey gave rise to an illusion of self-liberation: instead of the Redcoat, single Uhlans, Hussars, Swiss Guards marching in step to distant rhythms. Yet American art was no closer than before to a reality of its own.

Coonskinism – Or the Made-Up

What could Braddock do among those sudden trees? One thing only: call for straighter ranks, a more measured step, louder banging on the drums. In Europe an art could be slowly modified and still keep its form; here, it either had to stand fast on its principles or risk becoming no art at all.

'I, for my poems – What have I?' exclaimed Walt Whitman, taking that risk, 'I have all to *make*.'

Crèvecoeur's mistake lay in assuming that every American was aware that he had to begin anew. His determinism took it for granted that if a man is in a given situation his consciousness will be there with him. Crèvecoeur should have reflected more deeply on the fact that the Dutch superimposed a small

Amsterdam on the tip of Manhattan and that the Pilgrims built not a New World but a New England. In art there have been few examples of the 'American' in Crèvecoeur's sense of a psyche designed by history for the constant production of novelties. What's more, the 'new men' have tended not to stay new but to settle into a self-repeating pattern.

To be a man is not a condition but an effort – an effort that follows a revelation in behalf of which existing forms are discarded as irrelevant or are radically revised. The genuine accomplishments of American art spring from the tension of such singular experiences. In honour of Braddock's foes I call this anti-formal or trans-formal effort Coonskinism. The fellows behind the trees are 'men without art', to use Wyndham Lewis's label for Faulkner and Hemingway. This does not mean that they do not know how to fight. They have studied manoeuvres among squirrels and grizzly bears and they trust their knowledge against the tradition of Caesar and Frederick. Their principle is simple: watch the object – if it's red, shoot!

Obviously, this proposition can be valid only in a particular situation. The Coonskinners win, but their method can hardly be considered a contribution to military culture. It has a closer tie with primitive art, which also learns from its subject and which, like Whitman, *has* nothing but has all *to make*.

Creation by a mind devoid of background, or deliberately cleansed of it, results in primitive art. The best painting in America is related to the primitives in its methods of overcoming ignorance through the particular problem to be solved. Copley contrives his New England style through carefully studying his models during unusually numerous sittings. His American portraits owe more to the British style of his sitters than to the contemporaneous British manner in painting. When he goes to England, he can no longer paint in the same way and his portraiture declines. Perhaps Copley missed in the Britons in Britain the conflict of style with non-style which had stimulated him in their American imitators. Waterhouse, in his *Painting in Britain*, points out that Copley's best British portraits are of children, who are made to look 'unEnglish'.

Coonskinism is the search for the principle that applies, even if it applies only once. For it, each situation has its own exclusive key. Hence general knowledge of his art does not abate the Coonskinner's ignorance nor relieve him of the need to improvise. Melville's masterpiece begins by being a novel and becomes in turn some fragments of a play, a scientific and historical treatise, an eye-witness report. Out of the Bible, Homer, the newspapers, opera, Whitman puts together poetry from which the appearance of poetry has managed to depart. Art is similarly subsumed in the intense prose of Eakins's paintings which find their problems in the manner in which a pair of well-worn feet hold on to the floor or in the shine of the skin on the back of an old man's hand. If Eakins's realism tends towards the non-Look, Ryder's romance of being privately in a cosmos tends in the same direction. It is not, as the academicians say of artists like Copley or Eakins, that in them Truth conquers over Beauty, it is that both Truth and Beauty are for them the result of a specific encounter.

As made-up art, folk painting in America is the mass-product of Coonskinism, as academic painting is the continuing output of Redcoatism. American artists have moved in both directions between these two extremes, self-taught limners turning into august Redcoats, learned academicians – from Allston to Edwin Dickinson – shedding their red coats, hopping behind trees and aiming with the stubborn concentration of Coonskinners.

Under these circumstances American folk painting cannot be separated from its fine art, as it makes sense to do in other countries. Folk art has no development; its successes are a sum of individual pot shots; in sum, it lacks history. But in the United States, fine art also lacks history and its best examples consist of individual inventions which do not carry over into the future. Nor does any of its imported styles reach a culmination; it ends by being replaced. An historical exhibition of American painting is not complete unless it presents the Coonskin antithesis to the prevailing Redcoatism. Audubon, for instance, is very close to folk art, being largely a self-taught peerer through trees who derived his style from

absorption in his subject matter; yet he is, without doubt, a much superior painter to, say, Bierstadt – in fact, Audubon is the first important painter who belongs thoroughly to the United States. Nor can many American painters and sculptors be found who equal as artists the draftsmen of Currier and Ives. (I have seen enlarged details of their New York scenes that are a match for Seurat.)

Coonskin doggedness is a major characteristic of America's most meaningful painters. Not one – Copley, Audubon, Eakins, Ryder, Homer, Marin, Stuart Davis, de Kooning – in whom this quality is not predominant. To make one's own art, one must be able to overcome an enormous amount of doubt and waste of time.

Coonskinism as a principle won ascendancy in American painting for the first time during the Second World War. With no new styles coming from Europe – and for deeper reasons than transportation difficulties – American artists became willing to take a chance on un-Style or anti-Style. Statements in interviews and catalogues emphasized the creative bearing of such elements of creation as the mistake, the accident, the spontaneous, the incomplete, the absent. The aesthetic watchword of the new American painting might almost have been adapted from Melville's: 'So far as I am individually concerned and independent of my pocket, it is my earnest desire to write those sorts of books which are said to fail.'

At the same time Redcoatism, no longer overfed, reached new degrees of refinement. The American practitioners of Cubism, Neo-Romanticism, Neo-Plasticism, highly conscious of their debt, were able to accumulate a balance of their own.

Today, Coonskinism itself in the form of 'free' abstract expression is in danger of becoming a style – as I reminded Crèvecoeur, the new man does not automatically stay that way. With most of the pioneers of 1946, the transformation of the Coonskinner into a Redcoat has already taken place.

What is historically unique is that American Coonskinism has become the prevalent Style of Europe's newest paintings. The Europeans of the fifties have captured the look of the

made-up in American art, though their pictures fail to achieve the reality and the feeling of being made-up. The uneasy insistence and individual self-consciousness that go with discovery and give the new American painting its vitality and point are lacking in the Europeans.

Coonskinism has become the Redcoatism of Europe. Once again, the hallucination of the displaced terrain. But this time everything in reverse – Art copying non-Art, rocks and trees carefully laid out as an obstacle-run on the parade ground. It is the setting of a comedy.

J'ai fait des gestes blancs parmi les solitudes. APOLLINAIRE

The American will is easily satisfied in its efforts t o realize itself in knowing itself. WALLACE STEVENS

WHAT makes any definition of a movement in art dubious is that it never fits the deepest artists in the movement – certainly not as well as, if successful, it does the others. Yet without the definition something essential in those best is bound to be missed. The attempt to define is like a game in which you cannot possibly reach the goal from the starting point but can only close in on it by picking up each time from where the last play landed.

Modern Art? Or an Art of the Modern?

Since the War every twentieth-century style in painting has been brought to profusion in the United States: thousands of 'abstract' painters – crowded teaching courses in Modern Art – a scattering of new heroes – ambitions stimulated by new galleries, mass exhibitions, reproductions in popular magazines, festivals, appropriations.

Is this the usual catching up of America with European art forms? Or is something new being created? For the question of novelty, a definition would seem indispensable.

Some people deny that there is anything original in the recent American painting. Whatever is being done here now, they claim, was done thirty years ago in Paris. You can trace

this painter's boxes of symbols to Kandinsky, that one's moony shapes to Miró or even back to Cézanne.

Quantitatively, it is true that most of the symphonies in blue and red rectangles, the wandering pelvises and bird-bills, the line constructions and plane suspensions, the virginal dissections of flat areas that crowd the art shows are accretions to the 'School of Paris' brought into being by the fact that the mode of production of modern masterpieces has now been all too clearly rationalized. There are styles in the present displays which the painter could have acquired by putting a square inch of a Soutine or a Bonnard under a microscope. . . . All this is training based on a new conception of what art is, rather than original work demonstrating what art is about to become.

At the centre of this wide practising of the immediate past, however, the work of some painters has separated itself from the rest by a consciousness of a function for painting different from that of the earlier 'abstractionists', both the Europeans themselves and the Americans who joined them in the years of the Great Vanguard.

This new painting does not constitute a School. To form a School in modern times not only is a new painting consciousness needed but a consciousness of that consciousness – and even an insistence on certain formulas. A School is the result of the linkage of practice with terminology – different paintings are affected by the same words. In the American vanguard the words, as we shall see, belong not to the art but to the individual artists. What they think in common is represented only by what they do separately.

Getting Inside the Canvas

At a certain moment the canvas began to appear to one American painter after another as an arena in which to act – rather than as a space in which to reproduce, redesign, analyse or 'express' an object, actual or imagined. What was to go on the canvas was not a picture but an event.

The painter no longer approached his easel with an image in his mind; he went up to it with material in his hand to do

something to that other piece of material in front of him. The image would be the result of this encounter.

It is pointless to argue that Rembrandt or Michelangelo worked in the same way. You don't get Lucrece with a dagger out of staining a piece of cloth or spontaneously putting forms into motion upon it. She had to exist some place else before she got on the canvas, and paint was Rembrandt's means for bringing here there, though, of course, a means that would change her by the time she arrived. Now, everything must have been in the tubes, in the painter's muscles and in the cream-coloured sea into which he dives. If Lucrece should come out she will be among us for the first time – a surprise. To the painter, she *must* be a surprise. In this mood there is no point to an act if you already know what it contains.

'B – is not modern,' one of the leaders of this mode said to me. 'He works from sketches. That makes him Renaissance.'

Here the principle, and the difference from the old painting, is made into a formula. A sketch is the preliminary form of an image the *mind* is trying to grasp. To work from sketches arouses the suspicion that the artist still regards the canvas as a place where the mind records its contents – rather than itself the 'mind' through which the painter thinks by changing a surface with paint.

If a painting is an action the sketch is one action, the painting that follows it another. The second cannot be 'better' or more complete than the first. There is just as much in what one lacks as in what the other has.

Of course, the painter who spoke had no right to assume that his friend had the old mental conception of a sketch. There is no reason why an act cannot be prolonged from a piece of paper to a canvas. Or repeated on another scale and with more control. A sketch can have the function of a skirmish.

Call this painting 'abstract' or 'Expressionist' or 'Abstract-Expressionist', what counts is its special motive for extinguishing the object, which is not the same as in other abstract or Expressionist phases of modern art.

The new American painting is not 'pure' art, since the extrusion of the object was not for the sake of the aesthetic. The apples weren't brushed off the table in order to make room for perfect relations of space and colour. They had to go so that nothing would get in the way of the act of painting. In this gesturing with materials the aesthetic, too, has been subordinated. Form, colour, composition, drawing, are auxiliaries, any one of which – or practically all, as has been attempted logically, with unpainted canvases – can be dispensed with. What matters always is the revelation contained in the act. It is to be taken for granted that in the final effect, the image, whatever be or be not in it, will be a *tension*.*

*With regard to the tensions it is capable of setting up in our bodies the medium of any art is an extension of the physical world; a stroke of pigment, for example, 'works' within us in the same way as a bridge across the Hudson. For the unseen universe that inhabits us an accidental blot or splash of paint may thus assume an equivalence to the profoundest happening. . . .

If the ultimate subject matter of all art is the artist's psychic state or tension (and this may be the case even in nonindividualistic epochs), that state may be represented either through the image of a thing or through an abstract sign. The innovation of Action Painting was to dispense with the *representation* of the state in favour of *enacting* it in physical movement. The action on the canvas became its own representation. This was possible because an action, being made of both the psychic and the material, is by its nature a sign – it is the trace of a movement whose beginning and character it does not in itself ever altogether reveal (e.g., Freud's point about love-making being mistaken in the imagination for an assault); yet the action also exists as a 'thing' in that it touches other things and affects them. . . .

In turning to action, abstract art abandons its alliance with architecture, as painting had earlier broken with music and with the novel, and offers its hand to pantomime and dance. One thinks of Rilke's

> Dance the orange. The warmer landscape,
> fling it out of you, that the ripe one be radiant
> in homeland breezes!

In painting, the primary agency of physical motion (as distinct from illusionary representation of motion, as with the Futurists) is the line, conceived not as the thinnest of planes, nor as edge, contour or connective but as stroke or figure (in the sense of 'figure skating'). In its passage on the canvas each such line can establish the actual movement of the artist's body as an aesthetic statement. Line, from wiry calligraphy to footwide flaunts of the house painter's brush, has played the leading part in the technique of Action Painting, though there are other ways besides line of releasing force on canvas.

H. R., from 'Hans Hofmann: Nature into Action,' *Art News*, May 1957.

Dramas Of As If

A painting that is an act is inseparable from the biography of the artist. The painting itself is a 'moment' in the adulterated mixture of his life – whether 'moment' means the actual minutes taken up with spotting the canvas or the entire duration of a lucid drama conducted in sign language. The act-painting is of the same metaphysical substance as the artist's existence. The new painting has broken down every distinction between art and life.

It follows that anything is relevant to it. Anything that has to do with action – psychology, philosophy, history, myth-ology, hero worship.* Anything but art criticism. The painter gets away from art through his act of painting; the critic can't get away from it. The critic who goes on judging in terms of schools, styles, form – as if the painter were still concerned with producing a certain kind of object (the work of art), instead of living on the canvas – is bound to seem a stranger.

Some painters take advantage of this stranger. Having insisted that their painting is an act, they then claim admira-tion for the act as art. This turns the act back towards the aesthetic in a petty circle. If the picture is an act, it cannot be justified *as an act of genius* in a field whose whole measuring apparatus has been sent to the devil. Its value must be found apart from art. Otherwise the 'act' gets to be 'making a painting' at sufficient speed to meet an exhibition date.

Art – relation of the painting to the works of the past, rightness of colour, texture, balance, etc. – comes back into

*Action cannot be perfected without losing its human subject and being transformed thereby into the mechanics of man-the-machine. Action never perfects itself; but it tends towards perfection and away from the personal. This is the best argument for dropping the term 'Abstract Expressionism,' with its associations of ego and personal *Schmerz*, as a name for the current American painting. Action Paint-ing has to do with self-creation or self-definition or self-transcen-dence; but this dissociates it from self-expression, which assumes the acceptance of the ego as it is, with its wound and its magic. Action Painting is not 'personal,' though its subject matter is the artist's individual possibilities.

H. R., 'A dialogue with Thomas B. Hess.' *Catalogue of the Exhibition: Action Painting, 1958.* The Dallas Musem For Contemporary Arts.

painting by way of psychology. As Stevens says of poetry, 'it is a process of the personality of the poet'. But the psychology is the psychology of creation. Not that of the so-called psychological criticism that wants to 'read' a painting for clues to the artist's sexual preferences or debilities. The work, the act, translates the psychologically given into the intentional, into a 'world' – and thus transcends it.

With traditional aesthetic references discarded as irrelevant, what gives the canvas its meaning is not psychological data but *role*, the way the artist organizes his emotional and intellectual energy as if he were in a living situation. The interest lies in the kind of act taking place in the four-sided arena, a dramatic interest.

Criticism must begin by recognizing in the painting the assumptions inherent in its mode of creation. Since the painter has become an actor, the spectator has to think in a vocabulary of action: its inception, duration, direction – psychic state, concentration and relaxation of the will, passivity, alert waiting. He must become a connoisseur of the gradations between the automatic, the spontaneous, the evoked.

'It's Not That, It's Not That, It's Not That'

With a few important exceptions, most of the artists of this vanguard found their way to their present work by being cut in two. Their type is not a young painter but a re-born one. The man may be over forty, the painter around seven. The diagonal of a grand crisis separates him from his personal and artistic past.

Many of the painters were 'Marxists' (WPA unions, artists' congresses); they had been trying to paint Society. Others had been trying to paint Art (Cubism, Post-Impressionism) – it amounts to the same thing.

The big moment came when it was decided to paint . . . just TO PAINT. The gesture on the canvas was a gesture of liberation, from Value – political, aesthetic, moral.

If the war and the decline of radicalism in America had anything to do with this sudden impatience, there is no evidence of it. About the effects of large issues upon their

emotions, Americans tend to be either reticent or unconscious. The French artist thinks of himself as a battlegound of history; here one hears only of private Dark Nights. Yet it is strange how many segregated individuals came to a dead stop within the past ten years and abandoned, even physically destroyed, the work they had been doing. A far-off watcher unable to realize that these events were taking place in silence might have assumed they were being directed by a single voice.

At its centre the movement was away from, rather than towards. The Great Works of the Past and the Good Life of the Future became equally nil.

The refusal of values did not take the form of condemnation or defiance of society, as it did after the First World War. It was diffident. The lone artist did not want the world to be different, he wanted his canvas to be a world. Liberation from the object meant liberation from the 'nature', society and art already there. It was a movement to leave behind the self that wished to choose his future and to nullify its promissory notes to the past.

With the American, heir of the pioneer and the immigrant, the foundering of Art and Society was not experienced as a loss. On the contrary, the end of Art marked the beginning of an optimism regarding himself as an artist.

The American vanguard painter took to the white expanse of the canvas as Melville's Ishmael took to the sea.

On the one hand, a desperate recognition of moral and intellectual exhaustion; on the other, the exhilaration of an adventure over depths in which he might find reflected the true image of his identity.

Painting could now be reduced to that equipment which the artist needed for an activity that would be an alternative to both utility and idleness. Guided by visual and somatic memories of paintings he had seen or made – memories which he did his best to keep from intruding into his consciousness – he gesticulated upon the canvas and watched for what each novelty would declare him and his art to be.

Based on the phenomenon of conversion the new movement is, with the majority of the painters, essentially a religious

movement. In almost every case, however, the conversion has been experienced in secular terms. The result has been the creation of private myths.

The tension of the private myth is the content of every painting of this vanguard. The act on the canvas springs from an attempt to resurrect the saving moment in his 'story' when the painter first felt himself released from Value – myth of past self-recognition. Or it attempts to initiate a new moment in which the painter will realize his total personality – myth of future self-recognition.

Some formulate their myth verbally and connect individual works with its episodes. With others, usually deeper, the painting itself is the exclusive formulation, a Sign.

The revolution against the given, in the self and in the world, which since Hegel has provided European vanguard art with theories of a New Reality, has re-entered America in the form of personal revolts. Art as action rests on the enormous assumption that the artist accepts as real only that which he is in the process of creating. 'Except the soul has divested itself of the love of created things . . .' The artist works in a condition of open possibility, risking, to follow Kierkegaard, the anguish of the aesthetic, which accompanies possibility lacking in reality. To maintain the force to refrain from settling anything, he must exercise in himself a constant No.

Apocalypse and Wallpaper

The most comfortable intercourse with the void is mysticism, especially a mysticism that avoids ritualizing itself.

Philosophy is not popular among American painters. For most, thinking consists of the various arguments that TO PAINT is something different from, say, to write, or to criticize: a mystique of the particular activity. Lacking verbal flexibility, the painters speak of what they are doing in a jargon still involved in the metaphysics of *things*: 'My painting is not Art; it's an Is.' 'It's not a picture of a thing; it's the thing itself.' 'It doesn't reproduce Nature; it is Nature.' 'The painter doesn't think; he knows.' Etc. etc.

'Art is not, not not not not. . . .' As against this, a few reply, art today is the same as it always has been.

Language has not accustomed itself to a situation in which the act itself is the 'object'. Along with the philosophy of TO PAINT appears bits of Vedanta and popular pantheism.

In terms of American tradition, the new painters stand somewhere between Christian Science and Whitman's 'gangs of cosmos'. That is, between a discipline of vagueness by which one protects oneself from disturbance while keeping one's eyes open for benefits; and the discipline of the Open Road of risk that leads to the farther side of the object and the outer spaces of the consciousness.

What made Whitman's mysticism serious was that he directed his 'cosmic "I"' towards a Pike's-Peak-or-Bust of morality and politics. He wanted the ineffable in *all* behaviour – he wanted it *to win the streets*.

The test of any of the new paintings is its seriousness – and the test of its seriousness is the degree to which the act on the canvas is an extension of the artist's total effort to make over his experience.

A good painting in this mode leaves no doubt concerning its reality as an action and its relation to a transforming process in the artist. The canvas has 'talked back' to the artist not to quiet him with Sibylline murmurs nor to stun him with Dionysian outcries but to provoke him into a dramatic dialogue. Each stroke had to be a decision and was answered by a new question. By its very nature, action painting is painting in the medium of difficulties.*

Weak mysticism, the 'Christian Science' side of the new movement, tends in the opposite direction, towards *easy*

* As other art movements of our time have extracted from painting the element of structure or the element of tone and elevated it into their essence, Action Painting has extracted the element of decision inherent in all art in that the work is not finished at its beginning but has to be carried forward by an accumulation of 'right' gestures. In a word, Action Painting is the abstraction of the *moral* element in art; its mark is moral tension in detachment from moral or aesthetic certainties; and it judges itself morally in declaring that picture to be worthless which is not the incorporation of a genuine struggle, one which could at any point have been lost.

H. R., The Dallas Museum *Catalogue*, above.

painting – never so many unearned masterpieces! Works of this sort lack the dialectical tension of a genuine act, associated with risk and will. When a tube of paint is squeezed by the Absolute, the result can only be a Success. The painter need keep himself on hand solely to collect the benefits of an endless series of strokes of luck. His gesture completes itself without arousing either an opposing movement within itself or the desire in the artist to make the act more fully his own. Satisfied with wonders that remain safely inside the canvas, the artist accepts the permanence of the commonplace and decorates it with his own daily annihilation. The result is an apocalyptic wallpaper.

The cosmic 'I' that turns up to paint pictures, but shudders and departs the moment there is a knock on the studio door, brings to the artist a megalomania which is the opposite of revolutionary. The tremors produced by a few expanses of tone or by the juxtaposition of colours and shapes purposely brought to the verge of bad taste in the manner of Park Avenue shop windows are sufficient cataclysms in many of these happy overthrows of Art. The mystical dissociation of painting as an ineffable event has made it common to mistake for an act the mere sensation of having acted – or of having been acted upon. Since there is nothing to be 'communicated', a unique signature comes to seem the equivalent of a new plastic language. In a single stroke the painter exists as a Somebody – at least on a wall. That this Somebody is not he seems beside the point.

Once the difficulties that belong to a real act have been evaded by mysticism, the artist's experience of transformation is at an end. In that case what is left? Or to put it differently: What is a painting that is not an object, nor the representation of an object, nor the analysis or impression of it, nor whatever else a painting has ever been – and which has also ceased to be the emblem of a personal struggle? It is the painter himself changed into a ghost inhabiting The Art World. Here the common phrase, 'I have bought an O—' (rather than a painting by O—) becomes literally true. The man who started to remake himself has made himself into a commodity with a trademark.

Milieu: The Busy No-Audience

We said that the new painting calls for a new kind of criticism, one that would distinguish the specific qualities of each artist's act.

Unhappily for an art whose value depends on the authenticity of its mysteries, the new movement appeared at the same moment that Modern Art *en masse* 'arrived' in America: Modern architecture, not only for sophisticated homes, but for corporations, municipalities, synagogues; Modern furniture and crockery in mail-order catalogues; Modern vacuum cleaners, can openers; beer-ad 'mobiles' – along with reproductions and articles on advanced painting in big-circulation magazines. *Enigmas for everybody*. Art in America today is not only nouveau, it's news.

The new painting came into being fastened to Modern Art and without intellectual allies – in literature everything had found its niche.

From this liaison it has derived certain superstitions comparable to those of a wife with a famous husband. Superiorities, supremacies even, are taken for granted. It is boasted that modern painting in America is not only original but an 'advance' in world art (at the same time that one says 'to hell with world art').

Everyone knows that the label Modern Art no longer has any relation to the words that compose it. To be Modern Art a work need not be either modern nor art; it need not even be a work. A three-thousand-year-old mask from the South Pacific qualifies as Modern and a piece of wood found on a bench becomes Art.

When they find this out, some people grow extremely enthusiastic, even, oddly enough, proud of themselves; others become infuriated.

These reactions suggest what Modern Art actually is. It is not even a Style. It has nothing to do either with the period when a thing was made nor with the intention of the maker. It is something that someone has had the social power to designate as psychologically, aesthetically or ideologically relevant to our epoch. The question of the driftwood is: *Who* found it?

Modern Art in America represents a revolution of taste – and serves to identify the caste conducting that revolution. Responses to Modern Art are primarily responses to claims to social leadership. For this reason Modern Art is periodically attacked as snobbish, Red, immoral, etc., by established interests in society, politics, the church. Comedy of a revolution that restricts itself to weapons of taste – and which at the same time addresses itself to the masses: Modern-design fabrics in bargain basements, Modern interiors for office girls living alone, Modern milk bottles.

Modern art is educational, not with regard to art but with regard to life. You cannot explain Mondrian's painting to people who don't know anything about Vermeer, but you can easily explain the social importance of admiring Mondrian and forgetting about Vermeer.

Through Modern Art the expanding caste of professional enlighteners of the masses – designers, architects, decorators, fashion people, exhibition directors – informs the populace that a supreme Value has emerged in our time, the Value of the NEW, and that there are persons and things that embody that Value. This Value is a completely fluid one. As we have seen, Modern Art does not have to be actually new; it only has to be new to *somebody* – to the last lady who found out about the driftwood – and to win neophytes is the chief interest of the caste.

Since the only thing that counts for Modern Art is that a work shall be NEW, and since the question of its newness is determined not by analysis but by social power and pedagogy, the vanguard painter functions in a milieu utterly indifferent to the content of his work.

Unlike the art of nineteenth-century America, advanced paintings today are not bought by the middle class.* Nor are they by the populace. Considering the degree to which it is publicized and feted, vanguard painting is hardly bought at all. It is *used* in its totality as material for educational and profit-making enterprises: colour reproductions, design adaptations,

*The situation has improved since this essay appeared in 1952. Several younger collectors have appeared who are specializing in the new American painting – and to some degree the work of Americans has entered the world art market.

human-interest stories. Despite the fact that more people see and hear about works of art than ever before, the vanguard artist has an audience of nobody. An interested individual here and there, but no audience. He creates in an environment not of people but of functions. His paintings are employed not wanted. The public for whose edification he is periodically trotted out accepts the choices made for it as phenomena of The Age of Queer Things.

An action is not a matter of taste.

You don't let taste decide the firing of a pistol or the building of a maze.

As the Marquis de Sade understood, even experiments in sensation, if deliberately repeated, presuppose a morality.

To see in the explosion of shrapnel over No Man's Land only the opening of a flower of flame, Marinetti had to erase the moral premises of the act of destruction – as Molotov did explicitly when he said that Fascism is a matter of taste. Both M's were, of course, speaking the driftwood language of the Modern Art International.

Limited to the aesthetic, the taste bureaucracies of Modern Art cannot grasp the human experience involved in the new action paintings. One work is equivalent to another on the basis of resemblances of surface, and the movement as a whole a modish addition to twentieth-century picture making. Examples in every style are packed side by side in annuals and travelling shows and in the heads of newspaper reviewers like canned meats in a chain store – all standard brands.

To counteract the obtuseness, venality and aimlessness of the Art World, American vanguard art needs a genuine audience – not just a market. It needs understanding – not just publicity.

In our form of society, audience and understanding for advanced painting have been produced, both here and abroad, first of all by the tiny circle of poets, musicians, theoreticians, men of letters, who have sensed in their own work the presence of the new creative principle.

So far, the silence of American literature on the new painting all but amounts to a scandal.

3 Extremist Art: Community Criticism

MOSCOW, *November 14. The official view was still that the Impressionist chool was a setback for French art because it was formalistic and divorced rom realism. The* New York Times, *15 November 1955.*

IT is lugubrious to relate that the New American Conservatism (sometimes styling itself 'humanism', though nothing could be more remote from the spirit of Rabelais and Montaigne), having inspired a few drab volumes and laboured essays in literature and social polemics, has turned its melancholy and aggressive attentions in the direction of painting.

To analyse separately the position of these latest foes of Cézanne, Cubism, Mondrian, European Expressionism and American Action Painting would be a waste of time. Despite their pose of last-ditch resistance to the radical and de-individualizing tendencies of our age, their arguments and terminology are the old ones of the Communists and other social disciplinarians. About this homogeneity there is no great mystery. Whether coming from the Right or the Left, attacks on contemporary extremist art, especially while it is still extreme, are always launched from the standpoint of The Community. Each ideology has, of course, its own definition of what The Community is; but all agree that the most characteristic art of our century has not done right by it – apart perhaps from a contribution to linoleum patterns – and that in the representative paintings of 'Modern' art the communal voice has been silenced and the social wish repressed.

The gist of Community Criticism is to be found in the quotation at the head of this page, the dateline of which could

just as well have been Washington, the Vatican or The Art of the Ages. The key is the word 'formalistic', which in the pseudo-aesthetic jargon of the anti-Modern front means 'lacking in significant content', 'alien to the world of real values', 'pathologically self-isolated and private', 'insensitive to the tragedies and hopes of our epoch', 'snobbish refusal to communicate with the people', etc.

It is characteristic of the babel of Community denunciations of this century's styles that they project themselves above the heads of artists, art critics and intellectuals in order to exhort the 'layman', who for this occasion has been outfitted free of charge with suitable tastes and emotions. Upon the Common Man has been thrust by the anti-formalist cults a powerful natural admiration for Rembrandt, El Greco, Goya, even Giotto or Cimabue, that is to say, any painter of 'pictures'. Presumably all one needs to 'get' these painters is an eye, with perhaps a hint here and there from the Community Critic of profundities concerning Dutch life or Spanish death.

This simple citizen art lover, the fable goes, was of yore happily stimulated, refined, enlightened and uplifted by art into being a still better citizen. Having arrived, however, at the epoch of Cézanne and Picasso he feels frustrated, irritable and led by the nose; inhuman formalism has stiff-armed him out of his heritage of art. He would protest against these inane, vicious and underground insults forced upon him by The Modern Art Hoax but he is intimidated by its organized promoters. 'Don't let them bully you,' cries the ideological humanist. 'An art that does not appeal to your feelings is no art at all. The task of painting is to depict the Great Common Experiences of Man.'

Naturally, the Great Common Experiences, to stage which on canvas the art of painting has received an historical retainer, inevitably turn out to be situations which exemplify the values of the 'humanist's' particular fanaticism, Communist, nationalist, etc. What is called 'Realism' in art tends to consist of episodes of class struggle or defence of The Revolutionary Homeland, patriotic and homey scenes of the folk and its heroes, religious images of miracle and martyrdom. The 'experience' which the anti-formalists discover in the paintings

of the past as their grand Content is never the experienced experience of an individual artist – for example, the experience of Leonardo, as re-discovered by the formalist Valéry; it is an ideological substitute for experience, a Ready-Made, suitable for packaged distribution.

If there is anything the humanist resents more than the content-less art of our epoch, it is any statement about this art which explicates its content. If Mondrian or Miró or some interested investigator describes the motives, origins and references in experience of an extremist work or style, the tactic is either to remain silent about this reflection – how grant that a formalist has even wanted to communicate? – or to attack it as humanistically (i.e., mass-intellectually) speaking even more obnoxiously empty and mystifying than the paintings themselves. The thinking of painters (as distinguished from gossip about them) only adds verbal insult to retinal injury, and the less the humanist sees in a canvas the stronger is the evidence it presents of a conspiracy to drive everyone mad.

The humanist's reflex to existing writings about extremist art demonstrates that his argument of Content versus Formalism has no bearing on the actual meaning or obscurity of paintings but is, primarily, a *political* argument. The humanist seeks the *destruction* of modern art, not a better understanding of it. His criticism is part of an effort to organize a militant solidarity of Plain Men in the service of an ideology of social power by which everyone, including the artist, shall be 'integrated'.

A book like Selden Rodman's *The Eye of Man*, full of shot-gun judgements of paintings and artists in many periods and especially in our own, is political and nothing else – not because it promotes some party movement or theory of government, but because it creeps up on painting with an order of concepts that judges artists according to whether or not they show signs of being 'detached from the community'.

To Rodman, as to *Novy Mir* or the Pope, 'formalistic' work smells of society's outsiders and is without substance, other than the artist's sickness (e.g. Soutine); in painting created in the tradition of Cézanne, Rodman holds, content has, as never before, 'suffered a total eclipse'.

Rodman wants to lay on his yardstick somewhat differently from Huntington Hartford or the buffoons of city censorship councils – he, for instance, finds a religious message in Rouault's fat whores, who are just ugly to Hartford; and instead of attacking de Kooning, Rodman expresses the hope that the Venus that has risen out of the artist's waves of paint will get married and settle down. But Rodman's disagreements with the civic commandos is a family quarrel. A book 'addressed to laymen' with the aim of inciting them by appeals to exalted values against the art of their day as something vacuous and deranged, without giving those laymen a hint of their own abstractness and inner isolation, or of the motives and disciplines of extremist styles, cannot be considered pertinent outside its own circle of agitation either to art or popular education.

As politics, however, the connotations of such appeals are sufficiently specific: a society that does not tolerate outsiders, or which condemns their thought as *ipso facto* void, is an authoritarian community, be it secular or religious, republican, monarchist or totalitarian.

That in this century, when all the sciences operate under the regimen of mathematical symbolisms or methodological jargons, so that the physical universe and the social one each appears as a separate capsule of incomprehensibles, while, on the other hand, mass-injected superstitions represent the essences of politics, domestic life, virtue, the past, as a trayload of variously coloured powders; that in such a situation works of art should function as the exclusive language of the concrete human event, but by this very fact sever themselves from general intelligibility and, especially, easy definition – this rudimentary historical datum seems to have eluded the aesthetic traditionalists of all society-renovating Fronts. In practical effect, the organized opposition to abstraction in art by non-artists is simply a clamour for a still larger number of abstract responses by the populace. (May I note here that I am *not* taking sides in the question of Abstract vs. Realist art, and that this pseudo-antithesis will be dealt with later.)

Reality . . . by all means more of it and not only in painting! The Common Man himself could use quite a bit – and above all the conservative critic.

As for painting, one can admire new images and still be bored to death, apart from agitators and school teachers, by artists who likewise believe that the contribution of the past fifty years has been to re-define painting as an arrangement of coloured shapes.

What kind of and how much reality or experience a work of art can 'contain' at any given moment, and to what extent 'content' has vanished from the pictures and poems of the past through the hollowing out of the aesthetic language, is known only through efforts in which artists are the chief specialists. Ezra Pound, incomparable teacher of the art of poetry to Americans, derided John Milton because for Pound poetry existed only in the tension of the verbal surface. Yet compared with the huge shadow figures and cosmic chaos-and-dark-night of *Paradise Lost*, Pound's translated elegancies, inside stuff about history and personae and chop chop at 'our dying civilization' seem picayune. Does this make Pound a 'formalist' who wilfully shrank the content of poetry through a mistaken emphasis on its means? Nonsense. Poe had testified a century earlier that *Paradise Lost* had collapsed into a rubble of isolated passages and individual lines whose effect changed each time one read a few pages. The grand outlines of the work could be seen but it was no longer possible for the reader to get close to it as poetry. But if Milton's aesthetic content had evaporated, the problem was not how to re-bottle his 'themes'. Pound's judgement of Milton was wrong, but he was right about what poetry needed in the twentieth century: in the long run this would make him a help also to Milton.

Among works of the past the artist can only choose between what is art for him and what has become non-art; to keep the art he may have to throw away most of the lot and even the 'best'. Nor in his own work will the scale of its meaning be for him to decide. Of course, every artist wants to be as grand as the grandest, but only a fool or a backwoodsman demands of his idea that it submit a list of specifications before being put to work. For an artist today not to feel that painting has lost a great deal since Rubens only makes it more difficult for him to realize that Rubens is not an issue. Admiring inherited masterpieces, however, in order to saddle contemporaries

with the responsibility to 'equal' them is a trick of totalitarians and busybodies. The various currents of Community Criticism converge in misleading the public into believing that an artist has a free choice as to what the content of his painting shall be and that his failure to concern himself with social ideals and problems is evidence of malice. Once this myth has been established, 'Significant Content' can be introduced with the aid of Sanitation Committees and the thought police.

For American painters the question of willed content was settled for a generation by the frustrating adventure into 1930s politics, as well as by individual sorties into commercial and commissioned work. Artists who discovered their social will under the stimulation of the Left Front tried to reason out a conclusion concerning History's demand on art – after all, you couldn't have a more important boss. Some wasted years before the intuition dawned on them that to be told *what* to paint was inevitably to be told *how* to paint, and that any decision as to subject matter *or* form might be deadly if it happened to be incompatible with the creative process of the particular individual. Only when the collapse of the arts in the USSR and in Fascist Germany and Italy demonstrated beyond doubt the irreconcilability of art and ideological utility did artists in America shake off the nightmare of 'Responsibility'.

Following the *débâcle* of class-conscious art, regional-scene painting, Americana, WPA history and other 'communicating' modes, Reality, left, centre and right wing, was for a time as quiescent as the corpse of painting left by assignments, resolutions, artist congresses. During the War and for some time thereafter, art was obviously in no condition to stage a popular rally in behalf of either social protest or social order.

When, however, I reported a few years ago that American painting, having revived from its mortification by Values high and low in a cave happily devoid of pioneer and proletarian totems or reflections of middle-class faces, sheep or street corners, now essayed to evoke through the gesticulations of a limb ending in paint-clotted bristles an image on the underside of which the artist could, like Odysseus, be carried out of the reach of the howling Polyphemus of Responsible Art to the open sea of dramatic self-identification – no sooner had I

recounted this simple tale than it became obvious that the Thirty Years War of leaflet sowers had recovered its normal frenzy, although it was already the most open of secrets that *the slogans of both Realism and Abstraction now clumsily disguised the defence of vested interests in certain obsolete techniques.** That American Action Painting had been demonstrated to be exclusively *content* of a particular order prevented no one from whooping for or against its total preoccupation with Form. Of all the humanists who have since attacked this painting, not one, to my knowledge, has gone farther in the way of discussing its human and metaphysical testimony than to affix to it some phrases turned into their opposites by removal from their context, in order to support charges of formalistic emptiness, irrationality and anti-social withdrawal which had become platitudes decades before these canvases were conceived.

If a veteran New York painter, finding himself in art's dugout at the beginning of the forties, had the ingenuity, inspired by years of submarine existence, to fill it to the top with water and reproduce in Kodachrome the hues generated on different levels by the light falling through his fishpond, is his image less a 'communication of experience' than, say, Jack Levine's reminder on canvas that in a big city there are gangsters? I had heard about these gangsters before Levine made pictures of them and so had other people, including the gangsters. But before this submarinist, to the 'humanist' a mere geometer, I knew much less about being a fish, although there had been a few passionate outcries about this condition – for example, in Eliot's *Wasteland* and some novels heralding a new Ice Age. To me this most vacant of abstractionists had communicated a 'significant content' through paint, while Levine organizing in colour everyone's Reality represents nothing but style. In fact, Levine's flickering monochrome funeral parlour, with its sun-falling-through-leaves quality of

*Obviously, this sentence is overly long and ought to be broken up, perhaps into several chapters. I beg the reader's leave to retain it in its present form as a mental re-enactment of the tortuous progression of American painting during the past two decades. Anyone capturing its movement should be able to react instantaneously to the propaganda in favour of a socially disciplined art.

a last-century Continental lawn, augmenting with its ana-
chronistic gentility the quiet pleasure aroused by the way the
fat politician holds his head on a side, is to such an extent an
absorption of big-city unexperienced newspaper Reality into
art history that it could serve as a model of Formalism. Except
that – there is no such thing. Because, as the Hindus say,
Realism is one of the fifty-seven varieties of decoration.

4 Virtual Revolution

SUSANNE Langer's large, even great book *Feeling and Form* is a revolutionary event in Aesthetics, that queer country where for a century an assortment of philosophers, critics, artists and sentimentalists have been chasing the Phenomenon of Beauty with speculative butterfly nets.

Like all good revolutionists, Dr Langer has begun by perfecting the instrument: she has woven a net with smaller holes. With the basic theoretical stuff supplied by her earlier study of symbolism, *Philosophy in a New Key*, she turns wide-open ideas like Clive Bell's Significant Form into a close mesh of concepts and definitions which specify what Form is and what is Significant about it when it signifies. Dr Langer believes that art is a unity that can be trapped in a system in which such words as '*expression*', '*symbol*', '*vitality*', etc., have strong, clear meanings linked with one another.

The determination of a writer to define terms rather than to use the arts to express his own emotions, or display profundity or promote theories about other matters is in itself radical enough. But I was moved to call *Feeling and Form* revolutionary primarily because of the style in which it is written. The force with which it states its propositions, its scorn for the vagueness, paradox and lack of system of other writers, its tendency to correct those from whom it borrows ideas, remind me of 'Bolshevik intellectual thoroughness'. Words like 'silly' and 'nonsense' occur frequently. The broad span of its exceedingly positive conclusions, reaching to such rather specialized problems as prize-juries in painting and what kind of poems are best to set to music, cannot help but evoke

the mood of ideological *gleichschaltung*. Looking over her shoulder at Ernst Cassirer, the way Marx looked back to Hegel, Dr Langer does not hesitate to contradict *everybody*. 'Surely,' she remarks teasingly about expression in dance, 'no one would have the temerity to claim that *all* experts on a subject are wrong?' Promptly she demonstrates she does have just that.

This non-academic roughhouse is alternately refreshing and annoying and the reader should not be put off by it. However, I mention the tone of authority, belligerence and impatience of *Feeling and Form* for another reason: it is a way of illustrating Dr Langer's conception of what a work of art is and how to respond to it.

A creative work, she holds, is a 'single symbolic form' which is 'the embodiment of a feeling pattern' – this is as true of a non-fictional discursive composition, whose 'motif' is an argument, as of a poem, whose motif is an image. Thus, though *Feeling and Form* is an essay in the philosophy of art and analysable for its ideas, it is also a symbolic form; and this form, expressive of rhythms of conceptual hammering and correctional knuckle-rapping, has its own significance.

Now the *wrong* way to respond to the feeling in a work is exemplified by the philosopher who, reviewing *Feeling and Form*, complained that its 'authoritative tone' made him feel he was 'back in primary school listening to a rather crabbed teacher'. The error here, in Dr Langer's terms, is that the reviewer entered into relation with the author rather than with the work. What the didactic impatience in *Feeling and Form* makes the reader think of Dr Langer is irrelevant; he should find out what it means in the book.

That the work stands apart from the personality of the artist, at the same time that it is a form expressive of human feeling, is Dr Langer's central idea, represented by her concept of the 'art symbol'. An art symbol for Dr Langer does not mean a sign pointing to some other thing, not even to the feelings of the artist. It is a creation, an appearance or 'semblance', in which the thought, passion and craft of the creator take on a transformed life.

As a 'virtual' rather than an actual object, the art symbol

establishes its habitat at a distance from nature, as well as from the spectator and the maker. Each of the arts is removed in this way by its own 'primary illusion'. In painting, this illusion is 'virtual space'. The space in a painting is a semblance of actual space, but the art-space exists as an appearance only and has no relation to the space of common sense or of science – any analogy between a Picasso and non-Euclidean geometry is, Langerianly speaking, specious. Painting space, as the basic abstraction of the art, separates from reality every picture and what's in it.

The virtual space of painting is matched by the virtual volume of sculpture, the virtual 'place' of architecture (distinct from the usable room in a building), the virtual time of music, the virtual 'powers' of dance (to my mind, the most brilliant of Dr Langer's formulae), the virtual 'history' of fiction, etc. Every art, like Kubla Khan's pleasure dome, closes off a 'realm' for itself, twice five miles of sacred ground.

Does the fact that works of art float in their own illusion imply that they have no connection with life? No, says Dr Langer, for their forms are rooted in the vital rhythms of the organic process – growth, development, decline, death. Nor does its separation from reality deprive the work of intellectual meaning and define it as a mere occasion for neural reactions. In being a symbol, its thought content is well-nigh inexhaustible. Only, here, thought is not the opposite of feeling but identical with it; and 'content' is not the fact and logic of the practical or discursive consciousness, but the articulation of the forms.

From Plato to Nietzsche, art has been envisioned as a super-reality belonging either to the 'lie' of myth or the truth of revelation. Dr Langer has put this super-reality in its place with regard to science and logic and has specified its mode in each of the arts. Through the coherent connections of her terms she has set the arts in order and has initiated the systematic generalization of their generalizations in Whitehead's sense.

It is just this grand order and system, so seemingly clarifying, that I find whimsical and contradictory; that this order is at odds with the modern spirit of breaking up orders, even

expressive orders, may account for the dogmatism and impatience of *Feeling and Form*.

If, as Dr Langer believes, a unified philosophy of art, once its key terms were properly formulated, could be developed comparable to mathematics, logic or the sciences, the conflicts, vaguenesses and ambiguities of critics could be attributed to nothing more than theoretical sloppiness or mental sloth; in which case it would be just as well to bump the old mob off the raft. And apparently she feels the rougher the bumping the better.

In art criticism, however, this semantic evaluation seems highly dubious. Here chaos relates to real differences in what people in present-day civilization look for in art; which results, of course, in differences in what they find and also in what artists put there. In our time there exists no unified community where Art *is* and the arts *are*, each in its form and order. Art is constantly making itself; its definition is in the future. Criticism cannot therefore be a single developing theory; *it must be partisan and polemical in order to join art in asserting what art is to become*. Should everyone adopt the same terminology, the promulgation of conflicting interests would soon complicate that terminology beyond utility. The banging you hear in *Feeling and Form* comes from the need to drown out this potential clamour.

Systematic definition does not eliminate the conflicts in *Feeling and Form* itself; its coherence is a 'virtual' one produced by shifts in perspective. In opposing the inter-mixing of the arts and their assimilation of 'raw material', in slapping down psychologism in criticism, in emphasizing the role of intellect and imagination in the creation and appreciation of art, Dr Langer is a 'classicist' in the camp of Order, of Eliot and the religious humanists. In the modern world she finds 'degeneration due to secularization'. Above the Symbol hovers the tension of the communal and mythic trance.

At the same time she feels that these are great days for science and scientific method; and her notions that the work is a unique feeling-form made by the artist 'for himself, for his own satisfaction', that in 'handling his own creation ... he learns from the perceptible reality before him possibilities

of subjective experience he had not known in his personal life', that no generalizations can aid the evaluation of particular works – these views ally her with contemporary Expressionism.

Tremendous cultural, ethical, political and philosophical antagonisms divide Classicism and Expressionism. An individual artist like Thomas Mann could synthesize these conflicts symbolically in his images of self-isolating forms flooded by primordial rhythms. The contradictions cannot be reconciled, however, for *all* art, without regard to historical differences. For the artist interested, like Cézanne, in 'expressing personality' there is no 'primary illusion' restricted to painting, as there is no science and common-sense 'reality' existing apart from his perception and his work. Distance, yes. But the Distance is in him, as the lack his art overcomes in reaching the real. He paints himself into the picture before he paints himself out of it again. Distance is not in the form as such, as in earlier communities: there, indeed, the word 'feeling' is inapplicable, as Nietzsche suggested; we have to speak of ecstasy or possession, since artist and audience are taken out of themselves and have no 'personality'. The modern 'self-expressive' artist does everything he can to destroy the Distance of form, especially where he revolts against priesthood and hierarchy. Hence painting and literature today are full of smashed and mixed forms and deliberately 'pasted in' raw materials.

Though she claims to write from the 'point of view of the artist', Dr Langer thus finds herself in a steady wrangle with artists. Cézanne's reflections, she notes, 'always centre on the absolute authority of Nature ... recording what he saw, he earnestly believed that he painted exactly what "was there".' Henry James said, 'as the picture is reality, so the novel is history'. Poor naïfs – Dr Langer has to explain to them why their pictures are not real nor their histories 'objective'. 'All forces', she reminds them, 'that cannot be scientifically established and measured must be regarded from the philosophical standpoint as illusory; if, therefore, such forces appear to be part of our direct experience, they are "virtual", i.e., non-actual semblances.'

Philosophy of science, not the experience of the artist, has

decided for Dr Langer that the aura in which the painting, poem or dance wraps itself from the first stroke, syllable or movement has no equivalent in nature or history and that the work of art is consequently a symbol of the invisible, not an 'imitation' of it. Yet a hero has his aura and an action has its aura, too; a battle or an evening may isolate itself as securely in its own time and space as a poem or a painting; and where is the artist who has not found in the world 'three things that are too wonderful for me, yea, four which I know not'? That science cannot reconcile these with its 'reality' does not make them any the less real, and a 'philosophical standpoint' that 'must' (!) regard the set-apartness of the unique as illusory had better look to its premises.

Dr Langer has made good use of the limitations of science in knocking out scientistic critics like I. A. Richards. But she has left herself with art that is myth and with reality that keeps collapsing into the commonplace: to her an actual event is less vivid and mysterious than one in a novel. The theory of 'virtual' art objects does too much for form and for knowledge at the expense of experience. Like much of current methodological speculation in the social sciences, it is a blend of nostalgia and Utopianism: of looking back to the myth-guided communities where the archetypal forms ruled and feeling and belief were at their height, of looking forward to a future world of the altogether real which science is preparing. As for the present, it is seen as dominated by two élites: hieratic artists who give form and virtual existence to the primeval passions; methodological philosophers building their growing order of provable and measurable actualities. Beneath these stagger the great mass of mankind, no longer moved collectively in the trance of the forms, not yet educated in the logical 'musts' of thought.

The glory of art, when it is not priestly art (and at least this one *historical* distinction seems to me indispensable in any philosophy of art), is that for all its separateness it does not stay separate on one side or the other of the intellectual 'forces', as an evidence either for superstition or for science, but manages to maintain itself within actual events, where illusion and the real reproduce each other.

The Ape On the Doorstep

A LETTUCE is not a wild rose, yet the public continues to be regarded as a primitive organism, a kind of untouched Nature, with which the fine arts ought constantly to commune.

An easy formula for appearing thoughtful is to set up an opposition between the raw responses of the average man and the intellectualism of modern books, paintings and music. Elaborations of this opposition as a sickness of the age abound among the paperback philosophers. Here is a simpler version from *How Not to Write a Play* by Mr Walter Kerr, drama critic of the *New York Herald-Tribune*: 'These men' – he is referring to Shakespeare, etc. – 'found greatness because of their communion with the universal audience; the presence of the uncultivated mass in the theatre is an indispensable prerequisite for drama of genuine stature.' So much for the Giants Of Other Ages, the 'because' of whose greatness we now know. In contrast to them, we are told, contemporary playwrights have abandoned the Calibans (note that with Kerr 'universal' was synonymous with 'uncultivated') and turned the theatre into a hothouse of technical and ideological experiments.

Those familiar with similar polemics in painting will be amused to learn that on Broadway, according to Kerr, super-intellectuality, over-emphasis on technique, in a word, 'formalist' art, is represented by Realism! What keeps the aborigines from the $5.50 seats is a stage on which telephones ring, shades are drawn, meals served and eaten, kids sent off to school, just like in life. In the theatre it is Reality that makes

art unpopular; while in painting it is its absence and the prevalence of subjectivity and abstraction that is supposed to chase away the common geist. Kerr even goes so far as to claim that Realist plays are not only unpopular but anti-popular. The Realists ring those bells at every plausible moment for the same reason that the Action Painters drip and smear: on purpose to irritate and repel the general mind.

I am inclined to concur with Kerr that Realism has become repulsive. But I do not believe its lack of popular appeal is owing to disproportionate brainpower – baseball crowds, too, have been shrinking and the circus has gone out of business. The trouble with Broadway Realism, as with the Realism in painting, is not its intellectuality, but the fact that both its ideas and its reality have lost their character. Too much vermouth. The phoney look, the look of Style and nothing else, comes not from indifference to the public but from excessive confidence in having the public in the bag through these particular tricks. Big league ball fields have come to resemble stage-sets, and the circus before it died turned into a nightclub. The contemporary Realists fail not because their ideas overleap the limits of the common mentality but, on the contrary, because they are ideas *only* for the Public; their authors themselves are not otherwise interested in them.

The image of the simple layman waiting on the doorstep of art is a morbid fancy of modern thought. In actuality there exists no such thing as an 'uncultivated mass'. If there is anyone in America who has managed to elude being educated by free compulsory schools and by the millions of pictures and written and spoken words poured into every crevice of this country hourly, he is so hard to catch he may as well be written off as prospective audience material. Today everybody is already a member of some intellectually worked-over group, that is, an audience. And in the sense that it is literate, selective and self-conscious in its taste, every audience is an audience of intellectuals. Science fiction, tabloid sports columns, rock 'n roll gab, the New Criticism, presuppose various levels of technical preparation and familiarity with terminology on the part of their readers (I am not saying which way is up). Even the daytime broadcast designed for the

suburban housewife addresses itself to an expertise gained through womansday and digest journalism with its encyclopaedic how-to-do-it training and inside stories on heroes and heroines. The member of the soap-show audience may differ from the Museum of Modern Art first nighter in vocabulary and self-estimation, but not necessarily in intellectual background or capacity; each is where she is largely because of chance or social environment. Moreover, American audiences interlock and their components easily pass over from one to another.

The Public is not a single entity of high or low intelligence but a sum of shifting groupings, each with its own mental focus. Which intellectual category an individual belongs to is *not* decided by his appreciation of the fine arts – all modern geniuses are known to read detective stories and one doubts that Einstein's record collection included Schönberg or Varèse. The existence of a mass of generic art appreciators is a myth left over from European aristocratic and pseudo-aristocratic meditations on lost peasant cultures and noble savages. In America today this myth serves the purposes not of art nor of the public but of salesmanship or political propaganda – one who speaks on behalf of an art for The Public is trying to recruit a new public out of existing publics.

The novelty about the situation of the fine arts in the twentieth century is that for the first time in history no one is sure who the art audience is. Today, it is possible to ask: For Whom Do You Paint (or Write)? and for this question to be the beginning of a speculation, to say nothing of a fight. Proust's idea that the real audience of an original work is slowly shaped by the work itself merely confirms the presence of the enigma. To the tattoo artist on Melville's Pacific island who covered the village headman with an over-all design previously tried out on some bottom dog used as a sketch pad, the problem did not present itself. His audience was there in advance. The same for the painters and poets commissioned by the princes of church and court, and even for those whose acquaintance the educated bourgeoisie of the nineteenth century felt obliged to make. The radical twist in the art situation begins in earnest when the typical art audience

is no longer recognizable by the insignia of its social function. The turnout at a current art show, which consists almost exclusively of artists and of practitioners of closely allied professions – art teachers, museum employees, decorators, architects, designers, photographers – is by comparison with the élites of other days a very odd group; not only does it fail to represent social authority, it does not even represent its own social function as a professional group, since other artists and members of the same professions as those present, with an education, income, prestige, equivalent to theirs, despise this art or regard it as irrelevant to their work; as a *New Yorker* novelist once said to me, 'Kafka is interesting, but of course he's not in my field'.

Lacking objective cohesion, the new audience is truer aesthetically than former ones to the extent that it comes into being not through social status but through the magnetic attraction of the work of art upon random human particles.

On the other hand, the social amalgam that constitutes an audience today tends to be charged with currents of mood and opinion originating in the uncertain conditions of its existence and in the gratuitousness of its interest in any given work or style. These emotional and mental currents it diffuses upon the arts.

The study of the influences thus set into motion in art is the only appropriate ground for social criticism of contemporary work; while theories about what 'Society' demands of the artist, or of what art might communicate with an audience of everybody, are as out-of-date and useless as the idea of shocking or defying this phantom.

Notes On the New Public

The intellectualistic character of all current audiences is an effect of the steady transformation of the whole populace into professionals and semi-professionals; sociologists who classify people by the colours of their collars find a spectacular trend towards white and blue.

The professional mass keeps expanding and as it expands it divides. Old professions break up and each fragment becomes

the centre of a new constellation – it is not only that all doctors have become specialists but that the practice of medicine, like that of warfare, involves scores of other professions. At the same time the trades keep propelling themselves upwards into the professions; as the dentist not so long ago suppressed his past as a barber and assumed the rank of surgeon, so the kitchen manager becomes a dietitian and stockbreeders and policemen set up academic qualifications and conduct 'prestige' campaigns to convince society of the learned nature of their pursuits. Bricklayers, I am told, now lay exclusively on a fee-per basis, and their public relations representatives will soon, no doubt, have traced their craft back to Amenhotep's magicians and succeeded in ranking it with performance on the dulcimer – that is, assuming that there are still bricks . . .

Traditionalists resent this inexorable liquidation of the proletariat into the intellectual caste. They might console themselves with the thought that the process renders obsolete Lenin's conception of a vanguard of professional revolutionists hustling a semi-literate mass up this incline, and that the change of collars occurring spontaneously is probably the fundamental reason for the failure of Bolshevism in technologically advanced nations.

A form of work establishes itself as a profession not only through the complication of its technique – many of the ancient crafts involved more complex recipes than their counterparts today – but through self-consciousness with regard to this technique. A cop stops being a mere armed watch when he is aware of general reasons for his particular way of lounging on street corners. Thus the essential mark of a profession is its evolution of a unique language or jargon into which it translates its subject matter and in which its methods, purposes and relations to other arts and sciences are formulated. The more incomprehensible this lingo is to outsiders,* the more thoroughly it identifies the profession as such and elevates it out of the reach of mere amateurs and craftsmen.

One of the effects of the 'universal audience' illusion is that,

*The continued use of Latin by the medical profession appears as simple-minded compared to what newer professions have been able to accomplish in 'English'.

while gnomic language is taken for granted in the sciences and in newer modes of study, its use in the arts is treated as if they were still in an age when craftsmen bent silently over their tools. It would not, for instance, occur to the humanists of the picture weeklies to object to the following exposition of method in cultural anthropology:

When it is asserted that a certain behaviour is 'typical' in a certain culture, it is not implied that there is no other culture in which it is, at the same or some other time, equally 'typical.' What has hitherto turned out to be rather unique is the syndrome of each culture (the ensemble of its regularities), but not each element of the syndrome. *Psycho-Cultural Hypotheses About Political Acts*, Nathan Leites.

Yet anyone who thought as closely (no one goes *that* far) about the implications of his practices in painting would be treated as a genocide by audience builders, and perhaps also by Leites. In their turn, artists, responding to the surrounding professionalization, become convinced that the secret of art, as well as its honour as a calling, resides in the jargon of the studios.

In any case, incomprehensibility in the arts is inseparable from the fragmentation of the public through the expansion of professionalism. The segregation of occupations within the mazes of their technical systems increasingly demolishes the old mental cohesions of class and nation. Outside each profession there is no social body to talk to, and apart from the forms in which the thought of the profession is embodied there is nothing to say. One who calls for mass communication in the arts is like a sergeant who wants to go back to good old simple drill in what the Defence Department, following the trend, calls 'our new *professional* army'.

The normal relation of each profession with others contiguous to it is border warfare: architects seek to subdue and subjugate painters and sculptors; engineers brush architects under the table; clergymen and psychiatrists battle each other or enter into uneasy and unprincipled mutual assistance pacts; public relations experts clash with advertising men, Federal investigators with district attorneys. The Balkanization of the

professions is perhaps best illustrated by Hollywood, whose art consists of the mangled remains of a battle royal among the crafts it has corralled.

Each segment of the professional mass fights the rest for status, cash and satisfaction of vanity. Beyond these a metaphysical issue is involved. In contrast with the 'clerk' of former times, the modern intellectual has no myth which he shares with the whole community; nor does he inherit the customs of a class nor the gravity of material possessions. His world is not of the imagination, nor of society, nor of physical objects; it is a world of ways and means. Having no identity other than the one he creates for himself through his métier, he is compelled to regard the rank of his profession, and of himself in it, as the final measure of his existence. The painter cannot acknowledge the inferiority of painting to some other intellectual discipline without abasing himself as an individual.

When in the thirties poets, historians, physicists, under the atmosphere of social breakdown and mass violence, lost confidence in the absolute value of their work and acknowledged the supremacy of the new art of history-making action, the effect was panic and surrender of personality. Seeking the revolutionary idea, they discovered themselves in the presence of another band of professionals, 'the Party', became entangled in an unfamiliar jargon and were assigned apprentice tasks. Ezra Pound's broadcasts for the Italian Fascists showed no trace of the language master. But without poetry what was Pound? A man of the crowd, a member of today's mass audience, that is to say, a professional echoing the jargon of another profession which he only partly understands. The same self-loss overtook all who surrendered their calling to the pretensions of insurrectionary politics.

Once the misery inherent in their self-estrangement had been thoroughly experienced a reversal occurred. The galley slaves of the ideologies scampered back to their vocations declaring the self-sufficiency of each in tones louder than ever. Painting for the revolution set the dial for painting as revelation. To mention in America today the relation between politics and art is tantamount to repeating an old scandal.

Absolute intellectual claims on the part of painting or poetry are consistent with the notion of what thought is that prevails in a professionalized society. In each profession an 'idea' means an operating concept, e.g., a ventriloquist's or bareback rider's idea for a new act. When a novelist says that he has an idea about The War, it is naïve to expect an explanation of The War, a prediction concerning its effects, an image of its suffering and heroism. By an 'idea' the author means that he has figured out a way of doing a war book that takes into account that it can't be *The Naked and the Dead*, *War and Peace*, *A Farewell to Arms*, nor *The Iliad*, yet will be one that makes the maximum use of all of these. A painter's 'idea' may be, No more black; or, No straight lines – as a plumber's (sanitation engineer's?) that running the hot water pipe through the toilet tank will prevent it from sweating.

An idea that has no direct application to any professional function is considered either something 'literary' (even in the writing profession 'literary' all but signifies 'useless' or a misdirected effort) or a mere verbal knot in the brain of an outsider – it might also be a psychopathological symptom. This operational view of thought, elaborated under the name of Scientific Method as a criticism of metaphysics, is America's chief contribution to world philosophy and dominates our university philosophy departments. Through it philosophy itself has acquired a professional status as the watchdog of the professions against infiltration of their technical apparatus by hypotheses concerning what things are and why.

While philosophy has thus ceased to possess any independent content, a profession becomes truly top rank when it can offer its system of technical re-definition as the key to the human situation, that is, as philosophy. This is done by the arts, by history, psychiatry, religion, atomic physics, military science. Here is an example of history turning into philosophy and giving orders to thinkers in other fields:

Up to now everyone has been at liberty to hope what he pleased about the future. But henceforward it will be everyman's business to inform himself of what *can* happen and therefore of what with the unalterable necessity of destiny and, irrespective of personal ideals, hopes or desires, *will* happen. Spengler, *The Decline Of the West*.

In the same way psychiatric congresses discuss how wars can be ended through controlling the psychic bases of aggression, while admirals and generals argue that the efficient use of present-day weapons demands a new character-structure in the citizen. A technique of getting out a ninety-nine per cent vote becomes the equivalent of political conviction, and making a choice between abstract and representational painting is taken to imply that one has a philosophy of history and of nature, as well as of art.

Logically, the philosophy of method, or method as philosophy, means art for artists, biology for biologists, revolution for revolutionists, literary criticism for literary critics – for none of which is illustration lacking.

Above the practice of the profession stands its Truth, accessible to no outsider, nor even to the mass of its practitioners – a general to whom the proper way to fight meant carrying out Pentagon directives could never understand MacArthur. In this inner perspective the work of the profession is conducted as a ritual demonstration of its laws, which a public of mystified members of other professions attends like a band of Zulus watching a Holy Mass.

The ritualization of the professions causes each to lead a double life: pure and applied, theoretical and practical, 'for its own sake' versus profit and social utility.* Pure art, physics, politics, is nothing else than art, physics, politics, that develops its procedures in terms of its own possibilities without reference to the needs of any other profession or of society as a whole. It is pushing these possibilities to their logical extreme, rather than the penetration of new areas of experience or understanding, that results in the recognition of the work as 'vanguard'. Upon such demonstrations of how far it can go in asserting itself as an absolute depends the status of the profession vis à vis the rest.

Since its first apperance, 'pure' art has been attacked as nihilistic. If, however, all the high professions are nihilistic in

*Only an analysis of the subjective life of the professions can make clear why commercial art and ideological art, instead of opposing each other, invariably range themselves on the same side against art or an idea created 'for its own sake'.

the identical way, the accusation becomes pointless, though not necessarily untrue. Each métier is moved to detach itself from the social will and to ignore every other form of thought except as it can absorb it into its own technical apparatus. Manifestations of such dissociation may seem absurd or vicious to members of other professions, but a Barnett Newman dropping a single line down the middle of a canvas is in no different position from the Supreme Commander in the Pacific trying to solve the problem of Communism in the Far East by 'hot pursuit' across the Yalu.

It may be, as Dostoyevsky suggested, that the entire caste of modern intellectuals is at bottom nihilistic; which means, given the enlargement of the caste, that we live in a nihilistic society. Certainly, it would not be difficult to establish a relation between the vocabulary of ultimates in the arts and sciences and the concepts peculiar to twentieth-century revolutionary totalitarianism. A Dictionary of Puristic Ideas could be compiled of words, phrases and concepts that transmigrate from poetry into, say, military science, back into painting, over again into city planning, sideways into political agitation and party life. The politics of the 'professional revolutionary vanguard' ('vanguard' is a word that turns up everywhere) is in fact nothing but the abstraction of the absolutist theoretical cores of contemporary professions and their reformulation into a 'pure' technique for seizing power. Once the profession of revolution has gained domination over the rest, its first step is to tear out and destroy their self-concentrated centres. No more 'formalist' art, no more theoretical science nor education for education's sake. Totalitarianism may be defined as that system in which all the professions save one are deprived of their 'purity' and of their vanguardist energies, in which lie their freedom and potential of social influence, and compelled to become totally 'applied' and 'practical'. To preserve the separate nihilisms of the professions thus becomes, ironically, a condition for maintaining liberty.

Totalitarianism terminates the double life of the professions – one of its attractions to 'applied' intellectuals is that it gets rid of the snobs of 'pure' art and theory. Where such forced unification has not taken place, the dialectical antagonism of

practice-for-its-own sake versus practice-for-social-use continues to tear each profession apart, at the same time that it promotes its intellectual complication. Out of this objectively rooted conflict arise the rancour, malice and envy that rage within the professions even more violently than between each and its neighbour.

Demonstrating the most esoteric aspects of the laws of his medium, the work of the vanguardist has the look of arbitrariness and inutility; the only measure of its value is through its effects upon other practitioners, particularly when it arouses them to principled opposition. Thus with regard to such work, criticism becomes in essence polemical and has little to do with 'appreciation'; the critic either approves of or opposes the direction in which the work is pulling the profession. As we have seen, neither for the mass of the profession nor the public outside can it have any direct meaning.

Popular interest may, however, be stimulated by the reflected professional interest of the insiders and by propaganda concerning the presence of a mystery – 'there are only six (twelve, twenty) people in the world who really understand Einstein'. The public receives the work in the form of the ideas into which it has been translated. Thus every modern work of art is in essence criticism; the artist paints it as an assertion in paint about painting, and the audience admires it as an assertion in paint about words. In achieving popular attention, the vanguard steals the glamour of the profession from its journeymen, though this does not prevent the latter from collecting its material rewards. The resentment thus generated is fanned by the fact that, like any public gathering, the crowd around the vanguard tent makes it a ripe field for frauds and pickpockets.

Popularization, which acts as journalistic or educational intercessor between the isolated mind of the theorist-technician and the fragmented psyche of the public, is the most powerful profession of our time and gaining daily in numbers, importance and finesse. It is the intellectual reflection of modern industry itself, which brings to mankind the physical products of an invention and technology which it does not understand. Neither the benefits of the arts and sciences, nor

their secrets, are any longer restricted to the rulers of society. As total war guarantees to each citizen that he will be an equal target of any new development in armaments, so the recruiting of audiences for art, psychotherapy, political action, accepts as its goal nothing short of the entire population. Mass media, institutional and agitational middlemen package modern painting as new design and better living; literature as morality, religion, politics, information; electronics as hi-fi; radicalism as join-the-party; total war as total security. Through mastery of the inversions of meaning that constitute 'mass education', the intellectual go-betweens ensure their own growth and predominance.

The popularizers find their natural allies in the rank and file of each profession, to whom the latest discoveries are as alien and disturbing as to the public itself. The union of salesmen, publicizers and distributors with the applied technicians is enough to give them control over any new idea or work. In no case does the founder of a method determine the use to which it shall be put by the profession nor what the public shall be told it means – as against the practitioner chiefs who head the university departments and professional associations, the influence of the actual practice of a Freud or an Einstein has been negligible, and the same is the case, of course, with the innovator in the arts. He is doomed to isolation by the very processes through which his work reaches society. The larger the part played by his creation in the profession the less need there is to understand it, and the greater grows the distance between his idea and the influence exerted by his work. The more widely he is known to the public, the greater the misinterpretation and fantasy built upon his name, and the greater the distance between himself and his social existence. The famous 'alienation of the artist' is the result not of the absence of interest of society in the artist's work but of the potential interest of *all* of society in it. A work not made for but 'sold' to the totality of the public would be a work totally taken away from its creator and totally falsified.

6 Revolution and the Concept of Beauty

The Idea of the Home – 'Home , Sweet Home' – must be destroyed at the same time as the idea of the Street. PIET MONDRIAN

YOU can take it from noisy US Congressmen who pop up from time to time that modern art is subversive. Or you can take it from Herbert Read, friend of vanguard movements, who writes in his *The Philosophy of Modern Art*, 'The modern movement in the arts which began to reveal itself in the first decade of the century was fundamentally revolutionary ... when I characterize this movement as *fundamentally revolutionary*, I attach a literal meaning to these well-worn words.'

The *New York Times*, which hesitates to see things hanging in respectable American homes and museums given the embarrassing label of revolutionary, printed an article some time ago documenting the fact that abstract and expressionist art used to be banned in Nazi Germany and is outlawed in the USSR. If the Nazis and the Communists have disapproved of these modes, how can the latter be radical? This way of protecting modern art is a bit sly. The antagonism of Fascism or Communism does not exonerate it of subversiveness. Totalitarian hostility could prove just the opposite: that modern art is so socially disruptive that even 'revolutionary' governments will not tolerate it. Or it could prove that Fascism and Bolshevism, which in their early days had no policy against the new art, ceased to be radical at the point where unconventional forms appeared to them as hostile in spirit.

The best conclusion would seem to be that modern art is

revolutionary but that the revolution of art is not that of political radicalism. For Herbert Read it's not political at all but is the act of an individual launching himself into the unknown. Cézanne was revolutionary when he thought the artist ought to 'express his entire personality, great or small'. So was Klee when he declared, 'I want to be as though new-born, knowing nothing, absolutely nothing about Europe . . . to be almost primitive'. Also Mondrian, conceiving 'healthy and beautiful cities by opposing buildings and empty spaces in an equilibrated way'. Who can deny revolution in this sense to modern art with its repeated beginnings and its slogans of the New Man, New Realities, The New Order?

Things would be relatively simple if the Congressmen were wrong and vanguard art had nothing to do with revolution. Or if Sir Herbert and the Communists were right and revolutionary art had nothing to do with Communism.

The fact is, however, that in the twentieth century the world of art and the world of revolutionary politics, both of the Right and of the Left, have been thoroughly mixed together. The same Words are at their centre.

Yet the differences between revolution in art and revolution in politics are enormous. For instance, revolution in politics is a choice – one elects overthrow instead of the way of reform or reaction.

Revolution in art lies not in the will to destroy but in the revelation of what already is destroyed. Art kills only the dead.

Hence revolution as the artist lives it is an inescapable effect of his vision. The *decision to be revolutionary* usually counts for very little. The most radical changes have come from personalities who were conservative and even conventional – a powerful recoil from the radical present threw them backwards, so to speak, into the future. The artist who engages himself with angels or stained-glass windows may produce innovations as devastating as the designer of a new cosmos in plexiglass.

God is dead, said Mondrian, therefore we must have Neo-plasticism. 'It [pure beauty] is identical with what the Past revealed under the name of Divinity and is indispensable if we poor humans are to live and find Equilibrium, for things in

their natural state are against us and the most external conditions of matter fight us.' What's so revolutionary about looking for a God-substitute and finding it in Equilibrium (and in capitals, too)? Mondrian's radicalism consists not in wanting things to be different than they used to be – on the contrary, he longs for an ideal element in the past as 'indispensable' – but in recognizing that those older, cherished forms are no longer alive in nature, society and art.

Another contrast between revolution in politics and in art: in politics the alternative to revolution is another political position, reaction, for instance. In art the alternative is 'the Academy', which is not a position in art. Reaction struggles for its own aims and can gain victories. The Academy can adopt any mode, even the most advanced, but can never win anything for art.

With the Academy as his sole alternative, the contemporary artist must either find his way to the frontiers of art or cease being an artist.

These are a few reasons why sharing of the word 'revolution' by art and politics makes for tremendous confusions. But in art confusion is not necessarily bad. On the contrary, the history of art could be written in terms of the evolution of images arising from misunderstood ideas – the idea of perspective, for instance. Indeed, once the mistakes around an idea are cleared up and everyone knows how to apply it correctly, the evolution stops and art is finished with the idea.

The chaos resulting in the twentieth century from the concept of revolutionary art has equalled in fertility the most vigorous misunderstandings of the past. Nor is there visible any limit to what may still come out of it.

It is not important therefore that we succeed in dissolving the confusions inherent in the notion of revolutionary art, even if we could – though probably this is impossible so long as the conditions that created the confusions continue to exist.

It is necessary, however, to expose that there *is* a confusion, especially now that the adulteration of art with politics (and of politics with art) has ceased to be innocent. Today, everyone is aware that revolution in art and revolution in politics are not the same thing and may even be in opposition to each

other. This awareness is, however, kept under cover for professional reasons. To serve a variety of interests, a sophisticated, impure play upon the ambiguities of the revolutionary position is kept going, radical painters being palmed off as respectable (as in The *New York Times* article), philistine work screaming that it is changing the world. The result is an atmosphere of bad conscience, of dupery and self-dupery. It is not too much to say that bad conscience about revolution is the specific malady of art today.

Political revolution wants to finish with the past, to 'bring history to an end'.

Yet, while pronouncing the death of society, the political revolutionist does not accept that death as his own. Society's death is to be lived by those others who are to him history's left-overs: aristocrats, bourgeois, priests, gypsies. He, the revolutionist, has raised himself above the general decline through his ideology and his revolutionary will.

In withdrawing from the dying of society, the political revolutionist must renounce experiencing himself as a person. He too is, he recognizes, heir to society's moribundity, the symptoms of which – despair, dependence, ecstasy – threaten the performance of his revolutionary role. This inherited self steeped in death he must rigorously negate for the sake of the needs of the time. His decisions must flow not from his desires or intuitions but from the logic of history, which at every moment determines what the necessary next act shall be. The personal existence of the revolutionist is in the future, of which he is the type.

Revolutionary impersonality is a tendency in twentieth-century art. For the painter under the influence of revolutionary ideas – though he may consider himself non-political – the way to paint is determined by the logic of an external development, whether in art or in society. 'Since such and such has been done, it follows that art must . . .' Mondrian leaves 'naturalistic' art behind, and it's up to the artist who comes after him to leave Mondrian (or Picasso or Klee, depending on whom he conceives as 'last') behind. But not Rubens or Correggio, since Rubens was left behind by other people.

It follows that Mondrian is Art, but Rubens and the others are tombstones in a receding series, not even containing anything that can be negated.

There are painters who, applying the political revolutionary concept to painting, see 'the next step' in art as the last step in history. ('The creation of a sort of Eden is not impossible if there is but a will.' – Mondrian.)

This approach to art may be called Millennial Vanguardism. It tends *to thin out* painting more and more, as millennial political ideologies tend to thin out human history into the crimes of their opponents.

Though its aim is to close the door of history, revolutionary art contradicts this aim by its dream of permanence and continuity. It wishes to close the door *behind* itself.

The same for art criticism: no matter how revolutionary it gets, it cannot silence art's whispers of immortality.

Herbert Read, for instance, is a revolutionary critic. He's in favour of revolutionary art, but he's also for aesthetic values. Can these be reconciled?

On the revolutionary side what counts for Sir Herbert is a constant turnover of innovations, constant invention. Unless art keeps catching the new by the tail it loses its meaning. Thus Sir Herbert finds that art now is in a state of decline. 'The work of the younger men,' he writes, 'is still but the prolonged reverberations of the explosions of thirty or forty years ago. The general effect is diminuendo.' This is the judgement of a partisan of vanguardism rather than a critic of painting. Because if, instead of listening for 'explosions', you look at the work of 1948–53 and apply to it the canons of painting, you can't say it's worse than that of 1918–23. In the same mode, artists have learned how to handle paint and surface, how to play up and down the scale of formal and tonal relations – in short, how to paint with increased confidence and subtlety.

I happen, however, to agree with Sir Herbert's conclusion about the decline – except in America, where it is pretty much settled by now that the new Abstract Expressionism or Action Painting was not just a cork that popped out of an old bottle of French wine. But I wish to insist that the decline has no

visible relation to the aesthetic quality of the paintings produced. It has to do with a complex of meanings larger than the meaning of any one art and in which painting is situated. What fizzled was the revolution with which the century began, the will to overthrow and discover, and the originality, daring, enthusiasm, to leave painting behind, while absorbing into it the most direct experience and ideas from other fields of study.

That Sir Herbert's estimate of current art is governed less by aesthetic considerations than by his vitalistic outlook is indicated by his rejection of the modernist Academicism that seeks a 'synthesis' or consolidation of styles based on the revolts and experiments of forty years ago. To his credit, he refuses to trade in Mona Lisa's moustache, *White On White* or *Odalisque* for peaceful, prosperous revolutionary canvases. If modern art is revolutionary art, what good is there in piling up accredited Vanguard Masterpieces that repeat the old ideas? In the absence of the spirit of revolt, search and radical truth, the works of the innovators lose their point and the new works built upon them are farce.

All this undoubtedly makes sense. But does it make sense about art? Can one subordinate talent and style to discovery and impatience and still insist on aesthetic values? Doesn't the revolutionary position imply the renunciation of art criticism?

For art criticism the question of the particular painting keeps coming up. And what can the will to revolution tell about a painting? Only that it turned things over, failed to turn them over, or turned them over too thoroughly. If there is to be art criticism this is not sufficient. The painting must be shown as standing in relation to values in painting, not to the value of ending values.

But the only vital tradition of twentieth-century art to which criticism can appeal is that of overthrowing tradition. This makes every attempt at criticism of contemporary art inherently comical. You get conservatives who want to overthrow the radical tradition; though if we got rid of this tradition, too, the result would be not as they imagine the recovery of some graver tradition but the absence of any tradition, mere confusion and anarchy, as we have seen in American ex-

radicalism and in populist movements. In contrast to these anarchistic conservatives, you get traditionalist revolutionaries who, leaning back on the radical art of past decades, attack everything new on the ground that it does not come up to the revolutionary standard. Yet how can the radical artist be satisfied with the terminology of yesterday's revolts?

'My aim,' announces Sir Herbert, 'has been to represent a consistently revolutionary attitude.' This statement illustrates the comedy. Is it revolutionary to have a revolutionary attitude? Especially to have such an attitude as one's *aim*? Revolutionists have as their aim not an attitude but some specific act, event or progamme; with Cézanne total self-expression, with Klee creative re-birth, with Mondrian beautiful cities. These aims are different from one another, and often in conflict, and cannot be brought together in 'one consistent attitude'.

Sir Herbert can be 'consistently revolutionary' only to the extent that he has accepted revolution as a tradition *above any particular revolt*. Thus idealized, revolutionary art yields to the critic a system of aesthetic values. But this revolutionary aesthetics, like any other aesthetics, is inconsistent with revolutionary art.

For example, Sir Herbert questions whether surrealist painting, being in his opiinion so completely revolutionary, 'is still art'. 'We should deny the term "science" to an activity that refused to recognize the laws of induction; we have the same right to deny the term "art" to an activity that rejects the laws of harmony.'

Harmony! Well, I suppose there might be a revolutionary harmony. But what stands forth is that Sir Herbert is saying about Surrealism exactly what critics once said about Constable and Courbet, that they put Nature ahead of art. It is what some champions of modernism have said about de Kooning's 'Woman' canvases: that they fail to obey the rules of vanguard art!

If there are 'laws of harmony' consistent with revolution why cannot modern styles be 'consolidated' on the basis of these laws as a permanent grand mode? Why is Sir Herbert opposed to a new modernist Academy? Why speak of a

decline because of the absence of revolutionary vigour? Why look back nostalgically to the days of outraged tastes?

Or take Sir Herbert's reaction to Dada. Many of the best products of this movement were not seriously intended as art. They were gotten up as public events and publicity gags in Zurich and Paris. They have the same relation to the 'laws of harmony' as an actual week has to the laws of eternity. Speaking of Dada, Sir Herbert forgets his 'consistently revolutionary attitude' and pushes Dada art aside as the 'first conscious negation of the aesthetic principle' – which, for one thing, is not a bad way to be revolutionary and, for another, is for the critic to take Dada at its word rather than to analyse its product as a radical step *in* art, regardless of its intentions. Whether or not Dada was anti-Art or aesthetically cockeyed, the fact is that there exists much good Dada art because Dada itself helped to revolutionize the sensibilities by which art today is recognized.

Neither revolutionary art nor revolutionary criticism can get out of it: revolutionary art is a contradiction. It declares that art is art in being against art; and then tries to establish itself as the soundest kind of art. It demands of the critic that he take 'explosiveness' as an aesthetic principle, and that he protect this principle against being blown to bits by the 'conscious negation' of principles.

At war with themselves, revolutionary art and criticism cannot avoid the ridiculous. Yet upon the contradiction of revolution depends the life of art in this revolutionary epoch, and art and criticism must continue to embrace its absurdities.

Part 2

The Profession of Poetry

THE best French poetry since Baudelaire has been enlisted in a siege against the cliché. This has not been by any means merely a question of taste. It has been more a matter of life and death.

Any educated Frenchman can make up a poem, just as any American can improvise a new 'popular' tune. The French language is heavy with old literature, as the American air is loaded with ta ta, ta tá tá.

A word over there, as soon as it enters the mind, begins rolling down into a fine ready-made phrase. No leaf can fall except into an endless series of poetic mirrors of autumn. To get a glimpse of his mistress, the Frenchman has to invent ways of singling her out in a bath house full of literary twins.

The Frenchman has so much tradition he can easily say anything except what he wants to say.

To be conscious of his own feelings, to see with his own eyes, he must restore freshness to his language. This is a magical undertaking that can only be carried on by poetry, and which marks certain non-versified writings as indubitably poetry.

In order to think, the Frenchman has to be a poet. It's no use being a philosopher. He'll be too glib. Everybody knows that Bergson made ideas roll so smoothly they washed right through metaphysics, simply leaving it cleaner, but without much grit for the professionals to put under the microscope.

Yet, while gliding like surf around the coral reefs of philosophy, Bergson's thought did succeed in tracing its own verbal design. Thus the poets immediately recognized him as one of

themselves, as a man who knew how to speak, whose perception communicated itself through his style.

Lifting up a word and putting a space around it has been the conscious enterprise of serious French poetry since Baudelaire and Rimbaud. With this 'alchemy' poetry dissolves traditional preconceptions and brings one face to face with existence and with inspiration as a fact. Or it re-makes the preconceptions and changes the known world.

A French poet refers to the 'fragility' of the commonplace. Of course. The commonplace is the effect of a perspective to which the observer is held by a web of vocabulary. It turns to dust when the acid of poetry burns each word away from the old links.

Poetry as verbal alchemy is a way of experiencing, never the expression or illustration of a 'philosophy'. It neither begins with ideas nor ends with them. Its magic consists in getting along without the guidance of generalizations, which is the most difficult thing in the world.

You read that Valéry denied he was a 'philosophical poet', since philosophy and poetry, each consisting of its own 'apparatus', cannot be reconciled. In the words 'I cherish thee, brightness that seemed to know me' Valéry consciously lives, once, the experience of reality's love for the human creature; but he does not seek to establish that reality is capable of any such feelings in general.

Claudel, in contrast, has the *idea* of such a love relation. His doctrine tells him that God and His universe are on the side of man, and he tries to feel and express this in poetry. But there is no verbal alchemy in

> Salut donc, ô monde nouveau à mes yeux, ô monde
> maintenant total!
> O credo entier des choses visibles et invisibles, je
> vous accepte avec un coeur catholique.*

French poetry has a lot to say about silence. The poet feels a tremendous need to turn off the belt-line of rhetoric that

*Hail, O world new in my eyes, world now complete!
 O whole credo of things visible and invisible, I accept you with a Catholic heart.

keeps automatically pounding away in his brain twenty-four hours a day. Before any poetic event can happen the cultural clatter must be stopped.

The silence of the French poet arises on the opposite side of the globe from the silence of the Kansas farmhand.

With the latter silence just is, an emptiness coming from American space and time.

The Frenchman has to will his silence, he struggles for it, in it he purifies himself of the past, makes himself ready for a new word, a round word, that can be his own and which will open to him a continent of *things*.

When he succeeds he is in the same position as the Kansas farmhand: sitting on a rail and waiting for something to show up. Whatever it is, it will be something totally real.

Mallarmé and Valéry tried to extricate the word that is a thing from the old poetry. That gives them the look of classicists or traditionalists. They seem direct opponents of the radical Dadaists or Surrealists, whose method is to pick up in the streets a word that had never been in a poem before. Certainly, different kinds of poems will result from beginning inside of poetry to restore words to innocence than from beginning outside of it to find innocent words.

But when Mallarmé and Valéry cut the word 'palm' out of the old poetry in order to make it into a finger touching a new experience, isn't their motive the same as that of the Dadaist who invites into poetry 'sardine can' which is nothing else than experience?

All the French alchemists are after the same thing, the actuality which is always new – and which will only come forth out of silencing the existing rhetoric.

Their poetry is an adventure, through and through. It cannot be written without placing their lives in jeopardy. Of course, Valéry in his study looks quite secure. Just the same, there was no way of knowing what might befall him during those researches. . . . It is a fact that he stopped writing for many years; something much more serious for him might well have ceased.

Mounting straight up into the thinnest ethers of consciousness in search of the demons that may lurk there (or worse,

that may not lurk there; so that the poet is lost in a waste of the eternal, with its boredom and its fascination that ruin for him all particulars) – every such pioneer flight repeats those sailings on seas whose borders the cartographers had decorated with monsters. No classicist with his legs twined tightly around his philosophy and the traditional uses of art goes in for such expeditions.

Valéry has said that poetry is an exercise. With this the academician will hasten to agree. The propagandist, too, to the extent that 'exercise' means the acquisition and development of skill apart from utility.

But to Valéry his own life was also an exercise. Without this equation: verbal substance equals living substance, every principle he announced appears in reverse.

Keeping in mind the silence of the farmhand and the inevitable non-rhetoric of the word that breaks it, we can understand why the French were the first to appreciate the American tongue. About twenty-five years ago René Taupin pointed out that poets in America were lucky in having a lingo that hadn't yet settled into a literary language.

The revival of American poetry around the First World War and the twenties depended on an awareness of this luck, an awareness in which the French consciousness played a leading part. The poets who spoke American best – Williams, Cummings, Stein, Pound, Moore, Eliot, Stevens – had all been enthusiastically frenchified. They learned from Paris what it meant to find a word that was free of poetry or that stuck out of it at any angle. Whitman alone had been unable to teach them this. They needed to see it in the French reflection.

'Call the roller of big cigars,' sang Stevens, the most conventional of them in form. With cigars and ice cream, billboards and wheelbarrows, American poetry became the poet's act of making his existence real to him, an act not 'assimilable' to any previous poetry.

Then a depressing series of events took place.

First, a new generation of American poets started out to invent themselves and found they had a philosophy, Marxism.

With this doctrine it made no difference what the poet experienced, so long as he expressed the doctrine. The best expression would be the one most useful in getting the Marxian message to readers. This meant using traditional verse forms and familiar poetic language. The language most easily recognized in America as poetry is *English*.

The cliché was restored to a premium. In time this led the Marxist poets to Hollywood, which is America's version of literary tradition, its treasury of poetic platitudes.

American poetry might have wriggled out of Marxism without too much damage, or even done something with it, as one or two European surrealists did. But having forgotten its French lesson regarding the space around words necessary for consciousness, it began hunting for speech in the poetic tradition. The turn towards tradition was too much for it.

Beyond Hollywood, tradition can mean only one thing for Americans – back to England. In the past twenty years American poetry has become English again.

To be a radical or fascist ideologist, an American must turn to the ideas of the Continent. To be respectable he need only learn to love Merrie Olde Englande. The foreign relations of American poetry were divided between Ezra Pound and T. S. Eliot.

American poetry has never been deeper than it is today in English school books. Unfortunately, though, not so far in as to reach the Elizabethans.

The Elizabethans are not tradition. They, too, *think* in their poetry and don't know where they will come out. They gather up every novelty and run an open bazaar of language, putting space around their words. A tradition must make itself superior to such acts of consciousness – that is its whole point, to make thinking unnecessary or, at least, safe.

Like a philosophy, tradition asserts that the important thinking has been done before the poet started to write his poem. The poem is thus an entertainment, or an illustration of the traditional conviction. The new traditionalists have done their best to compress the Elizabethans into their Order or to show the 'heresy' of their thought.

Convinced by Marxism, by psychoanalysis, by sociology, in a word, by 'science', that the truth was already in existence elsewhere than in the poem, the Americans were softened up for Anglicanization. Once this had taken place, it did not matter if some also added Catholicism.

For American poetry, France meant experiment, risk, perception, conversion of the everyday; England means a poetry of comments that sound like poetry.

The chief Pied Piper to *The Oxford Book of English Verse* was, of course, Eliot. He had learned to think his feelings by way of French symbolism. But his own thinking was not enough for him; sometimes he gave the impression that it made him sick. He needed other thoughts – those of Maurras and the French reaction. Finally, he needed the thoughts of The Church.

The combination in Eliot of poet and academician, word specialist and snob, made him destructive in the moment of America's decline in poetic and individual independence. With his famous formula of the supremacy of tradition over individual talent, he succeeded in making poetry appear as a thing with a life of its own, to which a certain caste had given itself as to a minor trade or cult.

On this premise, the French concept of the not-to-be-duplicated word emerging from the unknown was perverted into the petty guild rule of 'precision', which enabled Eliot to stamp REJECT on the keenness of Blake and the brightness of Shelley, and which let loose on poetry a mob of professors determined to make their logic the last word regarding the meaning of an image. In this triumph he was aided by the disconcerting triviality of the semanticists and the 'scientific' criticism.

In his own verse, Eliot continued to preserve silence as a source – though a silence protected by dogma. For those, however, who accepted his 'classicism' as the term for their refusal to test their own powers, it was left only to keep busy.

With poetry separated from the act of discovery, the poet as a maker of verses could circulate at will from terminus to terminus of the Moscow-Hollywood-Rome axis. By simply

redefining 'tradition' he could drop an offering, one after another, in all three repositories of authority, usefulness and the delivered audience.

Whoever speaks the American language is forced into romanticism. His strictest discipline is itself a spiritual oddity and gives birth to an oddity – witness *The Scarlet Letter*, Emily Dickinson, the early gas engine. The American landscape is not easily mistaken for an endless wallpaper of nymphs and fountains – in the American language it takes hard application to achieve academic deadness. Precisely the fact that it gives them something to do and keeps them out of trouble is perhaps what makes the filing cabinets of tradition so desirable to the morally insecure.

Homeopathy apart, the American poetic impulse in this century has been given its most intimate hints towards self-knowledge by the French poetry of immediate presences, through which Poe's psychic experiments, Whitman's vocabulary of objects and the strange American fact have been growing steadily more speakable.

8 The Profession of Poetry and M. Maritain

JACQUES MARITAIN thinks of poetry as a practical activity carried on in a dangerous relation to spirit. As an art it has a '*raison*' of its own, needs and aims proper to its 'making' of particular works, and on these every practitioner must keep his eyes fixed. But dealing with spiritual substances, poetry, like philosophy, science or saintliness, is constantly tempted by the soul or absolute lurking within it. Poetry's rebellious spirit is Beauty, an unlimited metaphysical power, 'one of the Divine Names', which the written poem, subject to worldly conditions, can never encompass.

The demon dwells in the body of the art and seeks to lure it to its destruction. Thus for many years Maritain has cautioned the poet not to forget that, though different from the useful arts, his art is related to them and 'participates in their law'. In this respect, Maritain's approach has had much in common with utilitarianism or even materialism, and this has been one of its strong points. To the surprise of those who expected the exact opposite from a 'religious' thinker, his philosophy opposed transcendental pretensions in art and set up the work, rather than the soul adventures of the artist, as the aesthetic aim. At the same time, it reminded the poet and painter that spiritual satisfaction is to be found in the artistic labour itself, precisely in that unfolding of his skill and knack which results in the formation of an individual '*habitus*' (a very meaningful word brought to us from the Schoolmen) by which the hand becomes ever more unerring and graceful and the whole body is filled with light.

In *Creative Intuition in Art and Poetry* (1953) Maritain still

holds to the Thomistic concept of 'art as a virtue of the practical intellect', though his emphasis has shifted from the 'work-making activity' of art to the 'creative intuition' of the artist, to that grasp of things by the inner Self 'which is a kind of divination'. In this new light of free creativity Maritain's attitude towards contemporary art appears to have softened somewhat; its interests seem less a heresy than they did in *Art and Scholasticism* and other earlier Maritainian discourses and more a matter of right or wrong gestures of the Self. Yet Maritain's terms remain the same; and modern poetry, towards which he has always been sympathetic though anxious, is still a descent into a spiritual Dark Night.

With mixed feelings Maritain has found that, since Poe and Baudelaire especially, poetry has fallen into a profound and unprecedented spiritual ambivalence with respect to both God and Nature. Baudelaire 'marks the discontinuity',* he drew the curtain dividing the workshop of poetry from its forbidden sanctum of 'self-awareness'. At once the machinery of poetic production was thrown into disorder and irrelevant excitements of the poets have since disturbed the body of this ancient art. Its very identity has undergone alteration: instead of 'poetry' signifying *the making* of poems (an activity), the word now refers to *the poems* themselves (things, with their mystery of being). The result has been a '*prise de conscience*' which, like the knowledge of self sucked from the apple of Eden, has inaugurated a course of change and suffering, marked by 'crises of growth', whose end is not yet in sight.

In the measure that poetry has concentrated upon itself, that is to say, upon spirit, its art has decayed† though that has not prevented the creation of works of the most significant order. In losing its hold on the art work, modern poetry has been torn loose also from the limits of reason and social sense. Therein poetry's night of the soul: profession no longer, it has isolated itself and by 'its own trend allows no harmony with anything else'.

*This quotation and many others in the present chapter are from Maritain's lecture 'Poetry's Dark Night', printed in *Kenyon Review* in Spring, 1942. In his *Creative Intuition In Art and Poetry* sections of this piece have been incorporated.

†'Thus, poetic knowledge tends no longer to an object to be produced.'
Creative Intuition.

Baudelaire and Rimbaud are Maritain's chief exemplifications of modern poetry as a kind of knowledge; to their dream of unlimited knowing he attributes Baudelaire's personal miseries and Rimbaud's abandonment of poetry. The surrealists, too, were 'taken in the trap' of poetic knowledge. They made the additional mistake of confusing 'passivity of inspiration' with 'psychic automatism' and of regarding the 'animal unconscious' as the 'unique source of poetry'.

In the end, however, Maritain resigns himself to poetry's 'descent into the lived-in subject' as an advance in 'creative subjectivity'. He proposes as the aim of 'poetic knowledge'a primary unconscious (now 'preconscious') deeper than the Freudian, the 'unconscious of spirit at its source', reached, not through the 'inquisitive intelligence' but through 'docility', and releasing an element, similar to melody in music, 'which is the spirit of poetry'. Thus his argument ends by leading the way to something like Eliot's 'still point of the turning world'* where the 'soul' of poetry and its 'art' are reunited.

One might summarize Maritain's view of modern poetry as follows: poetry, which had always been an episode (a spiritual one) in the history of work, became in the nineteenth century a metaphysical drama pointing towards a religious outcome.† But is modern poetry such an irruption of subjectivity as Maritain describes?

The answer depends on whether Maritain is right about the poetry of the past, whether it be true, as he says, that 'only at a comparatively recent time has this word [poetry] come to designate the *poetry*; previously it signified the *art*, the activity of the working reason, and it is in this sense that Aristotle, and the ancients‡ – and our own classical age – dealt with

*In *Creative Intuition* Eliot is included with Satie, Debussy, Hopkins, Chagall and some others in a list of those who took the 'right direction which pointed straight to poetry itself'.
†'As to the *prise de conscience* of *poetry as poetry*, it was only in the course of the nineteenth century that the phenomenon came about.'
Creative Intuition.
‡In Maritain's *Art and Scholasticism* we gather that '*les anciens*' to whom art was 'working reason' were chiefly Aquinas and Aristotle as interpreted by medieval philosophy. Convinced that these writings brought into order the experience of all antiquity, Maritain does not limit his 'ancients' to the Scholastic tradition but contrasts the definition of

Poetics'. If poetry always followed – even though on a heavenly plane, as Maritain now reminds us – the norm of the crafts, modern poetry is without doubt an aberration in the history of the art.

Since Maritain appeals to 'the ancients' his crucial instance is Greece. Here, however, he encounters severe difficulties. Poetry among the Greeks, far from 'participating in the law of the useful arts', was an inspired calling, drawing on streams beyond the individual shaping mind. Everyone has read the passages in Plato's *Ion* on the madness of the poet. Aristotle, too, asserts in *The Poetics* that 'poetry implies a happy gift of nature or a strain of madness'. Both 'happy gift' and madness are seen as bringing about that estrangement of the poet from his reason, passion and will which is called inspiration or enthusiasm, a state in which he could hardly 'participate' in the canons of the useful arts. 'In the one case,' Aristotle continues, 'a man can take the mould of any character; in the other, he is lifted out of his proper self.' What is involved in either state is self-displacement, the substitution of another identity, either of a person or of a demon – never a transcendence of personality through 'creative intuition'.*

Quoting these texts in *Creative Intuition* Maritain strives to recast them in such a way as to make 'possession' synonymous with the Scholastic '*habitus*' – indeed he now corrects his earlier translator who had rendered the latter word as 'state of capacity' by suggesting that 'state of possession' would be better. But if 'possession' means '*habitus*', when the Greeks spoke of madness they meant 'an inner quality or stable and deep-rooted disposition' not seizure by a separate being. Possession ceases to be a frenzy dyed in the history of magic and superstition and 'becomes our most treasured good, our most

poetry he derives from them with the practice of the art that arose 'only at a comparatively recent time'.

*Maritain grants this difference in his way of correcting Aristotle: 'Aristotle added few and sometimes ambiguous indications about the Illuminating Intellect, which he only described *as superior in nature to everything in men*, so that the Arab philosophers thought that it was *separate*, and consequently one and the same for all men. The Schoolmen anterior to Thomas Aquinas also held it to be separate, and identified it with God's intellect.' *Creative Intuition* – which also contains a section entitled 'Exit the Platonic Muse, enter real Inspiration.'

unbending strength, because it is an ennoblement in the very kingdom of human nature and human dignity'. In short, by his identification of 'possession' and '*habitus*' Maritain has switched the Attic demons for an elevated, even holy, psychological state.*

Demoniacal possession among the Greeks was not, however, a gilding of work; through it their poetry existed as an episode in the life of the popular cults. In other words, as a profession of inspiration poetry followed the course of the social forms of trance and intoxication and put these to its own uses. Oesterreich in his work on demonology† insists on the connection between this type of identity-change and poetic creation. After describing the seizures of the priestesses of Apollo and other oracles, his chapter, 'Voluntary Demoniacal Possession', goes on: 'It should be noted that the Greeks themselves gave a wider extension to the term "possession". They understood by it all the phenomena of inspiration, particularly of the poetic kind. In the beginning it must surely have been understood in the literal sense when the poet invoked the Muse at the opening of his work: ἄνδρα μοι ἔννεπε μοῦσα - - μῆνιν ἄειδε, θεά - - Musa, mihi, causas memora . . . *it is the muse and not the poet who must sing* . . . the poet was convinced that he did not create, but that another, the Muse, did so in his place. . . . Such a conception . . . can only be explained by admitting that the voluntary activity of the creative artist was unconnected with his work and that his most perfect productions were obtained as a gift.'

If this is correct, the ancients, at any rate the Greek ancients, knew no conflict between the art or 'body' of poetry and its being or 'soul'; nor did their poets possess any 'creative subjectivity' or intuition capable of reconciling these opposites. In Maritain's terms their practice involved the following paradox: they could meet the only requirement of their trade over which they had any control, their reason, by voluntarily making themselves mad, that is *by wilfully depriving themselves* of working reason; to these ends, complicated techniques were

*'Creative intuition and imagination,' he writes in *Creative Intuition*, 'do not proceed in an angelic or demonic manner.'
†*Possession* by T. K. Oesterreich. Richard R. Smith, Inc., 1930.

no doubt employed, as among all initiate groups. In any case, in Greece the profession of poetry was one of madness and as 'excessively enthusiastic', at least, as modern poetry. 'In their total ignorance of causes,' says John Addington Symonds, paraphrasing Vico, 'they wondered at everything; and their poetry was all divine' – obviously, they were obsessed with ambition for 'poetic knowledge'. Did not the Greeks seek through magical means even a knowledge of coming political events? And what is one to say of the Hebrew prophets with their formula of the possessed: 'The word of the Lord came to me saying, I...'?

Perhaps in the Europe of the Middle Ages, poetry was disciplined into an activity of working reason; we are now only too aware that under certain social conditions a conflict does come into being between the creative enthusiasm of the poet and the production of the poem as a visibly existing 'thing'. To an extent, Maritain's theory of art is an attempt to precipitate into our time the universals with which the Scholastics generalized and justified the subordinate position of the arts in their own. This does not mean to imply that Maritain would like to bring about the subordination of the arts today*: but the origin of his concepts does suggest why they are too limited to capture the interests and the content of modern poetry.

Historically, the norm of the evolution of poetry is its practice as an inspired profession, which in the past could only develop as an episode in the history of religion. To understand the peculiarities of modern poetry we must examine the recent activity of the profession in relation to those sacred powers by which it was formerly uplifted. Maritain's conception of poetry's modern turn towards 'enthusiasm in a pure state' ignores the specific shape given to poetry by the beliefs, official and popular, of the past century and by the poet's changed conditions of work.

According to social historians the religious world is created

*The idea of the release of 'creative subjectivity' by modern art that runs through *Creative Intuition* seems to me closer to Ortega's intra-subjective interpretation (which follows Hegel's) of the historical direction of art towards pure spirituality or inwardness than it is to the Neo-Scholastic notion of essences to which Maritain's earlier position seemed to point.

and given intensity by the *conscience** of the community; in early societies all professions rely on the supernatural, though not in the same way nor to the same degree.† This collective *conscience* has, however, been dissolving steadily, though irregularly, throughout history under the pressure of the progressive division of labour and the complication of social life brought about by it. By the nineteenth century, with specialization tremendously quickened by scientific methods in industry, communal sentiments, where they have not altogether vanished, have lost their surface of social myth and have tended to sink out of sight. In a word, the 'supernatural forces' which had made themselves felt in poetry since its origin – these forces themselves reached in our epoch a crisis and not one of growth. 'The individual feels himself to be,' says Durkheim, 'he is in reality, less acted upon [*moins agi*]; he becomes to a greater degree a source of spontaneous activity.'‡

*The French word *conscience*, which refers to consciousness as well as to conscience and the moral sentiments, is here intended.

†Everyone knows that prayers used to accompany every undertaking and that success was credited to supernatural favour. But even when all work was thus 'inspired', poetic inspiration differed from that of the trades. The aid received by the smith or mariner merely augments the capacity which is the result of his skill; while the afflatus of the poet adds to his work not more of the same power but a unique element for which the practice as a whole is valued. Thus poetry is to a greater extent than other professions *dependent*; and from this very 'weakness' comes its prestige in religion-dominated societies and wherever the individual is set into motion from 'the outside'; while in a nation that believes in self-reliance poetry is regarded as an activity of women and invalids or, at best, as a game of language specialists.

‡'If there is one truth that history has placed beyond doubt, it is that religion embraces a smaller and smaller portion of social life. At the beginning, it covers everything; everything social is religious; the two words are synonymous. Little by little, the political, economic and scientific functions free themselves from the religious function, set themselves apart and take on a character more and more openly temporal. God, if one may so express himself, who was at first present in all human relations, progressively withdraws from them; He leaves the world to men and their disputes. At least, if He continues to dominate it, it is from on high and from afar, and the action which He performs, becoming more general and indeterminate, leaves more room for the free play of human forces. The individual feels himself to be, he is in reality, less acted upon; he becomes to a greater degree a source of spontaneous acitivity. In a word, not only does the domain of religion fail to grow at the same pace as that of the temporal life and in the same measure, but it increasingly contracts.' *De La Division du Travail Social*, by Emile Durkheim, Librairie Felix Alcan, 1911.

The crisis of the supernatural contains the crisis of poetry – a crisis of its creative energies as well as of its position in society. Poetry, too, is 'less acted upon' in the nineteenth century, not more, as in Maritain's interpretation. But other forms of labour and action are no longer moved from above at all. Human initiative aided by science has become adequate to all the old tasks; and a surplus of capability rapidly piles technique upon technique, until every gesture of production is conditioned not by the individual gift of the craftsman but by tools and rhythms arising from other labours and discoveries. The poet's professional dependence upon the mysteries, far from placing him at the centre of the sources of power, now seems to alienate him from them entirely. To the wiping out of the old crafts, poetry had contributed nothing. Measured by what had been achieved and by what was promised for the future – a science for determining the sex of children, a therapy of rejuvenation, mechanical chess players, trips to the moon – poetry appeared at the dawn of the age of inventions as a stupid, feeble, egotistical and even monstrous survival of darker days.

As a 'profession of inspiration', poetry was thus faced with a hopeless dilemma. If it held to inspiration as a 'gift' from above, it would lag behind the productive organization of society, lack the method of a modern profession and, deprived of the material and spiritual support of the community, be left to pay itself with divine counterfeits. If, on the other hand, it abandoned the powers of the unknown, it would fall from its age-old prestige and have to hire itself out as a petty trade. In either case, it was bound to lose its status as a profession indispensable to the collective consciousness.

Poetry reacted to this dilemma in both ways. In one direction it attached itself to objects of worship: Nature, the Antique, spiritualist cults – and became the voice of quaintness and superstition. In another, it purged itself of inherited passions to change itself into an auxiliary in the expansion of work and its discipline, becoming the supplier of commodities of entertainment and a tool of propaganda and education. These opposing aims have constituted the poles of the Romantic-Classical debates of the past century. Both, however, arose as passive reactions to the situation of poetry.

A critic who speaks of 'poetry since Poe and Baudelaire' does not mean, of course, all the poetry written after 1857 nor even the poetry in the accepted anthologies and collected Works. He wishes to call to mind a particular unfolding, which has no periphery but does seem to have a core. An essential aspect of his definition is that this 'poetry since' appears as *something new*; it is an 'emergent' of a crisis, whether of authority, or of belief or of the social status of the poet. In any event, in the poetry called 'modern' we are dealing with a continuing creative phenomenon and not merely as in other poetry of the same period with a series of reflexes to the break-up of poetry into a choice between making and inspiration.

The contradiction encountered by poetry in the early nineteenth century was an inner contradiction as well as a practical one, and was thus loaded with generative power. Brought into being by a vast advance in human consciousness and freedom, it corresponded to a predicament that has continued to throw the world into revolutions and wars. Man had been freed in his work from the social myths only to find himself anxiously dependent upon social relations represented by no unifying image or principle of justification. Making lacked inspiration; inspiration lacked content. The poetry baptized 'Modern' was born out of this contradiction as a thing fresh and unpredictable. Springing from the tension that split the practice apart, poetry in the line of Poe and Baudelaire has combined the old elements of poetry with raw materials belonging only to our own time and has transformed them.

Maritain's doctrine of the self-consciousness of modern poetry, which suggests no historical reason for its recoil from its traditional role, misrepresents the direction in which poets have sought the solution of the crises.* To the extent that

*In Maritain's idealistic dialectics, which sees poetry as containing a conflict of essences (*Faire* vs. *Agir*, 'activity of the working reason' vs. 'the spirit of Beauty'), poetry achieves harmony or synthesis only in the past, according to *Art et Scolastique* by the 'wise' action of the Church, or in the future, through poetry's teaching itself to sit still. This is the exact opposite of the historical view, which sees the modern movement as *beginning* in a synthesis at the very moment when inspiration and making reach, for the first time, a total impasse.

modern poetry is modern, it is something much more than a flight into the desert. 'I think,' says Maritain, 'that what has happened for poetry since Baudelaire has an historical importance equal in the domain of art to that of the greatest epochs of revolution and renewal in physics and astronomy in the domain of science.' We prefer to discover this epoch-making importance of poetry in the professional experiences of those writers who according to Maritain 'turned away from the poetic work', rather than in meditations of poetry on its own essence. These experiences, in which the shape of the historical crisis is always outlined, group themselves about the following projects: (1) to master the problem of inspired creation freed from dependence on religious systems; (2) to conform the methods of poetry to those of scientific experiment; (3) to rediscover the creative energies of the whole community. None of these interests was ever publicy asserted by poetry before our epoch; they are direct responses to it and to it alone; separately and together they are the identifying signs of modern poetry.

Poetry and criticism from Poe to the present day is filled with diagnoses and outcries on the profession – Maritain is fond of quoting such statements as proof of the Narcissism of modern poetry. In interpreting them, he ignores their practical intentions, thus stripping them of relevance to the life of art and the colour of the real world. So voided, they reflect nothing but the void and can be read as standing for the concentration of the 'spirit' of poetry upon itself.

'It is of *itself as poetry* that poetry achieves awareness in him [Baudelaire],' says Maritain. But the passages from Baudelaire brought forward to show that he had become conscious of poetry as a spirit and had contributed to it a 'theological quality' do not point towards these depths. On the contrary, each refers to the profession of poetry, its new requirements, its position in society and its changed relations to the mysteries.

'It would be a prodigious thing,' Baudelaire noted, 'for a critic to turn poet, but it is impossible for a poet not to have the makings of a critic.' To Maritain this means concentrating on the essence of poetry, and Baudelaire's statement becomes 'it is impossible for a poet not to have the makings of one

who contemplates the self of poetry'. But as he did so frequently, Baudelaire was here simply repeating an idea held in common with Poe: a poet must understand the means whereby the work is produced, that is, he must be aware of its *laws*, he therefore has 'the makings of a critic'. Even a critic might turn poet if he possessed this knowledge of method. The direction of Baudelaire's idea is that the poet can no longer wait for inspiration to provide the poem; he must consciously, *experimentally*,* set it into motion. 'In the spiritual life of great poets a crisis infallibly arises,' he says in the same passage, 'in which they want to reason out their art, to discover the obscure laws by virtue of which they have produced, and to derive from such a scrutiny a set of precepts whose divine aim is infallibility in poetic production.' This thought had been sketched in a letter of Poe in which he attacked Wordsworth 'for wearing away his youth in contemplation' and remarked of Coleridge that 'it is lamentatable to think that such a mind should be buried in metaphysics'. Yet according to Maritain, both Poe and Baudelaire are not only guilty of contemplation and metaphysics but find the poem of no importance in comparison with the state that produces it (as if these could be separated); they are not makers of poetry but perverse seekers of salvation.

Maritain also quotes the first stanza of Baudelaire's *Benediction*, which expresses the disgrace of the profession of poetry in this 'tired world'. Neither it nor the next exhibit, the famous remarks on the correspondence of earth with heaven, contains any hint that Baudelaire felt that 'the mysterious knowledge of poetry was *the whirlpool, going along with him*' (Maritain's italics). Baudelaire says nothing of poetry 'in itself'; to him it is an instrument 'through' which the unknown is glimpsed by the soul *of the reader*. Most significant, he seeks, like the later pragmatists, to demonstrate the existence of immortality by its subjective or psychological reality, characterizing it in scientific language as 'a demand of the

*In his *Marginalia* (XVI) Poe describes 'experiments' to 'induce' and 'control' a condition 'compelling heaven into earth,' with the 'end in view' of 'embodying' it in words.

nerves'; that is to say, being for Baudelaire is in living creatures not in the being of poetry.

In Poe and Baudelaire we see the drive towards a synthesis of inspiration and conscious method that was to result in a separate movement in poetry. Poetry would keep its identity as an inspired profession by seeking out the 'divine manias' and detaching their processes from the rule of the other world. By ceaseless experimentation, it would release the hidden forces from the decaying popular orthodoxies and set them to work at man's command. Poetry would then be no more dependent upon the myth of the Muses or of Grace than travel upon the good will of St George.

One recalls Poe's challenge based on the power of method in *The Philosophy of Composition:* 'Most writers – poets in especial – prefer having it understood that they compose by a species of fine frenzy – and ecstatic intuition. ... It is my design to render it manifest that no one point in its [*The Raven's*] composition is referable either to accident or intuition – that the work proceeded, step by step, to its completion with the precision and rigid consequence of a mathematical problem.'

The intention is obvious – whether or not *The Raven* was actually so composed. Science should leap ahead by means of intuition, Poe argues in *Eureka*; poetry, however, must be produced scientifically. 'Inspiration always comes when a man *wishes*,' Baudelaire echoes from across the sea, underlining the volition.

The first analytical step towards the control of inspiration was to re-examine all divine images and concepts in terms of man's nature. Immortality? 'A demand of the nerves.' Baudelaire made other discoveries: 'Prayer is a storehouse of energy.' 'Of augmenting all the faculties. A cult (Magianism, evocatory sorcery).' 'Infinity,' says Poe, 'like "God", "spirit", and some other expressions of which the equivalents exist in all languages, is by no means the expression of an idea, but of an effort at one. ... A word, in fine, was demanded, by means of which one human being might put himself in relation at once with another human being and with a certain *tendency* of the human intellect.' (His italics.)

At the very moment, then, when the historical sciences and psychology are beginning to penetrate the old mysteries through systematic research, poetry lays them open through imitation, extracting from them the living powers of creation covered with myth and abstraction. Believing in nothing, poetry now subjects itself to all deities. Assuming postures of prayer, it makes notes on the results in sensation and vital rhythms. It mimics the trances of the jungle, kneels before painted fetishes, decks itself out as Satan, tattoos itself with the pentagram or Evil Eye – all the time keeping a record more and more exact of its faintings and floods of strength. These open acts of warfare on religion extend the humanistic struggle against the Church into the farthest provinces of the spirit and on a more radical and deadly level than ever before. While the gross materialism of the ninteenth century, denying the reality of spirit, leaves it intact for reaction to appropriate, the dialectics of poetry undertakes to deliver the changing gestures of the soul into the common vocabulary. ' "*We should have to be God ourselves!*" ' Poe reflects. 'With a phrase so startling as this yet ringing in my ears, I nevertheless venture to demand if this our present ignorance of the Deity is an ignorance to which the soul is *everlastingly* condemned.'

This revision of the profession of poetry through the scientific conversion of divine Being into definable states of consciousness was achieved only through enormous technical labours entirely removed in character from Maritain's 'spiritual reflexivity' with its mystical abandonment of 'the line of the work'. No modern poet has been able to take existing methods for granted. This constant revolutionizing of its 'tradition' is another factor that separates modern poetry from artisanship and its norms. With his medieval standard, Maritain hastens to form a 'syllogism': no artisanship, therefore no poetic work; therefore nothing but spirit and the absolute. But the ceaseless discovery of new techniques is the chief characteristic of *modern work*, which has also left artisanship behind. Thus in modern poetry, as in scientific production, 'making' and the penetration of the unknown do not stand in opposition but dynamically advance each other.

In all this, the rediscovery of the community as the source

of poetic energy has played a major part. The first *scientific* glance at inspiration disclosed its connection with a community *conscience*; the second, that in modern times the poetic community has become mankind itself. No longer joined to its community of origin through religion and myth, poetry has striven in various ways to establish new relations with men everywhere. From Poe's effort to irritate a special area of sensibility in his audience and his exploration of dreams to the fathoming of a collective unconscious by the Surrealists, the line of modern poetic thought is not clear without this search for a *collective subject*, identifying individual inspiration with a wider surging. 'I kept steadily in view,' says Poe, 'the design of rendering the work [*The Raven*] *universally appreciable*.' And it is not to be supposed, he warns, that the states with which he is experimenting 'are confined to my individual self – are not, in a word, common to all mankind'. 'Immense depths of thought,' observes Baudelaire, 'in popular phrases, hollowed out by generations of ants.'

Rimbaud carried to new heights the analysis of how poetry had to work. Deliberate inspiration, scientific conformity of means to end, popular culture – he concentrated these themes into a single novel practice which completely revolutionized the profession.

Everything modern becomes, however, in Maritain's hands an appetite for infinity. 'The experience of Rimbaud,' he says, 'is decisive.' Of objectivity? Method? Synthesis? Not at all. Rimbaud is to stand for mysticism as the opponent of art, for 'poetic knowledge' or 'enthusiasm' in that 'pure state' where 'the poetry necessarily enters into conflict with the art', and where 'it no longer seeks to create but to know'. Did not Rimbaud describe the inspired ego in the formula, 'I is another'? Let us forget that this was also language of the Greeks and of the prophets. To Maritain it means being tempted by the absolute of poetry: 'how can we better define this descent into the lived-in subject, which is the poetic knowledge?'

Besides the phrase 'I is another' Maritain quotes from the second of the *Lettres du Voyant* in which Rimbaud outlined his

scheme of the poet as a 'seer'. Re-examining these paragraphs, from whose depths so many mystifications have been fished up, we note that they do not deal with 'poetry as itself', that is, with what poetry is, or contains, or what it will yield to the poet; they describe what must be done in order to create poems. The letters are 'studio notes' or observations on method in poetry, in the spirit of Leonardo's notebooks. Their main aim is to contrast 'cultivation of the soul' with reliance on its 'natural development', which, says Rimbaud, 'takes place in every brain – so many egoists proclaim themselves authors'. The epithets applied to this cultivation indicate a technical, even clinical, approach, rather than a metaphysical one: he 'who *wishes* to be a poet ... *looks* into his soul, *examines* it, *tempts* it, *takes hold* of it ... he *seeks* ... he *drains* ... *in order to preserve only the quintessences* ...' Practices throughout, never essences; never does he say that one becomes more pure or more real. Only once does the letter, quoted to show that Rimbaud 'has dedicated himself to *knowing*' (Maritain's italics), refer to the intellectual results of this process, and then it declares that the poet 'arrives at the *unknown*', he 'ends by losing the understanding of his visions'. It would be hard to imagine a greater indifference to knowing or a greater devotion to methodical creation.

Rimbaud had concluded from his studies of antique poetry that the genuine poet did not centre his attention on the poem, as the artisan aims at the finished chair, but on the transformation of himself into a maker of poetry. The path to the page was indirect – it led through the caves of Apollo. This detour in search of a *process* of poetic creation, rather than a recipe, is analogous to the scientific way of producing: to make one chair a week, the prolonged 'habitus' of a craft is needed; a thousand a day are achieved only through the laboratory. Poe and Baudelaire, relying on intelligible method rather than upon the memory of forms, had seen the need for systematic experiment. They had continued, however, to accept the poet as he was, with his moods, poses, paraphernalia of Beauty. Rimbaud threw all this aside. 'Unfortunately,' he says, 'Baudelaire lived in too artistic a milieu.' Poetry must be cleansed of everything belonging to the accidents of a trade or to per-

sonal sentiment. Through the force of the 'cultivated soul' the poet will force the external world to transform itself into poetic substances. Had it not formerly yielded up gods, angels, devils and miracles without end?

We need not discuss here the value of this programme as a criticism of religion. That Rimbaud's idea of the estrangement of the ego was a practical hypothesis and not a mystical abandonment of art is proved by the poems it produced during the course of the test. Maritain is in the position of offering the results of an experiment to prove that since the experiment was at length given up it makes such results impossible.

Like Poe and Baudelaire, Rimbaud takes off from a critical analysis of poetry as a profession. Personal need to decide on a career lends intensity to his conclusions. Long before he has conceived his doctrine of the 'seer', his poems, letters, conversations, ring with revolt against the métiers open to him. Later, the existing poetry business as a respectable profession becomes the chief object of assault; as the Parnassians professionally scorn the bourgeois, so Rimbaud despises them. By this gesture he publicly declares poetry to be distinct in social function from other occupations.

The 'seer' himself is shaped directly from judgements regarding work and creation in existing society. Rimbaud's letter to Izambard in which the plan for 'making oneself a poet' is first mentioned begins by ridiculing his former teacher's occupational ethics. Izambard had raised in Rimbaud's mind the conventional argument that 'one owes oneself to society'. 'You, yourself,' the youth retorts, 'belong to the corps of teachers – you roll along in a fine rut.' As for him, his job is telling 'stupid, filthy and vicious' stories, for which he is 'repaid' by his acquaintances with entertainment. This, too, he contends, is serving society. 'At bottom you see nothing in your principle [of owing oneself to society] but subjective poetry. ... Some day, I hope – many others hope the same – I shall see in your principle an objective poetry. I shall see it more sincerely than you will. I shall be a worker. ... Work now – never, never. I am on strike.'

Thus Rimbaud quickly sketches his view that all careers are equally repulsive because, far from contributing to the social

good, they merely satisfy the ego – as for himself he is pledged to a different conception of work as 'objective poetry'. In the next paragraph comes the programme for realizing the objective idea immediately in the profession of poetry. Here first occur the words 'I wish to be a poet and *work* to make myself a seer. ... It is false to say: I think. One should say: I am thought. Pardon the play on words. I is another.' In the inspired act, society and the individual are one, but beyond the will or egotism of either.

What is most important about Rimbaud's statement, or restatement, of 'I is another' is its affirmation at that historical moment as a professional creed, a kind of poetic Hippocratic oath, as distinguished from the confession of a mystic or 'knower'. Seen in these particular relations, which include the problem of work, Rimbaud's idea of the poetic identity provides no support to religious mystifiers.

I have referred to the terms in which the cultivation of the poetic 'I' is described. Those in which Rimbaud evaluates the effects of these rigours are equally non-metaphysical. His standard is positivistic and medical; in consequence, the role he is preparing himself for with so much enthusiasm is, in his own definition of it, ironically condemned from the standpoint of common sense: the soul is to be made '*monstrous*' ... it is like '*planting and cultivating warts on one's face*' ... the senses are '*deranged*' ... '*poisons*' ... '*criminal*' ... '*accursed*' ... '*horrible practitioners*'. No mystic ever used such epithets in naming the ineffable. The new poetic career is seen as if reflected in the social mirror of his mother and Izambard – he accepts it from them, as it were, with rubber gloves.

Consciously continuing the work of Poe and Baudelaire in revolutionizing the making of poetry through the translation of divine into human powers, Rimbaud carries the process into the inevitable problem of the identity of the poet – and halts his speculation at the exact point where the testing intellect can go no farther: the scientific limit of measurable effects. The metaphysician leaps forward to 'things', that is, to *words*, such as those mentioned by Poe. To Rimbaud the other 'I' is indefinable, *though it can be affected in precise ways*.

And once again, in Rimbaud's 'alchemy of the word', modern poetry seeks to link individual inspiration with the creative automatism of the collective mind. The language of the seer's art is to be made of '*vieillerie poetique*', the folks' own dreaming, unconscious 'objective poetry', 'poetry made by everybody', in the meaning of Lautreamont, that other evil angel of Maritain's Dark Night.

Rimbaud forsook poetry, Maritain maintains, he 'revenged himself' upon it, because of the disparity between its humble capacities as art and its monstrous demands as spirit. The anti-angelic doctor here reaches the crux of his argument: that too much 'soul' leads necessarily to the rejection of art. But how can this be proved by a biographical event? What we know of Rimbaud shows that he gave up poetry with unequalled finality, as a pragmatist might abandon a goal because the means required to realize it are too costly. It is remarkable how clearly Rimbaud's life in Africa makes a case that this poet was *not* pursued by poetry, like those to whom it is a spirit, that is, an indefinite urge. It is as if Rimbaud were to such a degree capable of absorbing himself in the discipline of his work that he could as completely satisfy himself with, or abominate, one practice as another. 'I have a horror of all callings,' he declares in the opening pages of *Une Saison en Enfers*, returning to his old theme of work. 'The hand with the pen is worth as much as the hand with the plough.' Poetry, magic sacraments; or money-making, politics, the trades – each to him is a technique. From the East he writes home impatiently for manuals on this or that mechanical process. Like his contemporaries the Russian Nihilist students, who made bombs in their kitchen sinks by following the steps in a treatise on explosives, Rimbaud's faith in the efficiency of intellect is unlimited. To interpret his career as the flight and plunge of a soul is to neglect the support he found in con-stantly expanding method.

It was, then, towards a new synthesis of making and inspira-tion, a synthesis made possible through an alliance with science and through the experimental dissolution of the poetry of the past, that Poe, Baudelaire and Rimbaud turned modern

poetry. This project carried them not 'deeper into poetry' (poetry has no depths of its own in Maritain's sense) but abroad into other fields which science was beginning to explore: psychology, folklore, anthropology, history. But poetry was not merely to trail after systematic research. 'Science,' cried Rimbaud, 'doesn't go fast enough for us.' Having been systematically disciplined for the unknown, the imagination could go ahead of the sciences, and the accuracy and flexibility of its reporting 'the news that grows out of silence' (Rilke) was to become the standard of poetic diction.

It is this consciousness of purpose that chiefly arouses Maritain's anxiety. 'Deliberate undertaking,' he notes parenthetically concerning Rimbaud's letter, 'and there already the trap lies hidden.' But scientific 'cultivation of the soul' is not a trap for poetry so much as for the organized religions, which also cultivate souls, but with methods that exclude freedom. And this trap of poetry is a formidable one, for it contains the fatal bait of imitation. As Attic tragedy and comedy, rising out of the popular cults, pushed on the decline of the latter by reproducing their myths and rituals on the daylight stage, so the experimental self-estrangements of modern poetry undermine the Church's overseership of that 'other "I"' which has always accompanied the individual. Maritain is well alarmed; this kind of poetic imitation is an invasion of sanctity.

Actually, it is the 'this-worldliness' of modern poetry, rather than its excessive spirituality, that Maritain is attacking in his image that shows everything upside down. Evidence of this is his sympathy for Symbolism, the one school which his theory might describe. As Valéry stated in *Variety I*, the followers of Mallarmé had 'the ambition of definitely isolating poetry from every essence other than its own', and 'in the profound and scrupulous worship of all the arts, they thought to have found a discipline, and perhaps a truth, beyond the reach of doubt'. This is exactly what Maritain is saying about modern poetry as a whole. Moreover, the decline of Symbolism, according to Valéry, resulted from its inability to 'coexist with the conditions of life' and its striving 'towards a beauty always more conscious of its genesis'. Here, if any-

where, the dialectic of the dark night would seem to have found a corresponding reality in literature. Yet not a word against Symbolism, though the Surrealists, who in reaction against Symbolism went to all lengths to disentangle poetry from itself, are given a special place in Maritain's abyss. One begins to suspect that Maritain's view of modern poetry is nothing but Symbolist aesthetics criticizing itself in the mirror of Aquinas? In any case to treat modern poetry as if it were identical with Symbolism and to say nothing of Symbolism itself is extremely odd. In the last analysis, Maritain's philosophy is a reaction against those particular interests of modern poetry that give it its novelty and its historic importance.

9 'Oh this is the Creature
that does not Exist'

MODERN poems are often notes on a secret experimental activity conducted by the poet in order, in the phrase of Rilke, to 'transform the earth'. The activity continues whether or not it produces poems – though we may assume that it is altered when the note-taking begins by the process of watching itself and by the intervention of language.

As the record of happenings and combinations thus brought about, the poem points not to itself as an object but to the process in which it originated and to the 'new realities' born with it. Involved in the manufacture of its own subject matter, such a poem seems far removed from the traditional one in which a landscape or a love affair is used to 'make' the work according to a preconceived idea of a good poem.

In some poets the activity of the poem has resulted in the abandonment or distortion of verse forms, e.g., Cummings, Williams. Others, however, have found it important to formulate their 'notes' in familiar patterns. A ritualistic element may have been involved which could only be recorded in an order of meter and rhyme. Or perhaps submitting to a form relieved the poet's anxiety. Or the poem was given an accepted verbal look for the sake of irony.

In Wallace Stevens's *Notes Toward a Supreme Fiction*, each 'note' has twenty-one iambic pentameters divided into seven three-line stanzas. Rilke's *Sonnets to Orpheus* are despite their form also 'notes', which, as the poet has said, 'show details from this activity' of changing the earth.

The idea of a poem as a 'note' has implications as to how it ought to be read. Unless the reader follows the exact move-

ments of the activity indicated he has missed the poem. This becomes most clear when the attempt is made to translate a modern poem into another language – success will depend on the degree to which the translator understands the new function of poetry.

For instance, Jessie Lemont's translations from Rilke have been done so skilfully they hardly seem translations at all. Ordinarily, this would be the best that could be said of a translator. If we were merely after good poems in English as close as possible in quality to Rilke's originals, Miss Lemont has done very well indeed.

But if we see Rilke's poems as notes on how he transforms the world, her effort to make equivalent English verses seems misguided. For she has held to Rilke's forms at the expense of the Rilke experiment and discovery – the peculiar way things had begun to behave for him. If her English renderings hardly seem like translations, too often they also hardly seem like Rilke. When Rilke says of the taste of a fruit

> *Dies kommt von weit.*
> *Wird euch langsam namenlos im Munde?*

Miss Lemont's

> There come slowly from afar,
> Namelessly in the mouth yet unsurmised,
> Discoveries . . .

simply fails to give us what is going on; while Herter Norton's version of the same passage does, because she has wisely sacrificed the sonnet structure for the sake of the poem's unique event:

> This comes from far. Is something indescribable slowly happening in your mouth?

It would be incorrect to say that Miss Lemont cannot capture Rilke's turn; she does it whenever the poem *she* is writing allows her to. Rilke is there except when the needs of English verse force him out of the frame, which happens somewhere in every poem. Then we get acceptable poems but lose the *process* of the original.

In sum, Miss Lemont's deficiency illustrates the effect of an

incorrect understanding of what a modern poem *is*. In Rilke we can let the sonnet go if we have to, it is not that important to have another English sonnet; but at all costs we want his 'inherent hearing'. Herter Norton's observation that 'the closest adherence to the poetry itself is best achieved through the most literal possible rendering of word, phrase, image', may not apply to translating all poetry, but it does recognize the nature and characteristic requirements of a modern poem. The poet himself had given priority to just such closeness in verbally 'rendering' his experience.

The images in Rilke form themselves from the inside out –

> Torn open by us ever and again,
> The god is the place that heals . . .

> Because they loved it,
> a pure creature happened.

The way objects have of moving for him is the result of his activity-induced method of seeing. Such a method grows by practice into a continuous spontaneous reflex, at the same time that the poet's vocabulary plastically accommodates itself to the new phenomena. Rilke's theory of 'nature becoming invisible in man' ceased being a mere theory when the tension of the objects he had absorbed into himself discharged them backwards from his eyes as from a mirror.

Rilke was in the line of Poe, Baudelaire and Rimbaud, of those 'heretical' modern poets who took from religion its angels and mysteries and set them to work as hypotheses in order to discover what powers they would release. If the other world did not exist, it was necessary to imitate it. The dead no longer have a realm of their own,

> But he, the conjurer, let him
> under the eyelid's mildness
> mix their appearance into everything seen.

Wallace Stevens's project is similar.

> Phoebus is dead, ephebe. But Phoebus was
> A name for something that never could be named.

The programme, however, of his *Notes Toward A Supreme Fiction* is to get along without angels. His poetic activity

applies itself neither to transforming nature nor to redeeming the past but 'to finding the Real'. To the wonders of the non-existent he prefers the human person. Hence – and this is rare in our time – Stevens will not accept a revived myth. No Orpheus, no angels.

> How clean the sun when seen in its idea,
> Washed in the remotest cleanliness of a heaven
> That has expelled us and our images.

> The death of one god is the death of all.

No less than Rilke, Stevens is aware of the part of the unreal in 'this invented world'. But he is determined to hold it to an humanly manageable minimum. The experimental activity recorded by his poems leads him in a direction opposite to Rilke's, towards a Supreme Fiction that is as empty of content as he can make it.

> To find the Real,
> To be stripped of every fiction except one,
> The fiction of an absolute – Angel
> Be silent in your luminous cloud and hear
> The luminous melody of proper sound.

Even upon his 'single, certain truth' Stevens imposes three conditions designed to guarantee his Fiction against becoming an object of superstition: 'It Must be Abstract' – 'It Must Change' – 'It Must Give Pleasure'. Rilke said that his angel was less a Christian angel than a Mohammedan one. Stevens's Fiction has relatives by Picasso.

As Thomas Mann's *Joseph* nears its end, its hero has become increasingly aware that he is an actor in a sublime charade, 'the God-invention of Joseph and His Brothers', as Mann calls it. Everything has been working to make the favourite son of the last of the Fathers a provider for many and to bestow upon him an exalted place in the hereditary descent. The figures of this design have become unmistakable to Joseph himself – it is almost as if he had read his own story in the Bible. Thus he feels himself to be less the author of his history, in the sense that we today make our lives, than its stage manager. He is not permitted to choose his acts, it rests with him to behave in such a way as not to let the great Plot down. 'What a history, Mai, is this we are in!' he exclaims to his steward. 'One of the very best. And now it depends on us, it is our affair to give it a fine form and make something perfectly beautiful of it, putting all our wits at the service of God.'

Once again Mann is re-telling the story of the Artist but with a difference. Joseph's world is complete; he may collaborate in perfecting it but, unlike Aschenbach in *A Death in Venice* or the artist-heroes of other contemporary novels, it is not up to him to create it. He lives in a story already written; moreover, one 'written by God' and not to be tampered with by men. To be enclosed in such a known history, that is to say, in a fate, is to derive of a psychic substance notably different from that of persons reared in uncertainty and the unknown. By the fact alone that one's future has been predicted, one enters the clarified landscape of the epic hero. Mental duality has been overcome – Joseph is not split like Aschenbach or

Castorp – and with it the irreconcilable ego that may well be the symptom of a disorder.

Conscious at every turn of what he may expect, Joseph's acts hardly go deeper than the aesthetic; by our standards he lacks emotional seriousness. His second descent into the pit, punishment for arousing the passions of Potiphar's wife, may be a symbolic passage through the netherworld but is in no sense a plunge into a night of the soul. Nor are his lifting up by Pharaoh and his subsequent reunion with his brothers and his father occasions for strong dramatic feelings. They occur rather as tableaux in a pageant of correct gestures moving towards the familiar sad-happy ending. . . . This quality of ordered response different from detachment, to which we apply the name 'Classical', comes from living within a history that has revealed itself, whether through myth or through philosophy. It is the mark of a life that has the character of a celebration and wherein action is inseparable from the pleasure of the mind in contemplating with mingled awe, credulousness and scepticism a legend that has become part of itself.

Like a jesting rabbi, Mann elaborates the Biblical text for the sake of this ritual pleasure. Of all his themes, the *Joseph* tale provided the one best suited to his genius, which is less that of a dramatist than of a dialectical comedian. In the idea of the God-story he discovered the high-comedy conception of an historically self-conscious age.

For a history to be known in advance it must be conceived as omnipotently managed. With half-lyrical, half-mocking acceptance of man's dependence on the absolute, Mann continues the investigation of the data of the divine which is the profoundest undertaking of our scientific culture.

It is part of Mann's later method to define individuals in terms of their objects of belief; for men 'only imitate the gods, and whatever picture they make of them, that they copy'. During her infatuation with Joseph, Potiphar's wife was a devotee of 'omni-friendly Atum-Re of On, Lord of the Wide Horizon', and gossiping with this soft voluptuous deity, drunken with good will, her personality was dimmed and her mind took on the other's graceful imprecision. But after the collapse of her romance she switched to 'him rich in bulls of

Ipet-Isowet, and to his conservative sun-sense' and thereupon grew hard and haughty.

The individual derives the shape of his being from the god-type. In becoming himself, he thus becomes more the other and like those who resemble that other. As he rises he loses himself in the common; as Mann had put it in the early *Royal Highness*, representing is something naturally higher than mere being. This doubling of self and not-self is a joke, though one depressing to human pride.

Absorption in the image that rules society is the rule. But *Joseph* shows an additional possibility: the possibility of the stranger. Bound to a foreign god, Joseph has a different sense of fact from the Egyptians; feels differently; most important, has a different story to tell. When we speak of the alien, we mean that a new god-story is there to be heard, by which whoever so wishes may change himself.

Like the shaping of the individual, the telling of the new story also involves a doubling of god and man and demands a double language, in order that the odd, accidental doings of human beings shall reveal their steadfast core of divine plot-direction. To mediate between the gross fact and the compelling dream of meaning that makes it worth repeating the double tongue of wit is needed. This is especially true of the Biblical god-narrative or history, which was all planned beforehand and managed in the happening yet came about through the passions and mistakes not of demigods but of ordinary men and women. 'Just because it is so solemn it must be treated with a light touch. For lightness, my friend, flippancy, the artful jest, that is God's very best gift to man, the profoundest knowledge we have of that complex, questionable thing we call life.'*

Modern positivism has popularized the observation that everything divine is ambiguous. Mann seems to maintain an interesting reverse principle: that everything ambiguous *is*

*That no one who is without wit can give a true account of what is happening in a history seen as planned justified Trotsky in making 'stupidity' his major accusation against Stalin, although thi : seemed to many a mere personal insult, moreover one inconsistent with the shrewdness of Stalin in defeating his rivals.

divine (compare Empson's contention that the ambiguous is the essence of the poetic). The many-in-the-one is the order of the dream and the vision; it has, we are told, the same source in the preconscious; and it induces a comparable state of dreaminess and profusion coupled with a sense of discovery. Joseph demonstrated his simultaneous grasp of the human and the divine by habitually dealing in ambiguities. With these he fascinated the 'mystical' Amenhotep, one-sided in his decadence, as he had earlier seduced the 'formal' Potiphar, god's eunuch. 'All your speaking,' exclaims the delighted Pharoah, 'turns on the Yes and at the same time on the No. . . . The wrong right one, you say, and the wrong one that was the right one? That is not bad; it is so crazy that it is witty.'

Wit through consciousness of their god-story is for Mann the typical genius of the lead-personages of Joseph's tribe. The Jews are a people of wit because they were constantly faced with the need to reconcile a primary opposition. From the start they conceived that God had a plan for them, yet their very sense of history induced them to cling tightly to the human character; they refused to spoil their story by converting it into a ritual masque. The Fathers, dreamers of the sheepfold, had learned how to come to terms with their destiny through a masterly shuffling of antitheses. To Mann skill in preserving the tension between the order of eternity and the life-scale of the individual is also moulded into whatever there is in the Greek and Christian traditions that is witty and double-minded in relation to spirit and earth. The humanistic hero appears in *Joseph* as the ironist who unites in himself the remotest unknown with the most pressing here-and-now.

The confrontation between this 'Western' type and the godly Amenhotep is the climax of the *Joseph* narrative and even, as Mann says, the occasion for which the entire tale is a preparation. Egypt had no ironists, and its imagination remained divided. Wise in science and religion, in the ways of things and of the dead, its magic excluded both the disorder of existence and the arbitrariness of individuality. This weakness of the Egyptian 'monkey-land' was exposed by the scion of Jacob-Ulysses in balancing his contradictions of the most-distant-and-nearest god before the feeble, trance-driven Pharaoh,

life-denying in his excessive divinity; inducing the other to yield to him the staff of authority so that he might organize the feeding of the people.

In affirming historical prediction while questioning it, Mann's own wit raises fascinating problems for contemporary historical thinking. Seven years of fatness and drought were dreamed by Pharaoh and foreseen by him through the Socratic prodding of Joseph. Could those symmetrical numerals stand up under investigation? Was the change from wealth to starvation as dramatic as in the dreamer's vision and the interpreter's explanation? 'In these fourteen years, things were neither quite so definitely good nor so definitely bad as the prophecy would have them. It was fulfilled, no doubt about that. But fulfilled as life fulfils, imprecisely. For life and reality always assert a certain independence, sometimes on such a scale as to blur the prophecy out of all recognition. Of course, life is bound to the prophecy; but within those limits it moves so freely that one almost has one's choice as to whether the prophecy has been fulfilled or not. . . . In fact and in reality the prophesied seven looked rather more like five. . . . The fat and the lean years did not come out of the womb of time to balance each other so unequivocally as in the dream. [They] were like life in not being entirely fat or entirely lean. . . . Indeed, if the prophecy had not existed [a couple of the lean years] might not have been recognized as years of famine at all. . . .' I recommend this passage to those who see history as following a plan, as well as to those who see it as following no plan.

Man cannot help fitting himself into god-stories. To have a part in one, especially a 'speaking part', is to have a part in the permanent, to be assured of personal continuity. What if a grand god-story, asks Mann, were unfolding under one's eyes and yet one had no part assigned in it? A good question for a generation defining itself by action in wars and revolutions. It is possible, Mann replies, that one might get in anyway – through luck or determination. For instance, Mai-Sachme, Joseph's jailer, wasn't cast for a serious part in the *Joseph* epic, but he was a good fellow and Joseph liked him for his philosophic calm so he took him into the later events as his steward and confidant. As for Tamar, she wasn't intended to be in the

Joseph narrative at all – being just the luckless wife of two obscure nephews who died early. But somehow she could sense that big doings were afoot stretching far into the future. Desiring to be immortal, she forced herself into the line of Jacob, indeed the top line, that of Judah, so that by a single calculated act of whoring at the gate she became a grandmother of the House of Kings and of the god to come. . . . With this chapter that doesn't belong and yet does belong – because Tamar 'wanted to be of the family, to shove herself and her womb into the course of history, which led, through time, to salvation' – Mann not only had the time of his life but reached a peak of the insight of our time into man's fate.

Part 3

War of Phantoms

'. . . the wounds this phantom gave me . . .'

CERVANTES

We have already seen Bernard change; passions may come that will modify him still more. ANDRÉ GIDE, The Counterfeiters

I

AN egg with an ancestry, developing, changing its form, maturing; later, degenerating, dying, decaying, again changing its form; always in a slow gradual way except for the shocks of birth and death – such is the broadest metaphor of the human personality developed by the organic point of view and expressed in such studies of mutation as biology, biography, history, psychology. Whatever unity an organism maintains at the base of its transformations is something mysterious: the single being may be compared with other organisms which it resembles, it may be classified, accounted for statistically, subsumed under a type; but its individuality can only be 'felt'. To the human person himself his own coherence is, as Herbert Read once put it, 'an organic coherence intuitively based on the real world of sensation'.

On the other hand, the concepts of morality or social law, applying exclusively to human beings and ignoring possible analogies with other living creatures, tend to define the individual not as an entity enduring in time but by what he has done in particular instances. A given sequence of acts provokes a judgement, and this judgement is an inseparable part of the recognition of the individual. Here too there is no final comprehension of the single person; but whereas the organic

approach points towards the existence of individuals, each of whom can be grasped only by a non-rational operation, social legality operates as if it were unaware of them altogether, except as they are totally defined by their 'overt acts'. If the law is not always satisfied with itself, it is not because it feels the need at any time to discover more about the nature of individuals, but for the reason that it realizes all at once that acts are being performed for which it has no means of holding them responsible.

The law is not a recognizer of persons; its judgements are applied at the end of a series of acts. With regard to individuals the law thus creates a fiction, that of a person who is identified by the coherence of his acts with a fact in which they have terminated (the crime or the contract) and by nothing else. The judgement is the resolution of these acts.* The law visualizes the individual as a kind of actor with a role whom the court has located in the situational system of the legal code.

In contrast with the person recognized by the continuity of his being, we may designate the character defined by the coherence of his acts as an 'identity'. Representing the human individual as an actor, the term stands against the biological or historical organism-concept, which visualizes action as a mere attribute of, and clue to, a being who can be known only through an intuition.

The modern novel has more in common with the biological or historical view of character than with the legal. *Remembrance of Things Past* and *The Magic Mountain* are models of a literature of character metamorphosis, *Finnegans Wake* a high point in the rendering of organic texture.

As for the legal definition, its way of shaping personae with a hatchet causes it to seem at first glance far removed from the needs of imaginative writing. Without considering the symbolic, collective or residual ingredients of feeling or motive, the law comprehends its 'characters' in terms of the most commonly ascertainable elements of their acts. Only infor-

*Razkolnikov, for example, in *Crime and Punishment* sought judgement so that his act would be completed and he could take on a new existence.

mation relevant and material to the legal 'cause of action' may be introduced as bearing on the parties and their transactions. The law is forever fixed to that edge of individuality where particulars are caught in the machinery of the abstract and pulled into an alien orbit. Yet in the old tragedy, the individual was similarly torn away from himself by the force of an impersonal system.

There too, however, distinctions must be made: social law is not dramatic law. That the persons who stand before the bar of justice are identities, that they appear to be personifications of, and completely explainable by, the logic of their crimes, is the effect of a visible artifice of judicial thinking. In fact, of course, a man who has committed a murder may not have acted in a manner recognizable as murderous until that last instant when he pulled the trigger. That he meant to kill at that moment satisfies the law's demand for premeditation and homicidal malice; but since all the acts of the criminal were not of a criminal quality, there is forced upon our consciousness a lifetime of extenuating circumstances. All those common details of existence, gestures in every way resembling our own, even including those preceding the murder – entering an automobile, stepping on the gas, obeying the traffic lights – to say nothing of receiving certain influences, being moulded by certain values, which go more to form part of the criminal in the innocence of 'alegality' of his animal duration than of the relevant *res gestae* of his crime, the law takes into account only to fill in the scenic accompaniments of the last act and the rationale of its intent. So that dealing with identities rather than with personalities, the law is enabled to do so only by wilfully converting persons with histories into emblems of unified actions of a given order. In other words, the law, like its victims, suffers from the discrepancy between being and action, the failure of the individual to conform in every respect to his role. Were this not so, law and justice could be synonymous.

If, however, the old drama, as contrasted with biographies of actual or of fictitious persons, succeeded, as has been asserted by ethical critics, in supplying a picture of action in which a kind of justice and a kind of law conform to each other, it must be because the dramatist started with identities. Like the

judge he left aside personalities, their growth, their structural pecularities; like the judge he established the particularity of a character only on the basis of the coherence of his acts with a chosen fact; like the judge he was interested in psychological phenomena not for themselves but only as bearing on the plausibility of the judgement with which he terminated the action. But unlike that of the judge, the dramatist's definition of the character was not an arbitrary superimposition that exchanged the emotional, intellectual and mechanical characteristics of a biological and social organism for some one deed that concerned the court; it constituted instead the entire reality of the character, avoiding the ruinous abstractness of the law by determining in advance that his emotions, his thoughts and his gestures should correspond with and earn in every respect the fate prepared for him. . . . In short, because the dramatist had created his characters he could maintain the relation between their emotions, their thoughts and their destinies; while those who confront the judge on his dais were, unfortunately, born.

Its distinction between personality and identity, quietly implied by its mode of defining the individual as an identity, is what dramatic thought has in common with the legal. The characters of biography and the novel are persons with histories, but in the drama the characters are identities with roles. The distinction relates to a difference in purpose of biography and tragedy. Biography aims to picture a life as fully and precisely as possible with the type of exactness which is proper to history, that is to events visualized as successive in time. But drama, as a 'poetical picture of life', is composed of events which, though seemingly related sequentially and causally, are chosen with reference to the application of specific laws leading to a judgement: the conventional coherence of these events, the suggestion to the spectator that they have actually happened or are at least within the range of probability, is superficial, and far from determining the outcome of the action serves only to connect in the mind of the audience the natural world of causal determination with the dramatic world of judgement. Those psychological explanations of the motivations of dramatic figures which form so large a part of criticism

apply to this layer of causality which is the outer form of dramatic movement; they do not touch on the dramatist's act of judging,* derived from his conception of how the world is ordered, by which his characters are moved. Psychology can establish the plausibility of Macbeth's or Lear's behaviour, but for the sufficiency of his motivation we must refer not to a possible Macbeth or Lear in 'real life' but to the laws of the Shakespearean universe.

It is with respect to these laws that drama reaches objectivity, that the dramatist's image mirrors the lives of actual people. In 'nature' individuals may evade any system of ends; but a dramatic identity is a creature in whom a judgement is involved at birth, a judgement which delivers him to pathos and gives meaning to it. In thus substituting identities, whose motor organs are judgements,† for personalities who live erratically within the freedom and hazard of moral laws not yet discovered, drama brings into being figures who are at once particular and general and its account of events appears as 'more philosophical than history'.

II

Religious thought also interprets the individual as an identity; it looks to the judgement that will establish his eternal role. To it the psychology of personality-development is irrelevant; for upon the fixed situation of an identity, mutations of the personality have no bearing. As in the bloody book of the law, there are in religion stirring examples of this division between identity and personality. For instance, in demoniacal posses-

*Instead of the 'dramatist's act of judging' we might refer to the 'dramatist's act of seeing judgement as involved in and carried out by action'. From the naturalistic point of view, there is no judgement impressed upon action, and the presence of judgement in the drama must therefore be attributed to an act of the dramatist; but from the 'dramatic viewpoint' there is no action that is not an effect of judgement, whether of the gods, the fates or history, and the judgement is therefore seen as present in the real formula of the action, is said to be discovered by the dramatist, and not to be the result of his act.

†The moral judgements of drama may, of course, not seem moral at all in the conventional sense; the dramatist may choose to execute a character because he is powerful rather than because he is wicked.

sion identities usurped personalities: the demon, in all respects a new being controlled by the conditions of a supernatural world, subjected the individual to its own will.* The personality of the possessed remained intact. The demon was a character with a name of his own. His voice was heard from the mouth of a man – but he was not that man, any more than Hamlet was Barrymore. And he could be influenced only by means fundamentally identical in all contemporaneous cases of possession – there was one law for demons belonging to the same system. Exorcism was a contest between powers of a purely religious cosmos. The exorcist addressed the demon directly; no attempt was made to affect the psychological structure of the possessed. As we have said, it was irrelevant.

An identity is constant. In the worlds which give rise to identities, growth is excluded and change of character occurs above the rigid substratum of the identifying fact: whatever happens to the murderer, the murder still stands as his sign. Dramatic reversal of situation derives its overwhelming effect from this persistence of identity. Everything has turned inside out, yet the actor goes on doing the same thing. Were psychological adjustment to the new position possible, it would destroy the tragic irony and disperse the pathos.

Identity may be revealed more fully as a drama progresses. In such so-called character development, behaviour rises or declines on the moral plane without, however, altering the fact by which the character is identified; we simply see a second side of the same character: e.g., the idling Prince Hal's

Well, thus we play the fools with the time

belongs to the same royal identity as Henry V's conscientious

Our bad neighbour makes us early stirrers,
Which is both healthful and good husbandry.

Unchanging identity may also be present in the sudden reversals of moral direction that occur in *crise de conscience* episodes

*See the references in 'The Profession of Poetry', above . The cases reported in the Middle Ages, including the epidemic outbreaks of possession, are perhaps the most striking.

of novels and plays, moral reversal being merely a species of character development carried on at quick-time.

Yet identity itself may change in a drama, not through moral or psychological development, but through a process that causes the central fact which identifies the character to give place to one belonging to a different constellation of values. When such a shift of centres occurs, the fact to which the character's action was previously attached loses its power to move him. His moral nature may remain substantially the same, but his acts crystallize differently; he is a different dramatic individual; all his likelihoods have been recast.

It is especially in the substitution of one identity for another, or for a personality, that the type of coherence which marks the identity is clarified, since change of identity takes place, as we shall see, all at once, in a leap, and not as in personality through a continual transformation of elements.

To begin with the legal instance: the fact of the crime organized (by determining their relevance) the acts of the criminal and interpreted them. For the law he lived by that fact alone. Were it suddenly discovered that no crime had been committed, the coherence of his action would collapse and the prisoner, having been converted in an instant into the hypothetical and undefined figure of an innocent man, would no longer exist under the eye of the court. If thereafter he were charged with a different crime, his legal identity would depend upon this new fact and would be entirely unrelated to the one he had lost; he would emerge out of the void as a 'new man'.

In religion identity and change of identity have been, one may say, the dominant interest of the most significant and important ceremonies. Professor Guignbert writes in *Christianity*:

In the Phrygian cult of Cybele and Attis, but not in that alone, for we find it in various other Asiatic cults and in that of Mithra, a singular ceremony, called the *taurobolium*, took place. It formed part of the mysterious initiatory rites exclusively reserved for believers.

Having given an account of the rites, Guignbert explains their transforming function:

The pit signifies the kingdom of the dead, and the mystic, in descending into it, is thought to die; the bull is Attis, and the blood that is shed is the divine life-principle that issues from him; the initiate receives it and, as it were, absorbs it; when he leaves the pit he is said to be 'born again' and milk, as in the case of a newborn infant, is given him to drink. But he is not born the mere man again he was before; he has absorbed the very essence of the god and, if we understand the mystery aright, he is in his turn become an Attis and is saluted as one.

Guignbert then draws attention to the resemblance between these rites and the Christian baptism and eucharist.

The change consists then in both the legal and religious instances in (1) the dissolution or death of the previous identity through cancellation of its central fact* – this may involve the physical death of the individual (as with Ivan Ilych, whom Tolstoy abandoned on the threshold of change) or his symbolic death; and (2) a re-identification, wherein the individual is placed in a new status, is 'reborn,' so to say, and given a new character and perhaps a new name.

Drama is no more religion than it is law. But the fact that the phenomenon of religious conversion is the only one which actually† effects a change of identity in the living person, in which through the touch of death a course of living is annulled and another substituted without rupturing the organic continuity of the individual, relates religion and drama in a peculiar way. To present identity-replacement in a credible manner the dramatist must imitate the experience of religion and subject his character to the ordeal of death. But he may do so in terms of action alone and without adopting any metaphysical supposition as to the cause of the change. In a word, dramatic

*That the purpose of the law in executing a criminal is to avenge itself upon him or to deter others has long been denied by philosophers of the law. The logic of the execution becomes clear when we understand it as an attempt to eliminate the criminal identity and thus to cancel the crime itself which that identity personifies. The death of the criminal is incidental to this aim of cleansing the past. Any other means equally certain of accomplishing the dissolution of the criminal identity would be, theoretically, as satisfactory.
†The legal change is of course a purely formal one.

death and regeneration need not be involved in faith:* there is the death-laden incident; then occurs a transfer of identities within the single figure, a change of faces behind the mask.

The process appears with characteristic modifications in different literatures. A very early account of identity-change is the life story of the Biblical Jacob, whose character is built out of connotations of the word from which his name was derived, as when Esau complains in the Hebrew pun that he was 'Jacobed' twice. A self-reliant trickster, he wins his way through ruses and negotiations until the threat of death descends upon him in the approach of the avenging Esau. Then 'greatly afraid and distressed' he calls on God to save him and schemes to be the last of his company to die. Alone behind the encampment however, he is met by the angel and wrestles with him until dawn. During this contest he receives the sign of the dislocated thigh and his name is changed to Wrestler-With-God. In the morning he advances to meet his brother, whose fury has been unaccountably – psychologically, that is, though enforcing the point of Jacob's new identity – transformed to love.

From that time the lone adventurer, gainer of property and wives, has disappeared; in his place sits the patriarch, and interest shifts to his children. In the next episode, the seduction of Dinah, it is his sons who plot and carry out the treacherous revenge. The transformed Jacob, Isra-el, his character 'deducible' from his wrestle with God, is busy with the erection of altars.

This is an extremely simple picture of the process of identity change. There is a minimum of action-detail, only the death threat and alteration by contact with the divine over-plot and by renaming.

In the next example, a personality is transformed into a dramatic identity. In it, the action of a person, which is the

*Death in the drama means only cessation of the character's action and the impossibility of his taking it up again. This stoppage may mirror natural death – the character has died or been killed; or, as in the impostor type of comedy, the death may apply to a *fictitious* identity – the individual continues to be present but through having been exposed as a fraud cannot go on with his old act.

expression of a psychological condition, is contrasted with that of an identity, which always takes place in response to his role – which he performs as required of him by the plot, by the whole in which he is located. That this hero is a person at the outset means that the work begins as a species of biography; that he changes into an identity means that from that point on the biography-drama becomes a true drama.

In *Hamlet* there is a fusion of two forms of interpretation, the naturalistic and the dramatic. The argumentative, self-analytical Hamlet of 'non-action', describing himself in every speech, and using speech as a substitute for deed, is very much the figure of a personality, of a being insufficient for, *because irrelevant to*, the dramatic role offered to him.* Hamlet has all the qualities required for action; what he lacks is the identity structure which would fit him to be a character in a drama, a one-ness with his role originating in and responding to the laws of his dramatic world. Thus he is contrasted or 'paralleled'† with Laertes whose situation is similar to his,

> For by the image of my cause, I see
> The portraiture of his,

but who is characterized as an identity by his readiness to act; and the point is repeated in setting off his psychological diffusion against the acting-craft of the visiting players. It is not a weakness of personality that impedes his action but the fact that he is a personality. The revolving sword of judgement cuts him off at that point where he would force an entry into the dramatic cosmos. He has been exiled to a middle ground

*Psychological criticism lays Hamlet's failure to act to the preponderance of one trait, usually the reflective one. Interpreting his character in terms of dramatic identity, we relate his incapacity to a structural insufficiency, that is, to his failure to be part of an action-system, a defect for which there is no pyschological remedy.

> I do not know
> Why yet I live to say 'this thing's to do,'
> Sith I have cause and will and strength and means
> To do't.

† 'Save yourself, my lord,' etc. The scene belongs in all respects to the role of Hamlet.

between the natural world and the dramatic; governed by contradictory laws, it is a playground of somewhat insane fantasies. Hamlet is inadequate to carry out the Orestean judgement because he has been permitted to retain a portion of himself. As a new kind of hero, the person who matches his self against his part, he thinks too much not because he is an intellectual but because it is impossible for him to do anything else. The mystery which surrounds him consists in that he is neither an identity nor a personality wholly but a combination of both, a hypothetical actor who has wandered by accident upon a stage.*

Clearly, then, this character must be changed if the play is to become a tragedy, if the action is to resolve itself and not to break down into a series of episodes exposing psychological layers. To arrive at a pathos, Hamlet must be given an identity which will alter his relation to the action and fit him into the drama. But there is only one way to represent such a change dramatically.

Until we meet Hamlet on his return from the voyage to England, where he had been sent to his death and narrowly escaped in the grapple with the pirates, we have to do with the standard figure of Hamlet-criticism. But after this immersion in symbolic death,† we encounter a new character, a regenerated man. In his next appearance on the stage, Hamlet takes death as his subject and discourses on it as an insider. More to the point, he has acquired a certainty with respect to his feelings and a capacity for action. 'This is I,' he announces, as he leaps into the grave of Ophelia, 'Hamlet the Dane!' Having *named himself* he is at once attacked by Laertes but with unexpected firmness proclaims his dramatic equality.

> I prithee, take thy fingers from my throat;
> For, though I am not splenetive and rash,
> Yet have I something in me dangerous,
> Which let thy wisdom fear. Hold off thy hand!

*'For he was likely, had he been put on,
To have proved most royally.'
†'High and mighty,' he writes to Claudius without apparent reason, 'you shall know I am set naked in your kingdom.'

With this 'dangerous' new ability to act, he is no longer troubled by ambiguity of feeling:

> Why, I will fight with him upon this theme . . .
> I loved Ophelia . . .

To his mother Hamlet's self-assured identity is unrecognizable; she sees him as he was before the change:

> This is mere madness,
> And thus a while the fit will work in him.
> Anon, as patient as the female dove
> When that her golden couplets are disclosed,
> His silence will sit drooping.

But Gertrude is mistaken. For Hamlet had commenced to act his role of self-purifying vengeance, had assumed immutably his dramatic being, at that moment when aboard the ship bound for England he had read his death-warrant. Then for the first time his mind had responded with the immediacy of the actor:

> Being thus be-netted aound with villainies –
> Ere I could make a prologue to my brains,
> They had begun the play –

And now this hero who had looked with such passionate envy upon passion is 'constant in his purposes' towards the King. The magical event barely indicated ('Had I but time, O, I could tell you') has released his forces. His action hustles the play to its tragic close and the apparently accidental character of his revenge serves to emphasize that he is controlled at the end not by the conflicting intentions of a self but by the impulsions of the plot. Transformed from the image of a personality into that of a dramatic identity, he has found at last his place in the play.

Our third example is from Dostoyevsky's *The Brothers Karamazov*. This author's handling of change of identity follows more literally experience of typically religious conver-

sion than does either that of the Old Testament or of Shakespeare; it is related directly to Christian beliefs and emotions.

The 'Biographical Notes' of Father Zossima set out two parallel cases of identity-change. First there is Markel, Zossima's brother, whose conversion is briefly sketched to furnish a ground for Zossima's own conversion which comes later and is developed in greater detail. After his brother's death Zossima was sent to Petersburg to enter the Imperial Guard. From the house of his childhood, he records, he had brought none but precious memories of a religious import, but these grew dimmer in the cadet school and he became a 'cruel, absurd, almost savage creature'. ... A disappointing love affair, an insult, and a challenge to a duel ... 'and then something happened that in very truth was the turning point of my life'. The evening preceding the duel, he flew into a rage and struck his orderly so violently that his face was covered with blood. When Zossima awoke the following morning he went to the window and looked out upon the garden. The sun was rising. 'It was warm and beautiful, the birds were singing.' At that point the conversion began.

What's the meaning of it, I thought, I feel in my heart as it were something vile and shameful? Is it because I am going to shed blood? No, I thought, I feel it's not that. Can it be that I am afraid of death, afraid of being killed? No, that's not it, that's not it at all. ... And all at once, I knew what it was; it was because I had beaten Afanasy the evening before!

Then Zossima recalls his converted brother, the deceased Markel. On the field of honour, risking his companions' contempt, he halts the duel after his adversary has fired. A short time later he becomes a monk.

This incident, turning on danger of death though fear of death is denied, stages the typical antecedent conditions listed by psychologists for cases of religious conversion; it may be assumed that, apart from his own experience after being threatened by the Czar's firing squad, Dostoyevsky was familiar with the subject through books on the psychology of conversion. Yet Zossima's transformation arouses no suspicion that it is an ideological fable of the descent of Grace

rather than a genuine dramatic happening. The change takes place through events which, for all their realism, are the equivalent of the legendary and picaresque circumstances of the Bible and *Hamlet*. In all three examples, the process underlying the character's change is the same, although the nature of the action accompanying it is different in each instance and explanations vary from angelic intervention to terror and remorse. In all three an identical anxiety is present. In the terse account of Jacob's transformation he is described as 'greatly afraid and distressed', Hamlet recalls that

> ... in my heart there was a kind of fighting,
> That would not let me sleep,

while Zossima feels 'something vile and shameful'.

The so-called psychic states preceding conversion seem all to have this in common, that they dissolve the economy of the individual, and excite the soul, but cannot satisfy it or allay its disturbance. They are psychic states which propound questions, but do not answer them; they initiate, but do not complete. They provoke a suspension of the soul in which they are being experienced.

Religious Conversion, Sante de Sanctos

III

Individuals are conceived as identities in systems whose subject matter is action and the judgement of actions. In this realm the multiple incidents in the life of an individual may be synthesized, by the choice of the individual himself or by the decision of others, into a scheme that pivots on a single fact central to the individual's existence and which, controlling his behaviour and deciding his fate, becomes his visible definition. Here unity of the 'plot' becomes one with unity of being and through the fixity of identity change becomes synonymous with revolution.

Of this dramatic integration religious conversion, of all human conditions, supplies the most complete example, although only an example. Through conversion the individual gains an identity which revolves upon a fact that is subjective in its unifying effect upon him yet extra-personal in its relation

to his world. In all converts, regardless of what they are converted to, there comes into being that surface coherence which is the sign of the dramatic character. To other individuals unity of action may be *attributed*;* the convert claims his one-ness to be himself and compels his life to conform to his interpretation.

It is recognition of the individual as an identity that establishes the fundamental connection between religious and dramatic thought. In both, the actor does not obey his own will but the rules of the situation in which he finds himself. In both, change (and escape from the plot) can be accomplished through one means alone, the dissolution of identity and the reappearance of the individual in a 'reborn' state. In thus reflecting the limits imposed by action, the 'unnatural' processes of religion and drama correspond to those of actual life.

*This is rarely done by biographers, who stress the 'human' aspects of a character. But contrast Prince Mirsky's biography of Lenin as a man who had almost no personal life.

We suffer not only from the living but from the dead.
Le mort saisit le vif! MARX, *Preface to* Das Kapital.

IN the past history had been at the mercy of poetry, thought Marx. The great revolutions had taken place as costume dramas. In the act of creating new social forms men had ceased to behave 'realistically'. They lost touch with the time and place they occupied as living men – they became, more or less automatically, actors playing a part. 'Thus Luther donned the mask of the Apostle Paul, the Revolution of 1789 to 1814 draped itself alternately as the Roman Republic and the Roman Empire.'*

Social reality gave way to dramatic mimesis because history did not allow human beings to pursue their own ends. They were thrown into roles prepared for them in advance. Beginning in a situation which they had not created, they were transformed by a 'plot' that operated according to certain rules. 'Men make their own history, but they do not make it just as they please; they do not make it under circumstances chosen by themselves, but under circumstances directly found, given and transmitted from the past.' It was the pressure of the past that took revolutions out of the 'naturalistic' prose of the everyday and gave them the form of a special kind of dramatic poetry.

The 'circumstances' in which historical acts take place con-

* *The Eighteenth Brumaire of Louis Bonaparte*, by Karl Marx. All quotations in this essay are, unless otherwise indicated, from this work.

stitute an external continuity: the plot of history. There is also an inner continuity between the men who are to act historically in the present and other actors who once trod the stage. Not only a plot but stars of other days. Not only a situation but heroes living in the memory – men who in a situation sufficiently resembling the present one played their part with greatness.

Compelled to add a new act to the drama which is 'given', the revolutionists were easily deceived both as to what they were doing and as to who they were. They imagined they were performing the part set down for them by the events of their own lives – their action became a spontaneous repetition of an old role. They imagined they were playing themselves – they were but mimicking the engraving of a hero on one of history's old playbills. Every great historical figure is a possible case of mistaken identity, Marx saw. The supply of fictions is inexhaustible. 'The tradition of all the dead generations weighs like a nightmare on the brain of the living.'

The question of myth in history is the question of the hero. And the question of the hero is the question of resurrection. The hero is he who is able to come to life again after he has perished. If the dead stayed dead, and could not cause what once was to be again, there would be no heroes and no myths capable of overpowering man's sense of his time.

The dead hero waits under the ground. Chthonian. In the darkness, 'like a nightmare'. At a certain moment he will be called up to replace the living. When? 'Just when they seem engaged in revolutionizing themselves and things, i n creating something entirely new, precisely in such epochs of revolutionary crisis they anxiously conjure up the spirits of the past to their service and borrow from them names, battle slogans and costumes.'

It is the revolutionary crisis, the compelled striving for 'something entirely new', that causes history to become veiled in myth. Crisis means that the plot of history can no longer be played along visible lines without leading to foreseen catastrophe. The actors stand at a terminal point of the action, with inevitable destruction before them on one side and an empty space of possibility on the other. Every familiar ruse

will but result in ending the performance for them. Hence anything may be allowed to happen, except the expected. In crisis men are dazed by the elimination of choice and the need to choose the unknown.

In this paralysing yet open moment the hero is released from the depths of dead events. The resurrected one is blind to the ambiguities and vacuums of the revolutionary situation. To him the present crisis is but the duplication of an event finished long ago – in Greece, in Rome, in medieval France. For the hero the plot of history has been written once for all, and is outside of time. To act historically means to him to enact a timeless incident *which he has played before*. The hero is aware only of eternal forms; duration is not accessible to him; when he says 'a thousand years' it is but a figure of speech for an endless series of recurrences.

That the hero is 'dead' means that he moves entirely in the completed, that the contingencies of his existence were ended before he mounted the stage. Hence he is totally defined and at one with his deed – unlike the living with their vacillations of desire and their dilemmas. Men recognize in him not themselves but the embodiment of a part which they shall have to play as if they were wholly given to it.

It is from his being dead that the hero derives his strength and the singleness of his passion that is beyond mania or fanaticism. When Marx speaks of 'the awakening of the dead in these revolutions', it is a kind of demoniacal possession of society that he has in mind, a spontaneous transformation or displacement of identity, followed by the surging up of new powers of vision and of action. By becoming 'resurrected Romans' the French bourgeoisie were able 'to keep their passion at the height of the great historical tragedy'. An inspiration lifted them out of the limits of the everyday. That this inspiration consists of an invasion by the 'dead generations' is what makes a 'nightmare' of history.

As the revolution brings forth the dead upon the stage, as the prose of time-connected occurrences gives way to the poetry of action, elements of classical tragedy appear in the drama of history. As in Aristotle's formulation of tragic plot structure, the historical protagonist, mistaken as to his identity,

is unaware of the meaning of his acts: 'the heroes, as well as the parties and masses of the old French Revolution, performed the task of their time in Roman costume and with Roman phrases, the task of releasing and setting up modern *bourgeois* society.' (Marx's italics.)

Also as in *The Poetics*, the mistaken identity of the protagonist is resolved in a Recognition, Aristotle's 'change from ignorance to knowledge'. 'The new social formation once established,' says Marx, 'the antediluvian Colossi disappeared and with them the resurrected Romans. ... Bourgeois society in its sober reality had begotten its true interpreters and mouthpieces.' History is a drama, rather than a series of objective events, in that the self-recognition of history's actors is an act of creation that can occur only through their struggle itself, never through contemplation. At a certain stage, the revolution caused the bourgeoisie to cease to be Romans and 'to beget' themselves. The coming into being of the true bourgeois identity and its revelation through its own 'mouthpieces and interpreters' had to take place by a 'begetting' of the action; it could not occur through an intellectual discovery that these heroes were not actually Romans but disguised businessmen.

Since it changes men into themselves by making them seem something else, history is ironical. But it is ironical only with regard to their consciousness of events and of themselves. The objective irony of Greek tragedy, Reversal of the Situation, 'a change by which the action veers around to its opposite' (Aristotle), does not rule over historical events.*

Reversal defeats the action of individual heroes. Their acts often produce results exactly opposite to those intended. Were history the drama of these heroes, the ironic principle of tragic Reversal would apply to it. History, however, is the

*The irony which Engels found in the Paris Commune is an example of how history upsets ideas but does not turn itself inside out: 'In both cases [the Proudhonists and the Blanquists] the irony of history would have it ... that both the ones and the others did the reverse of that which the doctrines of their schools prescribed.' The irony of history reversed the plans of the leaders, defeated their intentions, but the situation itself was not reversed, i.e., the revolutionary action did not in itself bring about a counter-revolutionary result.

tragedy not of individuals but of beings whose mortality extends beyond the individual life that can be crushed by the Reversal. In history the plot of the hero's action subject to final catastrophe is enacted within the movement of a larger plot whose actors are not individuals but social classes. As to these classes, with their indefinitely prolonged lives, no historical situation is reversible.

For all of the references by Marx and the explanations of Marxists, the exact relation between the acts of individual heroes and the acts of social classes has never been clarified. It has been said that class action is or produces 'the ground' of individual action, that the classes create the 'circumstances and relationships' in which the hero performs. But class action is sometimes more than a passive 'ground', it itself at times produces the historical event, it takes place on the surface, on the stage. Or it is claimed that class actions 'interact' with the actions of the heroes and together constitute historical incidents. But such a conception does not indicate what part of the action is contributed by the individual as an independent source (nor what 'individual' means as a source of historic action); nor what a class can do as a class without the initiative and originality of individuals; nor how individual and class acts become one.

Though Marx does not specify the relation between individual actors and class actors, he does found his analysis on the insight that history has a dual plot producing a single denouement, somewhat like *The Iliad* of Homer with its two sequences of actions, the gods' and the heroes', interweaving together to produce the destruction of Achilles and Hector, and the triumph of the Greeks. And because of this duality, history is at the same time ironic and yet not susceptible to the fatalities of individual existence.

Operating through the tragic mechanics of mistake and recognition, the historical drama of 'the resurrected Romans' does not break down into a Reversal but results in the creation of 'something entirely new', bourgeois society. Into the static dialectics of Greek tragedy has entered the principle of evolution with its 'leap' of the emergent event. In the classic theatre change of fortune could only be a 'veering around to its

opposite'; in the historical drama, change of fortune means entering a new world. There the action unveiled the past to the consciousness, exposing the elements of the present situation as a completed whole and confronting the actor with a trap. Here the repetition of the past event forces a development of the situation and confronts the actor with genuine novelty.

Out of 'the great historical tragedy' as Marx termed it comes *the step forward*. It is prepared not only by acts but by what might be called submerged events, history's interior life, mostly microscopic, invisible, themselves not of the scale of the stage – the 'organic' aspect of the 'circumstances and relationships created by the class struggle'. While the heroes keep repeating the past as if they were acting out an eternal plot, time has entered into their drama in the form of a continual modification of the situation. And this subterranean change in the historical situation, knowledge of which requires a new kind of *depth politics*, determines what the outcome of the action and its meaning shall be.

Through the effect of time, represented in action by the continuity of class struggle, upon the historical plot, the hero's repetition of the past becomes a repetition in appearance only; the permanent operation of change permits no true repetition, as it permits no Reversal.

Thus the actions of the awakened dead are deprived of the magical absoluteness of myth and become relative to 'the task of their time'. The stature of the hero is decided not by the awesomeness of his deed and by the pathos of the Reversal but by the historical step forward which he helps to bring about.

In thus making the hero relative to the historical situation, constantly altered by off-stage actions, Marx, having admitted the myth into history, refuses to concede to it the power to affect history's direction.

The historical relativism of the heroic is emphasized in Marx's contrast between the repetition of an event as a tragedy and its repetition as farce, the latter of which he defines as the repetition of a repetition.

The first repetition of the deeds of the Roman dead in the French Revolution became a novel incident in human development – its timeless poetry resulted in an original creation.

The re-enactment of Rome in this historical moment was a serious action not merely a ritual masquerade mocking real life. Imitating the Roman style was not an escape from the present and its 'tasks' but the means of plunging into the midst of the actual situation and taking hold of it. The automatism of spirit that transformed businessmen and lawyers into classical actors was a phase of a genuine historical confrontation whose tensions were to survive in other forms until they changed not only men's relations to one another but the earth as well. 'The awakening of the dead served the purpose of glorifying the new struggles.' Their being lost to themselves was the bourgeoisie's way of embracing the present with a maximum of inspiration, 'of keeping their passion at the height of the great historical tragedy'.

But if the men of the middle class accomplished what they had to do without knowing what they were doing, it was because the plot of history, its objective movement, so to speak, gave *its* meaning to their symbolic gestures. What happened was not a necessary consequence of their actions – those were locked in the fantasy of Rome; it was history that pulled them into the future. And only in *this time* could those acts have been creative, only at this turn of the subterranean clockwork of change.

Precisely, however, because his action is not absolute but relative to its moment, the hero's performance cannot be deliberately put on as a revival and retain its effectiveness: 'all great, world-historical facts and personages occur, as it were, twice ... the first time as tragedy, the second as farce.' The same act and the same hero appearing again in a different time are converted by the relativism of history from the grand to the petty, from the serious to the absurd. In Louis Bonaparte, says Marx, the French 'have not only a caricature of the old Napoleon, they have the old Napoleon himself caricatured as he would inevitably appear in the middle of the nineteenth century'. The myth cannot change history; on the contrary, history elevates or degrades the myth, makes use of it or casts it aside.

With Aristotle the distinction between tragedy and farce turns on whether the characters imitated are of 'a higher or

lower type'. In the historical epic neither moral nor social elevation decides the issue, only the time criterion, the relation of the heroes to the *given* 'task of their time'. By 1851, the 'old Napoleon' has been transformed inevitably from a hero into a clown, because the organic change of situation has made it impossible for the bourgeoisie, and hence for him as its 'representative', to produce an authentic historical novelty.*

Trying to go it on his own, so to speak, without the support of the creative energies of a class – as when the fighters in *The Iliad* or *The Old Testament* are abandoned by their gods – the hero becomes the repeater of the repetitions of others, in a farce of noble motions visibly empty of content. The function of the second repetition is to evade the present situation, as the first was the means for embracing it with passion. Brought forth to conceal existing relations, rather than having sprung up as their poetic equivalent, the hero and his myth become a desperate absurdity. History refuses to affirm itself through this second awakening of the dead. Change has taken another direction. Hence the violence of the hero, isolated from historical possibility and able to result in no step forward, is pledged to mount without check to self-destruction.

So in Marx's drama of history the hero and his act are contingent on the larger plot, the change in social forms and the replacement of one social form by another. This larger plot itself is relative to some future act of creation that will replace what is now being created. Historical action is action that begins in an aim which will become untenable through being realized and which the actor will have to abandon for another aim or find himself disengaged from the plot.

*The difficulties of defining the relation between the acts of individuals and those of classes – that is, the difficulties of the two separate but linked movements of the historical drama – appear sharply when we speak of someone as the 'representative' of a class. At times, representing implies that the class action and the leader's are almost identical, in that the leader has been consciously chosen to carry out the class decision. In other instances, the class may be passive to the leader's policies. In still others, the class may be hostile, in whole or in part, yet the leader can still be said to represent it, in as much as his action parallels a general direction of the class will and can be picked up and assented to by it, as, for instance, the German middle class, though in part hostile to Hitler, picked up his acts as its acts in different phases of the Nazi movement.

With the triumph of Christianity the drama of individual tragedy gave way to the divine drama of salvation. To play his part in that vertical Christian theatre man had to acquire a new capacity unknown to antiquity, the capacity to transcend himself morally.* In passing in modern times into the drama of history man once again comes to require a new capacity: the ability to give himself to the absoluteness of action, while being conscious that his act will be justified only if it is correctly timed in the unknowable whole of the historical situation – and thus to give himself while being conscious also that even if his act *is* correct and *is* justified, it belongs to a moment only and will be surpassed. The historical act will not end in the achievement of the desire or in the establishment of the ideal that made him ready to act – a new desire and a new readiness will be demanded by him. Situated in history I know that my act can at best bring forth only another beginning. Yet though it can contain but an atom of time, I must consent to stake my whole life on it, for this is the act that belongs to the plot and there is no other kind of act that belongs to it.

Does man possess this capacity for the absoluteness of action in a situation recognized to be relative to historical novelties to come? Apparently this capacity had not been acquired by the revolutionists of the eighteenth century. 'In the classically austere traditions of the Roman Republic its gladiators found the ideals and art forms, *the self-deceptions they needed in order to conceal from themselves the bourgeois limitations of the content of their struggle* and to keep their passion at the height of the great historical tragedy.' (My italics.) In order to act the bourgeoisie had to hide the relativity of history under the myth of Roman grandeur; they were set into motion not by economic or social aims but by the desire to play a part they admired: economic and social needs were 'concealed' under this desire. Historical action, Marx is saying here, demanded not historical understanding but the opposite, the *concealment* of the historical with its inevitable limits.†

*i.e., not merely through ritual magic, as in the instances of possession.
† The following point has been raised by readers of this text: in speaking of the Roman 'disguise' of the bourgeoisie, Marx treated the poetry of the revolution as a falsification of the capitalist 'reality'. But if the ideas

Action required the absolute ('ideals and art forms') and passion, and these came from the past. To make their revolution the bourgeoisie had to throw themselves out of their actual historical situation. This they did through spontaneous repetition that caused two segments of time to coalesce and the present to vanish in the eternal.

When he describes the human incapacity for the historical, Marx seems to be referring not merely to a weakness of the bourgeoisie but to a permanent inadequacy of man to confront his situation. Poetry is inescapable in crisis. Yet crisis only reveals what has always been there as a 'goal' or end of the existing – for example, the crisis of feudalism or capitalism springs from and exposes the laws of feudal or capitalist development. In the historical drama the daily world of prose is in constant precarious motion towards its extinction in the poetic. At the bottom of every situation lies the poetry of its ultimate wreck. To be genuinely historical in action and consciousness man would have to be a tragic poet. But man shuns the poetry of his future, which is the inevitable failure of his action. He uses himself up in the effort to preserve as long as he can the delicate, weak and humanly desirable world of prose. So that the ferocious leap of poetry finds him unprepared and he is forced to call upon powers other than his own. 'Just when they seem engaged in revolutionizing themselves and things ... they anxiously conjure up the spirits of the past.'

of the actors in the historical event are to him mere 'self deceptions' which 'conceal' this external reality, Marx is guilty of a crude or 'vulgar materialist' reduction of history to economics. For Marx, however, the Roman illusion is not a mere mental reflection; it springs out of the revolutionary situation of itself as its historical image. In falsifying the bourgeois reality, the assumed Roman identity humanizes it through action and thus brings it into being. It is not that the French revolutionists were 'really' businessmen posing as Romans, in the manner of Boston patriots dressed up as Indians. It is rather that members of an economic category could change into citizens of an historical community only in donning this costume. Without this self-concealment and 'mistake' the bourgeoisie could not have made their historical appearance and their revolution. Hence in relation to the total event, 'poetry' does not mean for Marx 'untrue'; it means the subjective form of the historical, which is bound to correspond with the possibilities of the situation and thus to constitute its truth.

The historical is unendurable, its content needs to be concealed, therefore revolutionary crisis appears inseparable from myth. Given the compulsion to create 'something entirely new' the nightmare of the dead generations will overpower the consciousness, the ghosts will walk, and whatever novelty comes into existence will be the unwilled and unpredicted effect of time's ironical victory. Because at the critical moment they *ceased* to think historically, because they transcended themselves as Romans, the bourgeoisie were able to realize their role in the great historical tragedy.

Yet to Marx the recoil of human consciousness in the face of the new was also a characteristic that would be surpassed. The revolution of the latest born class, the proletariat, would escape the mythical mechanism of resurrection and self-disguise which is the poetry of history.* When this new social identity took the stage as an historical actor, man for the first time was to gain the capacity for conscious action within the contingent situations of the historical plot. Through this newly developed gift of the living for the changing and the novel, the completed dead would be kept off the stage. Instead of yielding their parts to resurrected heroes repeating an old incident, the proletariat would step forth in their own guise *and in their own time* – and the historical drama would be played without costumes, without mistaken identities or mistaken roles, without absolutes, but with 'the limitations of the content' of the conflict in full view. 'The social revolution ... cannot draw its poetry from the past but only from the future.' It is to be inspired not by finished events but by the change that will overtake the present. 'It cannot begin with itself before it has stripped off all superstition in regard to the past. Earlier revolutions required world-historical recollections in order to drug themselves concerning their own content. ... There the phrase went beyond the content; here the content goes beyond the phrase.'

With the elimination of myth and heroes the basic structure

* As the poet of history par excellence, James Joyce passes from Dedalus' 'History is a nightmare from which I am trying to awake', in *Ulysses*, to the mechanism of resurrection and metamorphosis in *Finnegans Wake*, 'with that fellow fearing for his own misshapes'.

of the historical epic would be transformed. The complicated dual plot of individual and class action would give way to the monolinear unravelling of the 'final conflict' of classes. The poetic pageant of the quickened dead would be supplanted by a revolutionary realistic drama of action arising from the everyday. Delusion and irony would no longer haunt politics.

But the function of the mythical veiling of the historical was to arouse the passion needed for action. Deprived of the myth the proletarian revolution would have to take place without passion, or with a kind of passion altogether different from the ecstasy of doubled time which 'drugged' the revolutionary middle class. The myth-less proletariat would have to experience directly the new dramatic pathos which the bourgeoisie evaded through dreaming themselves Romans. Committed to 'the sober reality' they would have to undergo without relief *the pathos of the historical*.

Marx's version of the historical next-act that is to follow the bourgeois revolution (with its stabilization and decline), that is to say, his prediction of Socialism, depends entirely on the capacity of the proletariat to endure this pathos. If, in the open moment of crisis, the latest historical protagonist were to prove, like his predecessors, incapable of acting in direct response to the historical content; if, with the proletariat, too, the pressure of the tragedy cracked the span of time on which the historical consciousness makes its way and plunged the action into the abyss of myth, the social revolution in Marx's sense would never take place. Having failed to 'strip off its superstition' the working class could not begin with itself. Proletarians moved to revolt would fall victim to beliefs and motives that had filled them before their class released itself into independent action: dreams of national or racial superiority, impulses towards individual advantage, the dread of omnipotent masters. As before, each act of the historical plot would be fated to begin with a fall into recurrence.

Thus it would have been a mistake for Marx (as for Hegel) to have conceived the drama of history as following an upward movement of consciousness, and his attempt to outline in advance the act that was to follow the one being played in his day was doomed to fail through the impotence of his hero

to perform the deed demanded by his time.* The true image of the historical drama would be less *The Communist Manifesto*, with its symmetrical human movements, than *Hamlet*, in which those on the stage are exposed at all times to the never-quieted dead.

One hundred years after the revolutions of 1848 and the publication of *The Communist Manifesto* the simplification of history has not been brought about by the proletariat. The drama continues to be one of resurrections, disguises, costumes, productive mistakes, disastrous accuracies. Man has not acquired the capacity for the historical; in crisis his response is still – the mask. Across Europe and North Africa have marched businessmen, clerks, factory workers, farmers, led by the ghosts of Anglo-Saxon gentlemen, Teutonic knights, Slavic chieftains. England at its last defence barrier rejected the military, political and economic proof of inevitable defeat presented by the Germans, and rallied to heroic echo of the Shakespearian iamb.

For a time it seemed that the new actor, the proletariat, might have come to dominate the action of the plot in a section of the world and thus to have begun the alteration of the entire historical drama. For twenty-five years the question was debated whether or not the USSR was a 'workers' state'. The presence of heroes, Lenin and the Bolsheviks, was indisputable. Yet it was contended that the October Revolution was an original act of the proletariat. The mind has no

*'... If the world proletariat should actually prove incapable of fulfilling the mission placed upon it by the course of development, nothing else would remain except only to recognize that the socialist programme, based on the internal contradictions of capitalist society, ended as a Utopia.' (Trotsky, *The USSR in War*, 1939.) In insisting that the theory of socialism is totally dependent upon the ability of the proletariat to respond as actor to its time situation ('the mission placed upon it by the course of development'), Trotsky conveys perfectly the tension of the Marxian drama. His drastic formula is in illuminating contrast to the 'subtleties' of those who, having abandoned the proletariat or any other identifiable historical actor, or having accepted the subservience of the working class to the Communist Party, wish to preserve for themselves soothing effects of the word 'socialism'.

means for determining the origin of a mass act. The Revolution might have been a conspiratorial coup of the Bolshevik professional revolutionists, using as their instrument workers and soldiers distracted by war and hunger. Or it might have been the sudden upsurge, under extreme conditions and with the stimulation of an extraordinary leadership, of the class which had evolved with the development of Russian industry and had already engaged in preliminary struggles with autocracy. Even if we take the latter view, which in many important respects is the more intelligible, we must recognize that the Russian Revolution was the effort of *two* actors, the Party and the working class, mass entities separate in origin, structure and consciousness and which came together as one only during the revolutionary overthrow itself. Neither Lenin, Trotsky, nor Stalin ever contended that the Party was an organic part of the proletariat organized by the class itself as its leadership. Nor did they assert that *in its continuation* the Revolution was the open, direct act of the proletariat. So that without answering the question as to who made the Revolution, it is possible to decide definitely that historical action in Russia is not now the action of the proletariat but has been for many years the privilege of 'heroic' history makers.

It is also undeniable that in the USSR the plot of history has been swamped in myth. The figure of Stalin, which in many respects resembles that of other modern doubles, is a curious and significant variation on the theme of heroic repetition. The myth holds him to be the replica of Lenin and third in the identity-series: Marx-Engels, Lenin. At the same time he is Peter the Great and the latest of the Little Fathers. On the one hand, he is the resurrection of Socialist internationalism killed by the First World War; on the other, of Czarist nationalism killed by the October Revolution.

History, then, is still at the mercy of the poetry of the past. Everywhere the presence of crisis is recognized. The demand for 'the new' has become the standard chant of the chorus of political 'independents'. James Burnham, whom no one will accuse of being too senstiive to the intangible, declared in his 'Dialogue' with André Malraux:

One additional feature of Gaullism is of supreme interest to me: it is the first genuinely *new* political reality since Hitler. It has come into being in France. But if this reality remains new, and proves able to break through the present dilemma of traditional capitalism versus totalitarianism, then it cannot be confined within French borders.

Of course, de Gaulle's politics, though 'the latest', is not new.* The separation in our day between poetry and philosophical criticism on the one hand, and political and social analysis on the other, has brought about a condition in which the hardest heads are carried into a euphoria of the absolute the moment a word like 'myth' is mentioned. But the important phenomenon is that *will for the new* to which Burnham testifies and which is the sign of the crisis upon which the success of de Gaulle depends.

How this will for the new, accompanied by the absence of historical capacity in the social classes, implies a readiness for subjection to the myth is illustrated by an interpretation of the immediate past delivered by Burnham on the same occasion:

The economic measures instituted by Roosevelt when he took office in 1933 did not greatly differ from those of Hoover, and many of them were ridiculous from a narrowly economic point of view. It was the dynamic and integrating myth of Roosevelt and his 'new deal' that swept the nation out of the depression [when?]. The War was another illustration.

Burnham was unable to identify any social force that could accomplish these novelties, therefore they were achievements of the heroic myth – and a power of this order will achieve other novelties in the future. The programmatic rallying-call to conscious action, 'Workers of the world unite!' has since the First World War been replaced by the battle-cries of 'Germany awake!', 'France awake!', 'Italy awake!' – the call to *resurrection*.

Thus the old mechanism of the historical plot still operates.

*This was written in 1948. During the Algerian crisis of 1958, this analysis of crisis and resurrection was found applicable in detail to the propaganda of Malraux, then engaged in his brief career as Minister of Information in the newly formed de Gaulle government. See 'Le Magie et L'Histoire,' by Claude Lefort, *Le 14 Juillet*, July, 1958.

Once again as the line of the action turns visibly towards catastrophe an empty space of possibility appears. Dazed by the elimination of choice, men choose the unknown. Figures step forward to the footlights and identify themselves to the audience as partisans of an open future. In France's post-war crisis, J. P. Sartre declared that no plot of history exists but that it is for us to make events by our free choice, to write the drama as we like it. Behind his back, of course, the play went on with the old actors – *there* possibility seemed to have all but vanished. It turned out that Sartre had a free choice so long as he did not choose within the action itself. His calling for something entirely new had to remain entirely negative, a policy of resistance, for he refused to commit himself to a historical *who* that was to introduce this something new into the drama. He demanded action, but did not name the actor* – it is as if he were trying to arouse *the audience* to change the play. But can the 'we' who are to intervene with our free choice be the spectators of history, that is, men as individual human beings? That cannot be – if each of us could play his own part, it would be the 'end of history'. Except as hero the individual has never been able to supplant nations, classes, cults, as history's dramatic personae. We cannot intervene in the performance without identifying ourselves beyond ourselves, and M. Sartre does not tell us with whom to identify ourselves.

In choosing choice itself and ignoring the question of the identity of historical protagonists, that is, in choosing individual freedom, one merely bears witness that a crisis exists and that to the hopeful of heart historical crisis means room for the undefined. Emptiness, however, will be filled by Someone. Willing the new where no social power is present with a capacity for the historical means in practice *waiting for the hero*.

*Subsequent to this writing, Sartre did 'name the actor' – as the Communist Party, arguing in a reverse application of the thesis here presented that since the working class came into historical being only through its action, and since the workers had proved incapable of acting as a class of their own accord, the proletariat owed its existence to the Communist Party which thus became endowed with sole responsibility for history. Following the Russian suppression of the Hungarian uprising, Sartre abandoned this position.

André Malraux also rejects the old actors and speaks on behalf of the possibilities to be drawn from the situation through action. 'We have no faith in programmes but only in objectives. Let us define our objectives one after another, reach them as fast as possible, and then go on to what follows.' Since no intelligible choice is available for France he, too, is compelled to choose the unknown. But the image of Malraux is more revealing historically than the image of Sartre. Sartre, and this is vastly to his credit, is genuinely a temperament that seeks the open; even in his miscalculations, he speaks for the free individual, who has not yet won a place in the historical drama. While his position implies the hero, as a human being his will is to resist him.* In contrast Malraux, supporting de Gaulle, has placed himself in the shadow of the hero, the repetition of Joan of Arc who 'saved' France. 'What Gaullism stands for, first of all, is the restoration of a structure and vigour to France.' If Sartre and Malraux resemble each other in their faith in possibility, Malraux, eager for action at all costs, has abandoned the action of the intelligence – the criticism of the drama – and has given himself up to the myth and its catastrophe.

What shall we think of this act of once more anticipating the hero with desire? It is undeniable that there is something deeply pathetic in it. But as a commitment of the mind, is there not something banal and profoundly boring in this appeal to be taken by surprise? It has all happened before, each time in the name of the new. We are familiar with the heroes of the twentieth century; we should be experts in the process of their emergence from the depths.† They seem to stand for adventure and possibility, yet their careers are altogether routine. Each comes forth 'naked', an anonymous man – Hitler,

*It might be said that Sartre represents the modern individual's resistance to history whose fictional elements become more and more apparent, as well as his recognition that he is inescapably caught in it. In short, Sartre has continued, with deviations, in the admirable spirit of the French Resistance, wherein without an historical perspective the underground fighters 'engaged' themselves to resist and frustrate the making of history by the Nazis.

† The apathy of Frenchmen upon the second ascendance of de Gaulle seems to point to the triumph of this consciousness that the 'miracle' has happened too often.

Germany's Unknown Soldier; Mussolini, a socialist editor; Stalin, a party secretary; de Gaulle, an undistinguished brigadier. They have no features; they are supported by future victims and foes precisely because no one knows whom they represent nor what they intend to do ('we have no faith in programmes'). It is in action itself that they seek to acquire a physiognomy, yet they never overcome their vagueness.

The heroic duplications of the present century lack the demonism of earlier resurrections. They do not spring from the overpowering presence of a single predecessor, they rather combine in themselves a whole series of mimicries. In each series the figure of Napoleon is combined with that of some folk leader. The heroes of our time belong to contrived rather than spontaneous myths – on that account often evoking even more fanaticism than formerly as a psychological protection against disbelief.

In Marx's terms the revivals of the heroic by contemporary leaders belong to the category of farce. The comic nature of the twentieth-century hero is instinctively recognized the moment he makes his entrance upon the stage: in the popular phrase, 'At first nobody took him seriously.' The clown-hero retaliates to the ridicule of the world by exposing the lack of seriousness of the rest of the cast, of all the existing historical actors. The leader without a programme challenges all opposing classes, parties, governments, individuals, to live up to *their* programmes. And since all are playing a comedy of pretence, 'the adventurer who took the comedy as plain comedy was bound to win'.

The victory of the genuine hero was the victory of a new historical mass-actor in a state of transformation. This was revealed in the novelty of the 'sober reality' that slowly emerged from the mist of the poetry of revolutionary change. The pseudo-hero, on the other hand, represents only the failure of the plot to bring forth its protagonist. Having assumed power, 'the serious buffoon', as Marx dubbed Louis Bonaparte, can no longer 'take world history for a comedy' but is compelled to 'take his comedy for world history'. Thus each speech of Hitler after 1932 opened with an autobiographical incantation bearing testimony to the powers that lifted the outcast 'front

soldier' above the mighty of his time; while Stalin met every situation, domestic and international, by instituting a new purge while recounting his defence of authentic Leninism through purging the party of enemies of the Right and the Left. With the mock hero the myth must be permanently sustained against the historical fact. Malraux's 'no faith in programmes' finally comes to mean that in each turn of events the leader's solution is to repeat the process of his apotheosis.

The myths of the twentieth century do not 'beget' new forms nor are its leaders the 'mouthpieces and interpreters' of a new historical identity in the process of revealing itself. If our epoch is an epoch of crisis, it is of a crisis that cannot be overleaped by a magical duplication of the past. In vain are the dead of every period disinterred in nations old and new. The effect is not a heroic transcendence of 'the limitations of the historical content' but of mixing the 'nightmare' of the past into the 'sober reality' of the present.

In our century the intelligible plot of history presumed by various philosophies has to all appearances broken down. No one can define the reality that succeeds our interludes of farcical violence, no one can predict the next act, no one point with assurance to the privileged actor. To the Hegelian Marx it was inconceivable that a historical situation should not ultimately produce its true protagonist. With us, however, the surrender of identity seems the first condition of historical action. It was reported that Roosevelt, irked by the posing of the six-foot-seven French general as the Maid of Orleans, remarked, 'The trouble with him is he doesn't know the difference between a man and a woman.'

13 The Heroes of Marxist Science

THE Englishman of Gilbert and Sullivan's era may have been born either a Liberal or a Conservative, but no one is ever born a Communist. Nor is this form of 'greatness' ever thrust upon one. Nor is it something to be put on lightly, as the periodic party purges throughout the world attest. Becoming a Communist can only be achieved, the party chiefs have often declared, through an intense process of self-transformation – a process that may never be relaxed without the risk of sliding back into an earlier condition of being. What making oneself a Bolshevik demands psychologically and morally is testified to by the *Confessions* of the repentant ex-comrade which constitute such a live branch of modern adventure literature. As part of their conversion to the Party the heroes of Koestler, Chambers and others had to conquer every personal sentiment in themselves and attain the subjective state of veteran lab assistants or professional executioners. The Communist's trained abnegation of his sympathies cannot, however, be isolated from other aspects of his constructed character. A weakness of ex-Communist confession literature is that, written from the point of view of moral disillusionment, it separates Communist unfeeling from Communist transcendence and thus tends to portray the Communist as a 'sick' human being, rather than as a new coherent entity, purposefully constructed.

The Communist, then, is an invented type into which a small fraction of contemporary humanity has been able to convert itself. Who invented this type? Some writers reply: Russian history invented him; the Communist is a combination of the Nechaev-style Nihilist and the Czarist bureaucrat.

That may be so, but the Party member, whatever his origin, is a twentieth-century novelty and history does not of itself fashion new beings out of old materials; for this the creative intervention of individuals is required. The Communist was brought into the world by one man: Lenin.

The Communist was made in Lenin's image. We shall discuss later possible differences between the author and his creation, but the primordial features of the Communist are those of the father of Bolshevism. Here is the man who struggles 'twenty-four hours a day', and even in his dreams, a contemporary noted, to seize control through organizational manoeuvre and counter-manoeuvre of the revolutionary movement of Russia first, then of the entire globe. Such total identification with a total act is the sign of the hero, and the Communist is first and foremost of the abstract substance of heroes – what else but the desire to be changed into a hero could have attracted to this movement so many divergent social and psychological types? Lenin created the Bolshevik by supplying the model of a modern, even 'liberal' hero, one motivated not by an over-riding egotistical passion or lust for power but, as Bertram Wolfe pointed out in his *Three Who Made A Revolution*, by his 'unshakeable conviction of his own rightness' based on Marxist 'science'. This sense of himself he translated into principles and transmitted to others as the certainty of knowing what needed to be done on behalf of the revolution and hence of the future of mankind.

Every Communist is a small replica of this Man Who Knows. His knowledge is beyond analysis, like that of the revolutionary leader in Sartre's movie *The Chips Are Down*, who through being dead found out what would happen to the insurrection scheduled for the next day. A similar prescience enables the Communist to assert what the situation is and what steps are required to meet it. In a typical Soviet film or novel a Communist has arrived at a collective farm far out in the steppes: trust him to know that it is best for the farmers to stop slaughtering surplus cattle and take to clearing overgrown land for fodder. A Communist at a battlefront does not, like a leader in other armies, confine himself to giving orders and getting them carried out. More like an angel in disguise, or

Caesar's ghost masquerading as a scout leader, he bears an aura of perceiving what has been ordained. He will recognize the moment chosen by history for his company to stand and die against overwhelming odds. And, expressive of his folk-myth character, he will scare up some peasant trick to prevent this lethal decision from yielding its logical results. In factory work, in mining, in forestry, his role is always this one of inculcating belief. Above all, in the revolution, source of his authority. What is the drama of the October Revolution to the Communist but the Bolshevik – from Lenin himself, addressing a group of his lieutenants in his flat or at a caucus, to the leather-jacketed emissary among the peasants of some distant village – foreseeing everything, bringing everything to pass? (Actually, of course, even in an account most biased on the side of historical necessity like Trotsky's history, the Bolshevik seizure of power creates an impression of improvisation and chance that often verges on farce. One recalls, for instance, Lenin in disguise yet recognized by everybody; the gun of the battleship *Aurora* in the Neva blowing up at the first shot; Kerensky leaving the Winter Palace in an open car waving to the insurrectionists; the Commissar of War on a horse with a pistol in his hand galloping to the defence of Petrograd.)

All the other traits of the Communist are derived from his knowingness. For instance, his calm. Any anxiety he displays is intended only to arouse suspense in his audience – like an acrobat deliberately missing a try in order to make his act seem more 'natural' and hence a greater triumph. Actually, the Bolshevik knows he will succeed, and is internally at rest. Indeed, his calm is deeper than that which comes from mere confidence in a specific outcome. For even if his project does not succeed, it will still have succeeded. It will have been the correct thing to do historically; there was no alternative; and if he was mistaken who could have been right? Since history is continuous, the present failure, like that of the Red Army in 1941, is inevitably a contribution to the larger success that will become visible in the long run.

The Communist's composure has a fatherly cast, almost divinely fatherly. Like a wise parent, he knows that growth

and the victory of reason are compelled to issue by way of simple-mindedness, incomprehension, misguided exuberance. For those of his non-Communist fellow citizens who possess these handicaps he therefore keeps prepared the all-enduring smile with which toddlers are encouraged. Before him shines the pedagogical motto of Lenin: PATIENTLY EXPLAIN. As we shall see, this slogan does not apply to disputes with intellectual opponents; it is reserved for the instruction of the guiltlessly backward. Who these are depends, of course, on the party line – even Catholics and capitalists may during 'front' periods be included among the innocently lagging; at other times they are malicious schemers. Paternal affection streams from the responsibility-laden young Communist upon the grey head of the illiterate Ivan who remains folkloristically attached to his hand plough or machete until the superiority of the tractor has been explained to him; upon the liberal professor who is studying the rudiments of Marxism; upon the corpse of the boy of fourteen who has blown himself up under a German tank. The love of the Bolshevik is the love of the shepherd for his flock; and its tolerant facial expression, made up of a mixture of smugness, boredom, and absent-mindedness, is duplicated on Sunday mornings in homes and chapels throughout the world.

The pastoral species of affection comes into existence only in the presence of those standing in an acknowledged relation of intellectual inferiority. The response it aims at is the open mouth and widened eyes of sudden grateful comprehension. Idyllic as they are, however, fables of sheep contain the psychology of impending doom. The wolf is either lurking at the edge of the meadow or, disguised in sheep's clothing, has penetrated the flock itself. Without this ever-present threat, the shepherd's vocation would amount to but little. In each situation, fortunately, the Communist discovers the traditional lupine foe. 'We must remember,' said Lenin, 'that we are at all times but a hair's breadth from invasion.'

A peculiarity of the Communist's wolf is that he exists in a kind of double image – he snarls and shows his fangs at the frontier, at the same instant that he baas close at hand under his false sheep's head. The outside wolf has varied from Czar-

ism to American imperialism; the inside, or sheep's clothing wolf, from Menshevism to Titoism. Yet the Communist, perhaps because the sheep fable conforms in some profound way to his metaphysics, always insists that there exists but one, monolithic wolf. Long before the Revolution, Lenin discovered the anisotropic formula: Menshevik-Czarist. Since then, liberals have been White Guardists; Socialists, agents of fascism; Trotskyites and 'cosmopolitans', imperialist (French, Japanese, American) spies.

The wolf-in-the-sheep image is the more dire. Lenin characterized as follows his attack on the Mensheviks as 'traitors' in 1907: 'That tone, that formulation, is not designed to convince, but to break the ranks, not to correct a mistake of the opponent but to annihilate him, to wipe him off the face of the earth.' The wolfy wolf represents merely an historical opponent that may be temporarily evaded or pacified. The sheepy wolf, however, threatens to destroy *the very ground of the Communist's existence, his shepherdom,* and must be annihilated without delay. The enemy from within comprises any opposition to Communist knowledge born not of ignorance but of contrary knowledge. The offending knowledge need not be political or historical; it is enough that it leads to informed, rather than naïve, non-cooperation. This collective farmer opposes clearing brambles and favours eating the calves because, besides wanting meat, he is able to prove that the land is not suitable for tillage – he is a Social Revolutionary White Guardist. This worker withholds enthusiasm for a new speed-up because in his experience such methods bring no increase either in wages or in output – he is a Trotskyist saboteur. *Principled* resistance to the Communist's historical omniscience is the malignant mark of the evil third person in the sheep fable. Turned in his direction, the Communist's face has shed its benign ennui. The bored father has turned into the alert hunter. Now the pastoral vocation, which in Lenin's language makes it 'one's duty to wrest the masses' from rival leadership, reveals its most active function – to exterminate.

The Communist belongs to an élite of the knowing. Thus he is an intellectual. But since all truth has been automatically

bestowed upon him by his adherence to the Party, he is an intellectual who need not think. The Communist has often been criticized for his renunciation of independent thought. What good is mental activity if one can know more by giving it up? The Communist is contemptuous of the non-Communist intellectual. The latter goes through all the motions of thinking, but at best he can only hope to arrive at what is already known. At best. More likely his thinking will lead him into error. *Not one Bolshevik with a mind of his own who failed at one time or another to deviate from, 'betray', Leninism.* Actually, the intellectuals are superfluous people. Given the present unfinished state of history, they may be put to certain practical uses. But they have no future, and it is wise to be suspicious of them.

In this connection, the mind of the Communist is involved in a profound gnostic mystery: thought reels on the rim of error, while knowledge is given to the simple. Ask the worker or the peasant and he will tell you what is hidden from the genius. After he had moved into the Kremlin, David Shub tells us in his biography of Lenin, 'Lenin enjoyed incognito contact with the common people of Moscow, talking with the man on the street, the common labourer and peasant, to get their honest opinions on the Bolshevik cause.' Socialists who expressed *their* 'honest opinions' were silenced. In his debate with Trotsky on dialectics and logic some years ago, James Burnham cried out indignantly when his opponent spoke of 'the dialectics of a fox'. Why not? If the worker has his way of knowing that is superior to Martov's or Plekhanov's, why not a fox? Not that it is outrageous to speak of the wisdom of the simpleton, of animals, or even of things. It is in the best mystical and poetic tradition and is supported by the experience of great minds. But if messages in grains of sand or of old women in the forest are more revealing than the discourse of intellectuals, why should one kind of intellectual, the Marxist-Leninist, be privileged?*

Since he alone has the correct answer, the Communist

*The privilege is related, of course, to the Bolshevik conception of a party composed of 'professional revolutionists' who introduce Marxist 'science' into the directionless struggles of the masses.

everywhere seeks to control the activities of others. He does not always seek power – we have seen that with Lenin power was not a lust. Power itself is but one means, though perhaps the supreme one, for manipulating people. The Communist may consent to renounce this means temporarily, but never for a moment does he cease to reach for control. To this end he makes himself an expert in the mechanics of organization, for through it men can be controlled with or without authority. To the Communist the map of the world is an organization chart: the Communist programme on 'nationalities' cannot be understood unless this is taken into account; in it nationalism becomes internationalism through the Party's control of nationalist organizations. From 1903 to 1917 the life of Lenin is a saga of contriving majorities in conventions, splitting and annihilating opposition factions, packing editorial boards and committees, challenging credentials, laying hold of membership lists, party funds, communication facilities. 'His line of thought,' said Rosa Luxemburg near the beginning of his leadership, 'is cut to the control of party activity.' Wolfe points out that factional disputes engaged Lenin's attention to a greater extent in 1912–14 than the impending World War.

To be engaged in combat without pause 'twenty-four hours in the day' is the Communist's way of being equal to his world, whose primary law is combat. Courage is therefore indispensable to the Communist, and that he is courageous goes without saying. His courage, however, is of a different order than is met with elsewhere. The chance of dying simply does not interest him. Individual attachments, power over which gives death its terror, hold a secondary place in his existence. By temperament and philosophy the threatened curtailment of his personal future has no meaning to him. As for *the* future, he already knows what it will contain. Thus neither love nor curiosity contest his willingness to risk his life. In the face of torture, too, his own or another's, his courage preserves its difference – since he lacks the reaction of *horror*. With the rest of us, it is the strangeness of the inner state of the torturer, who resembles a human being, that freezes our spirit. We do not feel horror at the agony inflicted

by the surgeon because we know why he 'attacks' his patient. The Communist, accepting his political explanation of torture, similarly knows why his enemy inflicts it upon him and is never horrified. Thus enduring torture is for him a purely physical ordeal limited by the resistance capacity of his body. Even sadists among his tormentors appear to him in a political rather than a psychological or moral perspective; they only imagine they torture for pleasure, actually it is the policy they have accepted that turns them into fiends. Hence the Communist finds nothing questionable in the party's enlisting of former Gestapo or SS men in the service of Communism. The only issue for him is: have they abandoned the programme that made them fascist murderers for one that makes them comrades of the vanguard?

The readiness of the Communist to clasp to his bosom the hated enemy of yesterday and to denounce as traitors and monsters his former allies and even adored leaders has often led him to be considered cynical or immoral. Quite the contrary – such reversals of judgement and feeling are the very key to the Communist's morality and the fullest expression of his constructed character. Accompanied by the strongest passions, they have nothing in common with switches in attitude resulting from a mere absence or relaxation of principles. Morally weak or indifferent people may, for the sake of expediency, collaborate with individuals whom they have denounced and drop former friends as a liability; in this they violate *themselves*. With the Communist a change in the policy of the party transforms the nature of the former friend or ally. At one stroke the imperialist Roosevelt disappears and is replaced by Roosevelt the democratic champion of the peoples – while the isolationist peace-lover of this morning emerges this afternoon as a masked Nazi. It is as if Roosevelt or Hitler had never lived before the day of the change – as if their entire existence were conferred upon them by the Party line. Thus the Communist's judgements stem from a metaphysics of being, and are the moral extension of that metaphysics. The question of what a Tito or a Nagy *is* having been decided, the Communist bestows upon him the complete measure of his contempt or adulation. When a new decision is made, a new

Hitler or Gomulka appears, and the present judgement is extinguished in its opposite.

Since the way he is defined by the Party alone determines whether a man be good or evil, the personal harm or advantage he has brought to the Communist plays no part in the latter's judgement of him. The assault of Chambers upon Hiss was all the more in the Party tradition in that Chambers claimed that they had been close friends and that he had been the recipient of favours from the other. Such an attack is no sign of either ingratitude or hypocrisy. It is an act consistent with the metaphysical-moral structure of the Communist type, in which individual experience has no weight.

Accustomed to moral ambiguities, conflicting emotions, hesitations, doubts, we are endlessly astonished both by the automatic workings of the Communist moral mechanism and the immediate and total response it produces. In this area we stand gaping like Ukrainian peasants before a twentieth-century supermachine. A narrative in *The Dark Side of the Moon* set the contrast between old-style feeling and the Communist-made model. It was told by a Polish girl who was deported to Russia during the Stalin-Hitler pact. In a settlement for delinquent girls she and other young Polish deportees had been threatened with death by Soviet fellow-inmates who resented their stubborn refusal to acknowledge that Poland 'had ceased to exist'. All this was suddenly changed when, after having been attacked, the USSR signed the Polish-Soviet Agreement. A political director brought the girls the glad tidings. 'He was smiling and joking [they now belong to the flock] ...' the narrative continues. 'This news was so unexpected that we were quite stunned. A thousand thoughts crossed my mind. The feeling of happiness was marred by a still stronger realization of the wrongs we had suffered. The Soviet girls cried "*Da zdrastfuiyet Polsha*," "Hail Poland!" We kept silent. From that moment we were heroines, and Poland became a nation with a great past and a great future.'

The Polish girls were 'stunned' into silence by their conflicting feelings, in which personal resentment played a big part. In contrast the Russians forgot instantaneously that they had once thought these people had forfeited their lives by

choosing for themselves the non-existence of Poland. Out of the new Party line, the Poles had been reborn 'with a great past and a great future'.

The power to erase and restore human status is given to the Communist by his historical clairvoyance. For the Communist the humanity of an individual lies in his historical role and this role is at all times wholly visible to the Communist. Accordingly, his judgement is that of history itself. It states who exists truly and who has but a sham existence, in that his extinction is already under way. *It is as if the evolutionary process announced its preferences in moral terms.* Lenin's reference to an opponent as a 'political corpse' is more than an estimate of the value of his views. Like Trotsky's favourite description of people as 'swept into the dustbin of history', it implies that he has entered into non-being in everything but the physical sense. Actually killing such persons or removing them to Siberian camps simply assists time in its hygienic tasks. 'The prisoner is to get it into his head as soon as possible,' testifies a Polish Socialist in *The Dark Side of the Moon*, 'that he is nothing but a thing and that nobody has any reason to be particular about the way he treats him.' Prisoners of other systems have also been treated as 'things'. But with the Communist the separation of the individual from the human species is not a by-product of the callousness of police, military, or colonial administrations. It flows from his metaphysics of man in his relation to reality, and he justifies it by that metaphysics. For him a person conceived to be in a situation that deprives him of his past and future, like the defendants at the Moscow Trials, has literally lost his human identity. Vyshinsky's designation of Bukharin as 'this damnable cross of a fox and a swine' and others as 'beasts in human form', terminating in his demand that they 'must be shot like dirty dogs', was not just hysterical vituperation. The animal images belong to a serious attempt to establish by analogy a definition of creatures who are another kind of thing than man.

Just as the 'traitor' is made of a non-human substance, so also is the Communist leader – regarding some human beings as nothings or sub-men always goes hand in hand with the adoration of other beings as gods or supermen. Shub describes

the surprise and distaste of Lenin at the adulation he received from his comrades; apparently, he could not comprehend what had made his creature into an idol-worshipper. Yet the explanation is not so difficult. In his figure of Nechaev in *The Possessed*, Dostoyevsky exposed the idolatrous core of this discipline of contempt. 'Stavrogin, you are beautiful,' cried Pyotr Stepanovitch, almost ecstatically. '. . . You are my idol! You injure no one, and everyone hates you. You treat every one as an equal, and yet every one is afraid of you. . . . To sacrifice life, your own or another's, is nothing to you. You are just the man that's needed. It's just such a man as you that I need. I know no one but you. You are the leader, you are the sun and I am your worm.' The classification of persons as historically worthless or 'dead', and the duty to utilize them and then cast them aside, which Lenin's polemics instilled in the Bolshevik, could not fail to complete itself in the adoration of the leader – the figure who for the Party member *is* the world proletariat and its promise of human brotherhood, salvation and transcendence.

Lenin's personality is without a trace of bad conscience – all his biographers concur in this. Of the Red Terror he speaks with light-heartedness, almost with levity. History does not disturb itself with regrets* – nor does its personification, the Communist. 'Don't you understand,' Shub quotes Lenin as asking, 'that if we do not shoot these few leaders we may be placed in a position where we would need to shoot ten thousand workers?' The latter 'need', too, would reveal itself to him as beyond the possibility of doubts, as in the massacre of the Kronstadt sailors. Ruthlessness for him is an indispensable means for conserving human life. He does not resort to it on his own behalf nor for his group nor his nation – with him death is not in the employ of an ego, as with the Nazis. It serves the universal; it works for the good as such.

What deeper temptation can exist for the man awakened to the modern crisis than to accept this solution to the problem of

*On this score the Leninist imagination seems entirely deluded. History constantly repeats itself, preserves outworn modes, returns to the scenes of its crimes, and behaves generally as if it were overcome with guilt and nostalgia.

action? He has seen increasingly large masses of people sentenced to enslavement and death by dictatorship, famine and war. He has recognized that in his time the old issues of poverty and injustice, which earlier generations of humanitarians could approach with a certain softness and leisureliness, have given way to the issue of human survival itself. He feels that in such a situation action must be drastic, must be absolute. Yet this call to be 'hard' torments his consciousness. He is wracked by the puzzle of how to preserve in the plunge into action the fragile contingencies of the humanly desirable – freedom, sociability, truthfulness. By becoming a Communist or even a fellow traveller he can dissolve this riddle and with it his mental anguish. Through the party he will inherit Lenin's 'unshakeable conviction', he will know from moment to moment that his actions, no matter what they be, are necessary to rescue mankind from catastrophe. It will no longer be necessary to reconcile 'hardness' with good will, for his violence will be benevolent *by definition*.*

But is not the ruthlessness of a doctrine of benevolent aims the most extreme form of ruthlessness? Perhaps not – Nazism was worse. In general, though, the inhumanity of men who seek man's salvation is more consistent, thorough and fervent than that of the merely vicious. At any rate, it lasts longer, since it does not inspire the whole community to wipe it out. The ruthlessness of the Communist, composed of benevolence attenuated by 'science', recalls once more the image of the surgeon. Knowing that his act is good in that it is necessary, he is morally obligated to make himself indifferent to the pain of the patient. The Communist has chosen humanity itself as his patient, and he has become a 'true Bolshevik' when his inner peace is unmarred by the ills which his deeds bring to particular individuals.

The question of Lenin's relation to the Communism of Stalin and his successors continues to be a subject of debate coupled with violence. For thirty-five years the writings of

*The reader may recall the speech of Thorez on the attitude of the French Communists in the event of an invasion of France by the Red Army: he stressed that the Red Army was non-aggressive 'by definition'.

the master have been combed to establish the legitimacy of Stalin or Trotsky, Khrushchev or Tito. These doctrinal disputes, which take on an abstract, not to say theological, form, remain inconclusive until the issue is settled by 'liquidating' the opponent.

I should like to suggest here that the strongest link between the first Red occupant of the Kremlin and those that have followed him is not doctrine but the *figure of the Communist*. Trotsky was probably right about Lenin's ideas, and Khrushchev is undoubtedly right about Stalin's homicidal personality: but since Stalin was the master of the Party, Trotsky could not be a Leninist except in theory and Khrushchev cannot be a Leninist without being a Stalinist and condemning Trotsky.

The essence of Lenin's theory and practice was total control of the Socialist movement at the top. To this extent, Stalinism is indisputably a 'logical development' of Leninism. So logical in fact, that its main features were foreseen from the beginning. At the very founding congress of the All-Russian Social Democratic Labour Party in 1903, many Socialists fully recognized that the type of centralized organization for which Lenin was desperately battling would inevitably be composed of members who, in the words of Martov, had 'abdicated their right to think'. The bitter debate on Article I of the Party Constitution brought from Axelrod the query: 'Is not Lenin dreaming of the administrative subordination of an entire party to a few guardians of doctrine?' And shortly after the congress, Trotsky, who had sided with the opponents of Lenin on Article I, wrote that Lenin's 'egocentralism' would bring it about that 'the organization of the Party takes the place of the Party itself; the Central Committee takes the place of the organization; and finally the dictator takes the place of the Central Committee . . .'

Yet despite the evidence he presents that Leninism meant dictatorship, Bertram Wolfe, after carefully studying the issue of Party democracy, was able to state: 'Up to his seizure of power in 1917, Lenin always remained by conviction a democrat, however much his temperament and will and the organizational structure of his party may have conflicted with his democratic convictions.' A democrat who felt, willed, and

functioned as a dictator! If democratic convictions formed part of Lenin's doctrine, must not that doctrine have been something quite different from Stalinism? The issue cannot be decided by reference to the events of the revolution. Control by a man so contradictory in principle would inescapably produce phenomena in which one could discern, if perhaps but dimly, the suggestion of a Leninism to which that of Stalin bears only an outer resemblance. Thus Trotsky could point to the violent disagreements among members of the Bolshevik Central Committee even after 1917, to Lenin's yielding to majority decisions even on such vital issues as Brest-Litovsk. Wolfe, too, testifies to Lenin's constant self-criticism and his willingness to admit errors openly, to his generosity in stretching out a hand to former political foes. These might have been but expedients to which Lenin was forced, as Stalin, too, was forced into 'democratic' moves. On the other hand, they might be glimpses of a democratic core in Leninism which under different circumstances might have developed more fully.

Plainly, there is no such core in Stalinism. And were Bolshevism like other political doctrines, Lenin, though responsible for his own autocracy and terrorism, might be little more responsible for its perpetuation and intensification by Stalin than, say (though the comparison is admittedly far-fetched), Lincoln's Republicanism is responsible for Hoover's. Programmes, especially revolutionary programmes, are changed, if not reversed, in the attempt to realize them. One recalls Engels' remarks on the irony of history. If, as Trotsky claimed, the revolution was betrayed by Stalin, it might be equally true that Lenin was betrayed by the revolution. Along these lines, one could go on arguing forever as to what the 'pure' doctrine of Leninism really was.

But the doctrine of Lenin is not like other political programmes; it is even more than a *doctrine*, and is distinguished from Marxism itself in this respect. It belongs to that type of modern political movement to which one pledges not only his action but his being itself. One could be a pre-First World War Marxist without making himself into a type. Bolshevism turned ideas into flesh – and flesh into an abstraction. Lenin

invented the Communist *man*. This act of creation, whatever Lenin's 'democratic convictions' might have produced, makes the Communist of today into a Leninist regardless of his party's political programme, regardless of whether it is Right, Left or 'Centrist', regardless of whether it talks world revolution or peaceful co-existence.

Stalin saw in the existence of *the Communist* a fact above all considerations of programme and doctrine; it was here that the connection lay between Lenin and the Movement. Having seized the leadership of the Bolshevik personnel, through laying hands on the organizational apparatus (a deed of proper Leninism), his strategy lay entirely in preserving his cohesion with it and reproducing or curtailing it through recruiting programmes and purges to serve his purpose. By this appropriation of the Leninist type, the Leninism of *any* programme he proposed was guaranteed.

For his part, Trotsky strove to dislodge Stalin by doctrinal interpretations, in the centre of which he placed Lenin's internationalism, his 'democracy', and his capacity to admit error – *all irrelevant to the character of the Bolshevik*. Fundamentally, the former non-Bolshevik despised the Bolshevik type, in which he saw only the bureaucratic flunky who had 'abdicated his right to think'. He refused to acknowledge that Leninism had *embodied itself once for all* in this very flunky, and that apart from him it had no reality. Yet to an extent Trotsky did acknowledge it, for more than to the non-Communists he continued to address himself to the minds of men whose nature is that their minds exist at the end of thought.

Granted that Lenin, for all the authoritarianism of his thought and action, did believe in democracy; granted that, for all his conviction of being right, he could acknowledge that the facts had declared him mistaken. Granting all this, the doctrine of Bolshevism is not, as Trotsky contended, changed thereby. It is to life itself, not to doctrine, that the recognition of the rights of comrades and the experience of fallibility belong. 'That was the strength of Lenin as revolutionist,' says Wolfe, 'that, despite his passionate and dogmatic attachment to centralized organization and its rigid control of the masses, he could thrust both into the background whenever

the forming, tumbling, creative and uncontainable life of the million-headed mass in motion made their doctrinaire application dangerous to the Party's life.' This living intuition of Lenin did not create the Bolshevik type. The Communist was the product of his technique, as rigorous as that of any scientist or artist. Whatever else there was in Lenin was thus doomed to die with him. Out of his tomb was bound to rise Leninism, the doctrine without the living man, from which the dialectical possibility of Bolshevik democracy and Bolshevik doubt had vanished forever. What appeared with Stalin was not a different doctrine but the creature of the doctrine, as distinct from its author.*

All differences between Lenin and the Communist of today refer back to this difference between an author and his creation. Lenin took the dead for his authority, but he did not invoke in Marx a self to displace his own. His conviction of his own rightness was a conviction of the intellect; it did not represent an anaesthetizing of perception as did that of his invention, The Man Who Knows. To restore 'Lenin's Bolshevism' in the face of Lenin's creature, Trotsky would have had to do nothing less than bring Lenin himself back to life. For without Lenin, party democracy and the admission of error were to the Bolshevik but alien thoughts – as Stalin said, thoughts of a Menshevik.

The futility of a Leninism without Lenin was proven to the hilt by the failure of the slogan 'BACK TO LENIN' after Khrushchev's denunciation of Stalin – a denunciation whose only theoretical content consisted in its dubbing the Party of omniscience a 'cult of personality'. Instead of functioning as a cult the Party was now to 'return' to the 'principle of collective leadership'.

But if the Party leader was no longer the embodiment of Marxian certainty *what became of the Party member*? Apparently,

*Georges Sorel in his *Reflection on Violence* quotes Bergson's observation that 'the master insofar as he formulates, develops, translates into abstract ideas what he brings in already in a way his own disciple'. He is not identical with the disciple, but he does resemble him by way of the doctrine.

the functionaries who succeeded Stalin took the Communist for granted as 'part of the office furniture' and gave no thought to this question. Yet while 'BACK TO LENIN' meant for the new leaders a concert of power at the top, to the rank and file it could mean only the *distintegration of the Communist into an individual*, the beginning again of the old wrestle with self, with the Marxist text and with the events of the time. After thirty years of ideological chicanery, enforced by brutality and executions, the tendency towards such disintegration of the heroic image was, it seems, well advanced among the majority of Party Members. Mao's hundred flowers bloomed all too quickly. Developments in Hungary, Poland, China, the Parties in the democracies and in the Soviets themselves rapidly demonstrated that 'BACK TO LENIN' without Lenin could have only one result: the end of Bolshevism. Once and for all, Stalinism had become the fate of Lenin's Marxism.

EVERY place has its own time. This includes the rate of speed at which things move and happen there, the pace of its people in their work, entertainment, action. But the time of a place is something more than pace. It is part of the landscape – both the visible landscape and the hidden landscape of memory and feeling. It has to do with the depth of the surface image, the length of the historical reflection underneath it, like the reflection in water underneath a tree. In different places, streets, objects, ideas descend different distances into the past.

America, for instance, builds and acts on a thin time crust – its constructions reach upwards rather than down; its politics take account of the immediate future rather than of the past. Its watchword is the rate at which physical materials are transformed into things that can be seen, touched, used – the word Productivity.

American time has stretched around the world. It has become the dominant tempo of modern history, especially of the history of Europe. Other places, other peoples, find themselves overlaid by the American time surface – they are *in* or under this American time. The recognition of this fact is an inherent motive of every contemporary revolution. In its radical period, Bolshevik doctrine specifically enjoined party members to purge themselves of Russian sloth, egotism, and nostalgia and acquire 'American efficiency' – Albert Rhys Williams, an early biographer, declares that Lenin 'was constantly assailed for having a peculiar leaning toward America' and was called by his enemies 'an agent of Wall Street'.

Among European countries, Italy suffers in the extreme

from a conflict between Italian time and the larger time Italy is in. The time of the land of the Caesars conspires with its astringent sunlight to keep things motionless and intact, as if they stood in a vast bowl protected from the air currents of change. Objects become emptied out there and crumble, nothing is left of them but an outline, yet they are not transformed. At the same time, and especially since they turned to fascism and war, the Italians have also been enveloped in the ground mist of modern historical time, through which they finally saw armies clash in their fields, bombs fall on their towns, their means of livelihood disintegrate – until their liberation was declared and the fabulous GI's dashed among them in jeeps.

In *The Watch*, Carlo Levi, who studied the time that stopped two thousand years ago at Eboli, has sketched the landscape of the double time of Rome and Naples, with its old palazzi turned into weird apartment houses, aristocratic ladies collapsed into black-market pedlars, intellectuals who are peasants underneath, politicians who are priests in disguise. Levi has a physical sense of the hollow of time in which his country lies. In Rome, he says, 'the sky is not so high' as elsewhere, and at night you can hear from all parts of the city a low indistinct roaring as of the lions of antiquity or 'like the echo of the sea in an abandoned shell'.

The spirit of modern chauvinism is the veneration of local time and a burning hatred for universal time, that is, for modern history. You meet this spirit in its freest state in D. H. Lawrence, a chauvinist of *all* places and with a passion to dive into a native black or a native brown time out of the reaches of the machinery of Western change. . . . The opposite of the chauvinist spirit is that of the radical internationalist, in whom local time is dead or for whom it exists only as a barbaric drum-beat of obsolescent passions.

Neither a chauvinist nor an internationalist, Levi experiences the Italian counterpoint to contemporary time as a mysterious fact of the human universe. The native time that lives in him is a reality that he embraces yet feels the need to transcend; the universal time in which he lives is a counter-

reality that he fears yet feels the duty to confront. Symbolically speaking, the Italians need a *watch*, for something has broken the dial and bent the hands of the watch they have, while the time of the clock is bound to affect them as a tyranny.

The important thing is that the tempo that is their own shall synchronize with the time that rules the modern world; only thus can the people free themselves and make their own history. Such a human renewal of time means revolution – though not the revolution arising from the chauvinist intoxication with local time nor that produced by the radical hammer beat of a time detached from place. The true revolution can only be the merging of the local and world rhythms into a single genuine duration.

That is what happened briefly in the victory of the Italian Resistance, when men and women all over the country felt their own time surge up in them and mingle with the motion of world events. It was a surge of *dancing*, in which the inner tempo and external beat became one.

Milan was in ruins, but – 'the streets were filled with an exuberant, inquisitive and happy crowd. They were going to meetings, to rallies, for a walk, or who knows where? They all seemed happy to see one another, to breathe, to discover themselves again. . . . The people of Milan danced, the night deepened, the dancing continued without interruption, as though a miraculous trance controlled the muscles of those girls who had eaten so little for so many months. The lanterns went out one by one, and the dancing still continued. . . . In that light, in the whole city, the people of Milan danced, embraced one another trustingly, as though it was the first night of the world.'

That dancing was the Italian revolution. It was one of those moments, as with the British at Dunkirk, when politics or war becomes a close, personal act, when the individual reaches his own height in communion with others, when the past gushes through the present into a broader stream.

' "One can't go on dancing forever," I thought vaguely.' *The Watch* is the account of how the dancing ceased and of what was left in the morning, when the Resistance premier resigned and the professional politicians called a halt to the

music of change. It reflects the yesterday of triumphant hope, a hope that was an anticipation of a different condition of being, against a today in which Italy's two times have become sundered again, the Italians are sinking back into their old forms of life, and history is once more becoming strange to them.

The Rome through which Levi walks is a landscape of misery and hallucination – black-market stalls whisk in and out of their camouflage; the stranded Poles of General Anders's army, unhappy liars all of them, have replaced the Americans in the bistros; crooks, whores, and beggars have brought their techniques into line with current conditions; the intellectuals are mixing new brews out of every conceivable cliché. The new is wedged like a dart in the flesh of the old among this folk 'driven into a time that was not their own'.

Once the dancing had died down there was left to Italy its poetry of the past and its magnificent sky. But fallen apart into its double time, the country could not create any new poetry. It would have to raise its productive capacity – and to the Italians this meant not poetry but prose, a rhythm not from within. Yet while lapsing into their ancient lethargy they dreamed of an American paradise of depthless speed, a contemporary myth on the far side of the sea of purification. Matteo, the linotyper, who had worked in the United States, recites the standard features of the radical New World. 'To live over there, one must first forget a few things, also songs. It's a great country, everything's different. You feel it's different, not because of the houses, the skyscrapers, the subways, the elevated. It's different because they never turn to look back, and they don't have anything behind their shoulders. ... You might just as well forget your real name, it doesn't count for anything. We always have something over our shoulders: the family, the country, the party, our own ideas, and what has happened before, but over there? – Nothing. ... You must forget everything, throw everything away and always start from the beginning. You must plunge into the water. ... It's like a revolution that burns up everything that was there before. That's the only way to become an American. You have to enter the circle and run like the rest, hurrying

faster and faster. America runs. It's not built like a house that stands firm on its foundations the way we're made. It seems instead like a huge top or a huge gyroscope that rests on the ground on only one fine point and still stays steady because it's whirling, and the faster it whirls the steadier it is. . . . The first colonists had left behind, with no will or chance to return, Europe with its worn parapets and its ancient gods and history. From this voluntary gesture of renunciation was born the new thing that was America. This gesture with all it stood for was the American baptism.'

With Italy deprived of its dance tempo and with the touch of American time turned to the fantasy-revolution of individuals, politics re-assumed its old definition. Once again it had become the exclusive function of the professionals centred in ageless Rome, a 'country outside the world and outside of time'. Existing above their own time, like the bureaucratic *Luftmenschen* in all the capitals of the globe, they thought to reconcile the physical time of Italy with its American dream time. But living apart from both, they could only reconcile the two times as abstractions and could create nothing.

For Levi and his friends, these professionals, and those who thought and felt like them, were the enemy. 'Rome signified all those negative aspects of a world that was false and had failed; its name stood for the centralization of power, inept and parasitic bureaucracy, nationalism, fascism, the empire, the bourgeoisie.' But Levi has no answer to the bureaucrats (who has?). Without the dancing he and the Men of the Resistance were no longer political men. 'They [the Left and the Right] said he [the resigning Resistance premier] was not a man of politics, that he represented no real force, that he did not know how to manœuvre among entangled games of special interests, that he was nothing but a neutral and symbolic figure.'

For Levi politics means the 'eternal' moment of popular enthusiasm, and only such moments. When I talked with him shortly after the War, while the Resistance was still in power, he was impatient with questions concerning capitalism, Bolshevik organizational techniques, loans, relations of production. How could these determine the future? The new energies

in the Italian people would transform everything. Politics consisted of hoping for the prolongation of the dance.

Perhaps the conversation was pointless on both sides. If the 'historical elements' I referred to were going to dominate the situation, why should we, interested in human time and dancing, concern ourselves with it? On the other hand, if the future was to be a completely creative novelty – as Levi expected – nothing could be said in advance. At any rate, with the essential energy of modern politics missing, as well as its essential value, mass consciousness, Levi had only the choice of joining the enemy or lapsing into inactivity and 'irresponsibility'.

This choice between bad politics and no politics is a tragic choice – a kind of Hamlet impasse that exists everywhere today. For there is, apparently, no remedy for the decline of that popular vitality that gives meaning to democratic political action; yet, to follow Aristotle, man without politics is not his own kind of animal. The politics of the dancing 'moment' may be Utopian; it is probably naïve to remark: imagine what England would be like if the spirit of Dunkirk had been sustained. But this politics of mass creation is revealed to be not at all Utopian when the matter is put negatively: imagine what England would be like if Dunkirk had never taken place, if Dunkirk had been impossible for the British. Are not the Germans an example of a nation devoid of their moments or whose moments have been contaminated by hate and indifference to the human? Rosa Luxemburg criticized their 1918 revolution because it *forgot* to abolish capital punishment. The politics of the dance *is* a politics, even if it does involve time-vacuums and tragic stalemates.

Part 4

The Herd of
Independent Minds

The Style of Today

THE laboratory of the twentieth century has been shut down. Let us admit, though, the rapping of the soldier's fist did not interrupt the creation of fresh wonders. For more than a decade there had been a steady deflation of that intellectual exuberance which had sent out over the earth the waves of cubism, futurism, vorticism – and later, dadaism, the Russian Ballet, surrealism. Yet up to the day of the occupation, Paris had been the Holy Place of our time. The only one. Not because of its affirmative genius alone, but perhaps, on the contrary, through its passivity, which allowed it to be possessed by the searchers of every nation. By Picasso and Juan Gris, Spaniards; by Modigliani, Boccioni and Severini, Italians; by Brancusi, Romanian; by Joyce, Irishman; by Mondrian, Dutchman; by Lipchitz, Polish Lithuanian; by Archipenko, Kandinsky, Diaghilev, Larionov, Russians; by Calder, Pound, Gertrude Stein, Man Ray, Americans; by Kupka, Czechoslovak; Lehmbruck and Max Ernst, Germans; by Wyndham Lewis and T. E. Hulme, Englishmen . . . by all artists, students, refugees.

The hospitality of this cultural Klondike might be explained as the result of a tense balance of historical forces, preventing any one class from imposing upon the city its own restricted forms and aims. Here life seemed to be forever straining

*This chapter on the end of the cultural internationalism once concentrated in and symbolized by Paris appeared in *Partisan Review* in 1940 and is reproduced here almost without revision as background for the chapters on recent American intellectual history that follow.

towards a new quality. Since it might be the sign of what was to come, each fresh gesture took on an immediate importance. Twentieth-century Paris was to the intellectual pioneer what nineteenth-century America had been to the economic one. Here, the world beat a pathway to the door of the inventor – not of mousetraps but of perspectives.

Thus Paris was the only spot where necessary blendings could be made and mellowed, where it was possible to shake up such 'modern' doses as Viennese psychology, African sculpture, American detective stories, Russian music, neo-Catholicism, German technique, Italian desperation.

Paris represented the International of culture. To it, the city contributed something of its own physiognomy, a pleasant gift of sidewalk cafés, evening streets, shop signs, postmen's uniforms, argot, discursive female janitors. But despite this surface local colour, twentieth-century art in Paris was not Parisian; in many ways it was more suited to New York or Shanghai than to this city of eighteenth-century parks and alleys. What was done in Paris demonstrated clearly and for all time that such a thing as international culture could exist. Moreover, that this culture had a definite style: the *Modern*.

A whole epoch in the history of art had come into being without regard to national values. The significance of this fact is just now becoming apparent. Ten years ago, no one would have questioned the possibility of a communication above the national, nor consequently, of the presence of above-national elements even in the most national of art forms. Today, however, 'sanity movements' everywhere are striving to line up art at the chauvinist soup kitchens. And to accomplish this, they attack the value and even the reality of Modernism and 'the Paris style'. National life alone is put forward as the source of all inspiration. But the Modern in literature, painting, architecture, drama, design, remains, in defiance of government bureaux or patriotic streetcleaners, as solid evidence that a creative communion sweeping across all boundaries is not out of the reach of our time.

In all his acts contemporary man seems narrow and poor. Yet there are moments when he seems to leap towards the

marvellous in ways more varied and whole-hearted than any of the generations of the past. In the 'School of Paris', belonging to no one country, but world-wide and world-timed and pertinent everywhere, the mind of the twentieth century projected itself into possibilities that will occupy mankind during many cycles of social adventure to come. Released in this aged and bottomless metropolis from national folklore, national politics, national careers; detached from the family and the corporate taste; the lone individual, stripped, yet supported on every side by the vitality of other outcasts with whom it was necessary to form no permanent ties, could experiment with everything that man today has within him of health or monstrousness: with pure intellect, revelling in the tension of a perfectly adjusted line; with the ferocious trance of the unmotivated act; with the quiverings of mood and memory left by unmixed paints; with arbitrary disciplines and the catharsis they produce; with the nonsense of the street and the classics; with the moody pulps and absolute lyrics of paranoiac dreams.

Because the Modern was often inhuman, modern humanity could interpret itself in its terms. Because Paris was the opposite of the national in art, the art of every nation increased through Paris. No folk lost integrity there; on the contrary, artists of every region renewed by this magnanimous milieu discovered in the depths of themselves what was most alive in the communities from which they had come. In Paris, American speech found its measure of poetry and eloquence. Criticism born there achieved an appreciation of American folk art and music; of the motion-picture technique of Griffiths; of the designs of New England interiors and of early Yankee machines; of the sand paintings of the Navajo, the backyard landscapes of Chicago and the East Side. Ideas spreading from this centre of Europe and the world could teach a native of St Louis, T. S. Eliot, how to deplore in European tones the disappearance of a centralized European culture – and a modern rhetoric in which to assault Modernism.

True, the Paris Modern did not represent all the claims of present-day life. Any more than its 'Internationalism' meant

the actual getting together of the peoples of different countries. It was an inverted mental image, this Modern, with all the transitoriness and freedom from necessity of imagined things. A dream living-in-the-present and a dream world citizenship – resting not upon a real triumph, but upon a willingness to go as far as was necessary into nothingness in order to shake off what was dead in the real. A negation of the negative.

Perhaps the wrenching of Western culture that had produced this style had been too severe, resulting in a kind of 'Leftism' in the field of thought, an over-defiance of the powers of the past. Science and philosophy had crossed national boundaries in earlier centuries; abstract ideas had shown that they could drop from the skies without regard to time or place; but life itself, manners, ways of speaking, of acting, of composing images, of planning the future, had always been imprisoned by the gravitation of the community site, where the grip of the dead was most unrelaxing ...

Then, suddenly, almost in the span of a single generation, everything buried underground had been brought to the surface. The perspective of the immediate had been established – or rather, a multiple perspective, in which time no longer reared up like a gravestone or flourished like a tree but threw up a shower of wonders at the will of the onlooker.

The urge towards a free life, in a society that every year tangled him deeper and deeper in the web of the systematic, had carried the individual too far.

So the Modern became, not a progressive historical movement, striving to bury the dead deeper, but a new sentiment of eternity and of eternal life. The cultures of the jungle, the cave, the northern ice fields, of Egypt, primitive Greece, antique China, medieval Europe, industrial America – all were given equal due.

Strange vision of an eternity that consists of sheets of time and space picked from history like cards from a pack and constantly shuffled, arranged, scattered, regrouped, rubbed smooth, re-faced, spread in design, brushed off to the floor. An absolute of the relative, to be re-created in compositions of bits of newspaper, horse-hair, classic prints, the buttocks of a

South Sea Islander, petroglyphs, arbitrary shapes suggested by the intoxication of the moment.

Thus the Paris Modern, resting on the deeply felt assumption that history could be entirely controlled by the mind, produced a No-Time, and the Paris 'International' a No-Place. And this is as far as mankind has gone towards freeing itself from its past.

Modern art has been a series of individual explosions tearing at strata accumulated by centuries of communal inertia. In the words of one of its poets,

> The fairest monument which can be erected
> The most astonishing of all statues
> The finest and most audacious column
> The arch which is like the very prism of the rain
> Are not worth the splendid and chaotic heap
> Which is easily produced with a church and some dynamite.*

But note: processes less spectacular than those of the Paris studios had also been steadily loosening the cultural reefs of the past. Paris has been synonymous with Modernism in the sense of the special style and tempo of our consciousness. But it is a mistake to see this city also as central to the modern in the larger sense, the sense in which we think of the contemporary as beginning in 1789. This larger and more fundamental span has not belonged to Paris alone. It has embraced equally the United States, South America, industrial and revolutionary China, Japan, Russia, the whole of Europe, every spot in the world touched by contemporary civilization. Despite the fall of Paris, the social, economic, and cultural workings which define the modern epoch are active everywhere. Even the style has not vanished with the elimination of its capital: having been driven from the realm of art, it now reappears in new military and propaganda techniques. If there is a break between our lives and the kind of life existing before 1789, the current debasement of the Paris of the past 150 years does not imply a break of similar magnitude with the future. The

*Louis Aragon

world takes its shape from the modern, with consciousness or without it.

The Intellectual Form of Defeat

The cultural International had a capital: Paris. In the 1920s the political International, too, had a capital; Moscow. It is a tragic irony of our epoch that these world centres were not brought together until the signing of the Franco-Soviet pact, when both were already dead. Then the two cadavers of hope embraced farcically, with mutual suspicion and under the mutually exclusive provincial slogans: DEFENCE OF THE USSR and FRANCE FOR FRENCHMEN.

The intellectuals turned out in full dress – the 'proletarians', of course, with red rosettes and suggestive smirks – to the wedding of this pair of radical ghosts. And offered themselves as anxious godfathers to its earthly issue, the Popular Front. From that time on it became bad luck even to recall the graves of international culture and international socialism.

Thus it was that during the Moscow Trials we learned with surprise and alarm that it was here, in America! that the greatest opposition to the criminal burlesque was being voiced.

For a hundred years poets and artists of Paris had risen as to a personal insult against the organized sadism, lies and bad taste of the State, the Church, the Academy. Nowhere had the malice of office been more promptly raked with lucid hoaxes, verses of flame, cries of 'J'accuse'. On the Left Bank power itself was grounds enough for suspicion; and no one was thought to be less entitled to fair play than a man who had succeeded in making himself an Emperor, a Bishop, a Field Marshal or a National Poet.

As late as 1928, Louis Aragon, soon to become the leader of the League of American Writers* of all nations, could still assert: 'A gentleman who wishes to stand at the summit of events: definition of a clown.'

One had scarcely questioned the reception in the city of

*The League was one of the numerous Popular Front organizations against Fascism.

the Communards, and of Rimbaud, Courbet, Zola, of the stupid police pageant of Moscow, with its grotesquely staged appeal to the simple-minded of all countries – this mass assault by the nameless clerks of a State machine upon individual orators, theoreticians, writers, revolutionaries; this mockery of historical achievement more sordid than a thousand public monuments.

A few courageous men – Gide, Breton, Victor Serge, a few others – strove to uphold the tradition of French criticism. But what 'higher need' had paralysed the conscience of non-conformist Paris?

The higher need was Anti-fascism.

A struggle had to be undertaken, in parliament, on the streets, in the schools, the factories, the polling booths, the journals, the armed forces, against a system that would not only punish humanity for the sins of its past but also compel it to repeat them again and again: the system of Hitler.

The dead Internationals of culture and of politics went into battle with unwilling limbs. Like all organisms that have lost their potency, they sought some 'practical' contrivance that would ensure the desired effect without inner expenditure.

Wearing armbands supplied by Moscow, the Paris Left adopted the style of the conventional, the sententious, the undaring, the morally lax – in the name of social duty and the 'Defence of Culture'. Feasible Fronts were formed in which all the participants were forced to give up their power of action – perhaps a profound desire for this renunciation was the main reason for the coalitions.

Anti-fascist unity became everything; programmes, insight, spirit, truth, nothing.

Of course, the 'practical' is never of use in large matters, nor ever practical in time of crisis.

To the 'practical man' thought is a matter of taste. Some people enjoy Hegel, Shakespeare, Bach, Cézanne, scientific analysis, historical accuracy – others prefer mystery stories. It is all a question of how one spends his spare time; for 'doing', these differences are irrelevant. Molotov, with his scandalous 'Fascism is a matter of taste', simply formulated the attitude taken by his type towards *all* ideas.

To defend Paris, men and slogans long discredited were restored to power. The Communists claimed the 'Marseillaise' as their own and former surrealist poets acclaimed Romain Rolland.

In this milieu, inquiry soon became not merely a matter of taste but of bad taste. Another blow by fascist radicalism and it became treachery.

Meanwhile, modern formulae perfected both by Paris and Moscow in the hour of their inspiration, and now discarded, had been eagerly seized upon by Germany and adapted to its peculiar aims. In that country politics became a 'pure' (i.e., inhuman) art, independent of everything but the laws of its medium. The subject matter of this 'avant-garde' politics was, like that of earlier art movements of Paris, the weakness, meanness, incoherence and intoxication of modern man. Against this advanced technique, which in itself has nothing to do with revolutionary change, the Paris of Popular Front compromise was helpless.

Germany became the only country in Europe where thinking continued on the plane of extremist modern analysis. Thomas Mann has testified that he saw there a movement representing the same 'forces of darkness' that had animated the Expressionists and other modernist experimenters. (Mann, the Symbolist, confusing art and action, overlooked the tremendous *material* difference between a Picasso cubist portrait of a woman and a female torso chopped to bits by a 'Cubist' murderer.)

In Germany Bohemian spiritual negation had been armed with a scientific method based upon the techniques of subjugation employed in all modern class States. With increasing skill, the effects of violence were tried out in every sphere of life. Modernism in art was suppressed in order to seal the secret of the tyrant's spirit. The extermination of Reds and Social Democrats was accomplished through the primitive medium of the Reichstag fire; the breaking of the Jews with routine hoodlumism; the torture of the Protestant Bishops with an approach specially prepared; the silencing of the Catholics with strokes of a different sort. New provocations were invented with the prolixity of the Paris post-War

Schools in order to gauge the resilience of the victim. He was dosed with drugs of peace, allowing the analyst to chart his determination and will to victory. Greed was weighed against courage and love of tradition – so that friends might be purchased among the patriots of all countries. Finally, when the open fight began, the German 'extremists' pretended by months of sea battle to have agreed to fight with the enemy's weapons, all the time preparing to annihilate him with surprises.

Thus German leadership, with its ferocious enclosed energy, with an assurance and shamelessness that only philosophy can produce, seized control of the spirit of modern industrial culture relinquished by the Paris studios and political cafés. The scuttling of middle-class conservative values became a physical fact.

And the 'defenders of culture'? At the stroke of the Hitler gong, the last tremors in art, literature, science, politics, cease as if at a signal. For six years, not a single new idea makes itself heard. Impregnated by the thrust from the centre of Europe, minds formerly independent slink into institutions for the disgraced. Here sickly 'new worlds' are born – Stalinist Nationalist Utopias, Catholic Cities of God, Social Credit Luna Parks – and quickly disowned. No imagination dares to grapple with the present and the future. No one develops a fresh nucleus of resistance. Old faces reappear, the old banners are brought up from the cellar, and the blessings of the Church, the Family, and the Classics are heaped against the crumbling Maginot Line of the status quo.

So that, at last, when the crisis is ripe, a fast-moving explosive force* finds nothing in its path but a pile of decomposed scrapings.

The Academy had failed to halt modern art, and fascism was not to be stopped by clichés.

In the fascist political and military adventures, modernist

*In January, 1941. Andre Morize, former Director of the French Ministry of Information, in an article explaining the collapse, wrote: '... After the 10th of May both French and British lines were broken 'to pieces', literally, by an army which was led by a general staff free from all traditional dogmas and applying methods which came as a surprise and an irresistible shock.'

mysticism, dreaming of an absolute power to rearrange life according to any pattern of its choice, submits itself to trial. Against this experiment is opposed, not conservatism, but other forms of contemporary consciousness, another Modernism.

No one can predict the centre of this new phase. For it is not by its own genius alone that a capital of culture arises. Currents flowing throughout the world lifted Paris above the countryside that surrounds it and kept it suspended like a magic island. And its decline, too, was the result not of some inner weakness – not of 'sensuality' or 'softness', as its former friends and present enemies declare – but of a general ebb. For a decade, the whole of civilization has been sinking down, lowering Paris steadily towards the soil of France. Until its restoration as the capital of a nation was completed by the tanks of the Germans.

16 Couch Liberalism and the Guilty Past*

WHAT is remarkable about the manufacture of myths in the twentieth century is that it takes place under the noses of living witnesses of the actual events and, in fact, cannot dispense with their collaboration.

Everyone is familiar, or should be, with the Communist method of transforming the past: the formula for the production of historical fictions is no longer any more secret than that for the atom bomb. Through a series of public confessions a new collective Character is created and made retrospectively responsible for the way things happened. The Trotskyite Assassin or The Titoist Agent Of Imperialism who emerges from the judicial vaudeville changes events after they have taken place. To accomplish this miracle Communists are required; that is to say, former builders of the future must agree to destroy their actual pasts in order to substitute one provided by the political police. At their Trials, the condemned Communists are still making history – only this time backwards.

In the United States, too, recent history is being remade. If the Soviets have purloined our nuclear know-how, we have evened the score by mastering her technique of the fission and fusion of memory. To be able to dissolve segments of time is at least as important in modern politico-military struggle as the capacity to sear areas of space. With Communist help, it is now definitely in our power to alter at will the contents of the past twenty years.

*This was written in 1955.

195

Since under our free system the government undertakes enterprises only when private initiatives fail, our official investment in mythology has so far been a limited one. Save for occasional contributions by Congress and the Attorney General's office, most of the work of changing American history has been carried on by volunteers; although various Republican leaders have indicated their consternation at their Administration's refusal to use to the hilt a weapon which has been proved so effective. A single full-scale blast and the years 1932–52 could have been turned into the desert of 'twenty years of treason'.

As mentioned above, modern history-changing needs the services of a new kind of martyr: persons prepared to make a gift of their own pasts to the one under construction. Confession is a species of autobiography. In the political confession, however, the genuine 'I' of the confessor is not the interest of either the accused or his prosecutor. The defendant must give away a past larger than the one he actually possesses. The verdict is pronounced not against him personally but against a collection of individuals who consitute a single 'we'. The guilty Enemy is *one*, the effect of a composite of broad self-accusations, each of which fits into the rest to produce a total guilt which exceeds the sum of specific guilts assumed by the accused.

The reason for this overlapping was made clear in the last plea of Radek, one of the leading defendants in the original Moscow Trials. After proudly indicating in his testimony that he was a Fermi of psyche-splitting, Radek explained: there were in Russia, he said, 'semi-Trotskyites, quarter-Trotskyites, one-eighth Trotskyites and ... people who from liberalism ... gave us help'. Radek's confession had to implicate all of these different groups, shading into the acknowledgedly innocent, in the guilty 'we' being fashioned at the trial. With his help, the terrorism exercised against Vishinsky's Counter-revolutionary Mad Dogs could be extended equally to the politically sceptical professor, the gossipy clerk. A problem of intersecting planes and of contrasting hues and light-values of guilt. In the end, the Adversary would have the face of almost anybody.

Precisely in these wider radiations of his guilt lies the reward of the confessor. An act at once individual and collective, his self-accusation, besides giving effective vent to his resentment against those both less and more guilty than he (people who were perfect Communists and people who were in decisive opposition, becomes the means by which he rejoins society. His criticism of the regime, had it consisted in nothing more than an occasional doubt, isolated him through possessing the tone of his personal conscience in an environment where the personal was ruled out; especially if he was *not* part of an organized conspiracy, his dissent, all-but-hidden, bore down upon him with the full weight of solitary subversion. To whom could he communicate the oscillations of his thought? Were not his friends, his wife, his children, locked in the common façade of agreement in which he too was embedded only yesterday? His arrest was but physical confirmation of his separation from society.

In being forced to accuse himself the distracted dissident is given a chance to regain social conformity. Models of guilt are placed before him; he is invited to make full use of them in sketching his portrait of himself. His confession will not only bestow upon him solidarity with other confessing culprits, it will supply him with a community definition. Out of the solitude of his dungeon he marches in an ensemble of comrades into the full tableau of prefabricated history. That the scene is a hoax matters less than that he is no longer alone and has a role to play.

In America the part of the repentant history-maker has been played by the ex-radical intellectuals, some former Communists, others liberals and rebels who suddenly discovered that all roads of dissent cleared the way for Communism. In accordance with the recipe for history-recasting enunciated above, which category these belonged to made little difference in their confessions; all threw themselves into the same melting pot, were changed into the same character and assumed the identical guilt. Looking backwards, paying dues to the Party, following its line, were only deeper shadings of any criticism of capitalism, any questioning of the motives of

American foreign policy, any making of distinctions between Red and White totalitarianism.

Though confessing in America lacked the fatal finale of Iron Curtain confession, it was not without its hardships. The very absence of the bludgeon created special problems. It is possible that without the inspiration of the Russian originals, as an earlier generation of American actors was inspired by the Moscow Art Theatre, the entire effort would have failed. Far from being goaded to their parts by police agents hidden in the wings, the guilty here had to all but force their way on to the stage. Chambers himself, that witness of witnesses (one almost slips into calling him The Supreme Witness), describes how close he came to breaking under the ordeal of gaining the notice of people whose vital interests he was determined to defend. In time, we know, the barriers went down and whoever had a story to tell found a campfire waiting.

Still, the fact that one had possessed a radical bent did not of itself make him the star of a Congressional hearing nor supply him with a list of interesting names. Some leading candidate-confessors were probably never even interviewed by the FBI. When the appetite of the ex-radicals for at least a spear-carrying assignment exceeded their stock of misdeeds, they were compelled to draw upon a psychological reserve of guilt, the confession of dangerous frames of mind to which 'we the intellectuals' are prone – what has been called in totalitarian courts *moral responsibility* for sabotage or assassination performed by strangers. The exposure of such data, they argued, was as urgently needed as dates and places relating to the transfer of packages of film. How else than through 'our' instruction could a cop or a congressman understand and guard against the obscure mental processes of an Oppenheimer? Yet despite the logic of these guides to a wider world of subversion, the sales resistance of official America to anything but the sensationalism of spies and Communist 'plants' could never be quite overcome.

Since America lacked an agency for the effective extraction of confessions – the threats of McCarthy fell far short of inducing the profound self-doubt that was the speciality of Russian interrogation – the potential confessor had to heckle

himself into it. In the United States psychoanalysis assumed the function of the secret police. Americans, too, spoke in order to escape from a dungeon, but it was from the dungeons of their own selves. Of course, the Russian prosecutor has since *Crime and Punishment* been recognized as the personification of an inner voice, so perhaps the difference was not as great as it seems. In any case, despite the handicap of the Bill of Rights, our fugitive radicals succeeded admirably in making themselves victims; their do-it-yourself initiative ought to convince Khrushchev that prisons and torture are obsolete and that the cellars of the Lubyanka may be re-fitted as a game room.

In the end, a neo-liberal became available to admit the justice of any accusation, no matter how ridiculous. Since Oppenheimer gave money to aid the Spanish Loyalists, it mattered not that at the height of Russian-American cooperation he repulsed the proposals of Communist Agents: 'we' may as well own up for him that we are unreliable types and deserve to be fired, regardless of past services to the country. When McCarthy tried to bully Wechsler and spread his invented history into the headlines, the confessing liberal showed his fair-mindedness by conceding that 'we' never tendered names to the FBI unless we were forced to and were thus 'McCarthyites of the Left' in fighting distortion with distortion. Ex-radicalism even evolved out of its Freudian researches a new GUILT BY RHETORIC in which the criminal gave himself away by his passion for certain words and phrases. 'How desperately,' exclaims a characteristic document, 'they [the guilty liberals] wish in each case that the Hiss, the Lattimore *who speaks their language* might be telling the truth.' The important step beyond mere Guilt By Association taken here is that it is no longer necessary to know Hiss or Lattimore personally but simply to possess a literate vocabulary.*

*Guilt By Rhetoric was introduced by the US Army in a pamphlet on how to detect subversives through their use of key words like 'struggle' or 'imperialism'. The *New York Times* protested in an editorial and the next day announced that the booklet had been withdrawn. Undoubtedly, among the very high brows to whom we owe this attempted contribution to the defence of freedom, the *Times* is regarded as still suffering from liberal, i.e. Leftist, illusions.

The quotation above regarding complicity through language with persons we may violently disagree with is from Leslie Fiedler's *An End to Innocence*, a collection of 'essays on culture and politics'. This book is as representative of what I hereby christen Couch Liberalism as anything one may hope to find: its meditations on the evils 'we' have wrought are headed by a passage from that St John of the Couch, Whittaker Chambers, to the effect that History will get you if you don't get it first.

Half of Fiedler's book is devoted to an essay apiece on the Hiss Case, the Rosenberg Case and McCarthy, in each of which it turns out that we intellectuals with our 'shorthand' that the people cannot understand are deeply implicated: the rest of the book consists of literary essays with a strong discovery-of-the-true-America motif.

When I first read some of the political articles, together with pieces like them by other writers, I must confess (it's contagious) that I did not grasp what was happening. These slippery arguments that directed themselves against persons who had been punished by law, that complained about 'our' over-fussiness on the subject of civil rights, that while admitting that McCarthy was a crook placed under suspicion those who called him one, seemed to me simply odd. I could not grasp, especially, why these messages appeared under the name of liberalism. I, too, believed that Hiss was guilty, but so had the jury, he was in jail; so why these profound evocations of his perfidy, and of Chambers' ordeal and triumph, by a 'liberal'? Or why a 'liberal' indictment of Lattimore to supplement that of the Attorney General's office? Or an assault on people who, conceding the guilt of the Rosenbergs, opposed their electrocution? It was only after I had noticed that these ideas were appearing in concert that I recognized that a collective person was in the process of formation which named itself 'liberal' out of the same default of historical truth that caused the Communist sympathizers to cling to this title.

Fiedler's essays blend the new fake-liberal 'we' with that of the old fake-liberal fellow traveller to produce a 'liberal' who shares the guilt for Stalin's crimes through the fact alone of having held liberal or radical opinions, *even anti-Communist*

ones! For Fiedler *all* liberals are contaminated by the past, if by nothing else than through having spoken the code language of intellectuals.

Fertilized by Left-wing sophistication and by Freud, Fiedler's essays are confessions on another plane than autobiography. He has no facts to relate – one does not learn that he ever did anything in politics. The guilt he assumes is that of an essence; he confesses for the guilty 'we' without an 'I'. His theorizing about American politics derives from a vision of wrestling stereotypes, Right and Left wing, in which the collective Left sinks under a bad conscience. As one of our new volunteer cultural ambassadors 'explaining us' to the Europeans, Fiedler must have done as much as anyone to confirm the belief that everybody in America lives on a billboard.

An End to Innocence adds perhaps the final dimension to penitence. Fiedler's line is: We have been guilty of being innocent. Only by confessing will we terminate our culpability. In a rhetoric in which the kettles predominate, Fiedler laments Alger Hiss's refusal to confess as a defeat for all of 'us'. Hiss 'failed all liberals, all who had in some sense and at some time shared his illusions (and who that calls himself a liberal is exempt?), all who demanded of him that he speak aloud a common recognition of complicity. And yet . . . at the bottom of their hearts, they did not finally want him to admit anything, but preferred the chance he gave them to say: He is, we are, innocent.' Hiss's drama of Hush Or Tell could have cleansed us all had but its protagonist acknowledged his 'mistake'.

Whom Fiedler is here describing, except possibly repentant Stalinists who haven't confessed yet, I defy anyone to specify. His 'all liberals' is a made-up character with an attributed past. To his question, 'Who is exempt?', I raise my right hand and reply that I never shared anything with Mr Hiss, including automobiles or typewriters; certainly not illusions, if my impression is correct that he was a typical government Communist or top-echelon fellow traveller. I shall have a few words to say about the Communist 'innocents' later. Here I insist that it was Chambers who shared things with Hiss, not

'all liberals'; Chambers who was never a liberal, who in his book gave no hint of having ever criticized the Communist Party in his radical days from a libertarian position and who after he broke with Communism became something quite different from a liberal. Fiedler's 'common recognition of complicity' is simply slander, ex-Communist style; had Hiss testified according to Fiedler's suggestion he would have deserved an additional five years.

Perhaps from the point of view of the Department of Justice or of Couch Liberalism Hiss made a 'mistake' by not confessing as Chambers did. But from the point of view of American radicalism, the activities of the Chambers-Hisses when they were Communists were never 'mistakes'. Communists and fellow travellers on this level belonged to the Party's apparatus of intimidation and bribery. Their social respectability did not conflict with their support of Communist treachery and violence against non-Party Leftists or radical democrats throughout the world. On the contrary, boycotting, informing against or condemning to the executioner Socialists, anarchists, Trotskyites, POUMists, strengthened their patriotic disguise. Nor did confession ever purge these agents of power of their passion to browbeat critics of their historical mission. The same people who as Communists persecuted free opinion continued to do so with the same vehemence after they had turned themselves inside out and become organizers of anti-radical penance. Conversion alters the world in which a man acts; it does not change his character. Before he confessed the GPU chief Yagoda executed countless dissenters; by his confession he dragged down unnumbered others. The first law of the spurious 'we' is its malice.

How could we intellectuals, asks Fiedler, have been so wrong about Communism as against its lowbrow enemies? And if so wrong about *the* issue of the age, might we not be equally wrong about everything else? Ought we not therefore to abandon our intellectuals' ghetto and take our place in non-intellectual America? In a word, the end of innocence is a guilty return, as with the Moscow defendants, to the Community – the address of 'responsibility' is not the library, the study or the café but Main Street.

'The unpalatable truth we have been discovering is that the buffoons and bullies, those who *knew* really nothing about the Soviet Union at all, were right – stupidly right, if you will, accidentally right, right for the wrong reasons, but damnably right. This, most continuing liberals as well as ex-Communists and former fellow travellers are prepared to grant in the face of the slave labour, and oppression and police terror in the Soviet Union; but yet they, who have erred out of generosity and open-mindedness [!], cannot feel even yet on the same side as Velde or McCarthy or Nixon or Mundt.'

It takes passion to compile so gross a statement. Under the radiations of the fused 'we', facts have grown bulbous, lost their outlines, finally dissolved. Nothing is left but a conflict of stereotypes. I will leave to Fiedler the explanation of how a man can be 'right' about a subject without knowing anything about it. One recalls Lenin's incognito discussions with peasants who *knew* as against the damnably wrong intellectuals; their knowledge remains one of the mysteries of Bolshevik dialectic. Fiedler, however, cannot avail himself of Lenin's epistemology to claim a genuine interest in the thought-processes of his 'buffoons'. His demand for self-surrender and intellectual abdication has nothing behind it but the will to move to the right side.

This project seems to me a direct effect of totalitarian thinking, in which history appears as a two-character melodrama.* In America of the past twenty years one of these characters has been the Red-liberal who speaks in a caste vocabulary of universals and idealistic abstractions in favour of the CIO, the New Deal, Socialism, defence of the USSR, fronts against

*Fiedler appropriates this totalitarian mode of thought through his literary criticism of events, actually of their journalistic caricatures. Instead of political ideas, he relies upon 'a sensibility trained by the newer critical methods'. What this means in practice is that through the use of symbolist elaboration he can complicate the popular stereotypes without disturbing them – as for example, Kenneth Burke could find endless psychological and sociological clues in a cigarette ad. Thus for Fiedler the contrasting 'myths' of the Left wing and of public opinion lead a wonderfully complicated existence. But reality, the Soviet Union, for example, as the most baffling social, political and historical fact of our civilization, is so bare of literary suggestion, so obvious, that it may be left to the judgement of those who know nothing.

fascism – the other is the Common Man who mutters 'Dirty Red'. Character Number Two wins the argument by throwing Number One into jail. But in return for losing to the club-wielder who was 'right', the Left intellectual is given the chance of gaining self-knowledge and 'rehabilitating' himself through confession; all the Communist fakers, fools and position-seekers of yesterday become not only 'innocent' but 'generous and open-minded'.

Fiedler's 'Afterthoughts on the Rosenbergs' appeared originally in *Encounter*, the international magazine published by the Congress for Cultural Freedom. His thesis was 'that there were two Rosenberg cases, the actual case and the legendary one concocted by the Communists'. Naturally, Fiedler was not interested in the actual case. His meat was the Communist legend that placed before the world a pair of persecuted innocents. The Rosenbergs themselves, Fielder contended, believed in their fictional counterparts so completely that they experienced no guilt for having stolen the atom secrets; nor did they possess any cause which they could openly champion. Thus they died neither as heroes nor martyrs. More important, having assumed these false selves they were no longer even human. A couple of Red cardboard cut-outs were burned; there was nobody to feel sorry for, and the liberals who protested the electrocution were dupes. Just the same, Fiedler argued, it was an error to kill them, since the United States could have won a moral victory over Communism by sparing them. By acting as if there were a core of personal reality inside these self-made nothings we could have appeared before the world as champions of humanity.

I quote below from the letter I wrote to *Encounter* after reading this scandalous example of sophistical shuffling between propagandist apologetics and an insulting pose of conscience.

Fiedler was shrewd to deal with Communism in terms of its bad poetry. The characteristic of our time is that corn can be killing. The Rosenberg Case was the absolutely deadly mixture of American corn and Moscow mash. That in this incredibly shallow farce the Rosenbergs were playing for their lives was, of course, pathetic. This pathos Fiedler brought out very well.

I cannot, however, accept the explanation that the execution represented merely a negative failing on the part of the United States,

the absence of a higher humanity, resulting from 'political innocence', a 'lack of moral imagination' and a 'certain incapacity to really believe in Communists as people'.

With misplaced profundity Fiedler is talking about psychology, morality and 'myth', while we are confronted primarily with a question of injustice, the injustice of applying the death penalty in this case. What shocked fair-minded people was the objective factor of the disproportion between the crime as charged, and for which the defendants were convicted, and the death penalty. There was, and is, something hideous and unbelievable about transposing the loose atmosphere at the time the act was committed, when RESTRICTED DOCUMENTS used to lie around like leaves, to the tense one of the 1950s. At the time it took place the act was not in the realm of the absolute. Granted that the Rosenbergs were justly convicted, and I don't question that, they did not seem to deserve the electric chair. (This question of timing was implicit in Justice Douglas' desire to review which law applied.)

The injustice was easier to perpetrate because Communists dehumanize themselves. . . . But Sacco and Vanzetti, with whom Fiedler contrasts the Rosenbergs, were not saved by their real innocence nor by their human reality. Massachusetts did not experience them as 'people' either. The fact is that no defendant is a 'person' – *nor ought to be*. The law defines a man by his act. Justice requires only that he shall not be made to personify an act that he did not perform; and that the punishment shall not be cruel and inhuman and shall fit the crime.

The psychological question regarding the inability of many people (including myself) to feel sympathy for the Rosenbergs as individuals would never have arisen had it not been for the disproportion I have mentioned between the crime in its specific quality as an act of purloining information and the death penalty. Because of this disproportion the government itself, the press, the whole official U.S., had to be the first to resort to psychology and the 'moral imagination', that is, to unreality. . . . This monster-making, which took place before the Communists countered with their own milksop Frankenstein, is something quite different from 'political innocence' or an 'incapacity to accept Communists as human beings'.

In denying clemency, Eisenhower devoted his statement entirely, as I recall, to overcoming the disproportion between the crime and the penalty and to justifying the death sentence by holding these two feeble tools responsible for starting the Korean War and for the potential death of millions of Americans, in opposition to public statements by atomic scientists that the Rosenbergs could not possibly have transmitted, by means alleged, information worth a goddamn. . . .

The scandal of the Rosenberg Case would not exist if, as Fiedler contends, the United States had simply failed in the opportunity to

save the defendants from their own empty masquerade. The scandal exists not because of institutional lack of humanity but on the contrary because of human – all-too-human – passions not properly restrained by law but by making use of law. Instead of preserving the objectivity and *abstractness* of law, the government took up the slack in its case by creating its own fictional person, that of the fiendishly efficient underground incendiary capable of setting whole continents on fire. This caricature, which caused every act of the defendants to take on enormous magnitude, was needed to enable the court to render a brutal decision and the officialdom and the press to justify it. The dramatic imagination, *with its power of creating the person it judges*, supplemented the law and replaced the creature with its creation. This is demonism, not merely an absence of Christian charity.

Fiedler made the mistake of thinking there was too little humanity in the case, instead of too much, because he looked at this struggle as if it were a stage performance and compared the Rosenbergs as bad actors to Sacco and Vanzetti as genuine personalities. . . . But it is gruesome and a bit cowardly to drag out the corpses of Communists in order to demonstrate that there are no dead bodies but self-constructed dummies incapable of bleeding. If the Communists exile their victims from humanity in order to execute not men but devils and animals that is their extremest crime. If we in turn take over this process and forget justice because we are dealing with 'made' people, we are making our own contribution to the nightmare of the twentieth century.

To impede the process of turning American intellectual history of our own lifetime into a comic-strip encounter between a befuddled egghead and a right-thinking goon, I beg leave to cite a few data.

(1) Whatever its weakness in understanding Communism and its techniques, liberalism was in no sense responsible for Communist vileness. It is false to say that a belief in freedom, equality, individuality, induced adherence to the Red band, with its underband of party bosses, spies and masterminds. The liberal sentiment for radical equality and freedom was, in fact, the single intellectual mooring that held against the powerful drag of the totalitarian 'we', supported by the offer of a heroic part and material reward through social scheming. Moreover, the sentiment of freedom alone presented Marxism itself in its living intellectual form, that is, as a problem. One of the few serious American discussions of Bolshevism was John Dewey's essay on the Marxist conception of ends and means published around the time he went to Mexico to sit on

the commission of inquiry before which Trotsky crushed the evidence of the Moscow Trials and permanently damaged the revolutionary pretensions of international Communism (it was not Fiedler's buffoons who did that). Liberalism should not be held accountable for totalitarian 'responsibles' who refused to let the fate of individuals get in the way of the prestige of the USSR 'just when we are fighting fascism'.

(2) The intellectuals and fellow travellers who followed the Communists through the execution of the Old Bolsheviks, the extermination of POUMists and anarchists in Spain, the Stalin-Hitler Pact, the sabotage of French and British resistance to the Nazis, the partition of Poland, all of which took place in public and behind no curtain of any kind, were not 'innocent', to say nothing of 'generous and open-minded'. These scoundrels were, as a type, middle-class careerists, closed both to argument and evidence, impatient with thought, psychopaths of 'radical' conformity. The 'idealism' of this sodden group of Philistines, distinguished from the rest of their species by their more up-to-date smugness and systematic malice, can be respected only by those who ignore its function in hiding from them the cynicism which hardened their minds against any human plea or any evidence embarrassing to the Party. Delirious at finding themselves on The Stage of History, they eagerly carried out the intellectual atrocities assigned to them, while keeping one eye on a post in the future International Power, the other on the present good spot in the government, the university, Hollywood or publishing. In concocting arguments and social boycotts to cover up acts of the Party they complemented the terrorism of GPU assassins. One recalls, for instance, the international libel let loose against André Gide when he published his account of his trip to the USSR. To it, as to all criticism, the intellectual Left Front responded with character assassination reinforced by the stare of the social climber. During the Spanish Civil War, Left professors, government functionaries and party-givers of this stamp identified themselves with Malraux and Hemingway as ruthless *franc-tireurs* of the International. Without an appreciation of slapstick, in both its absurdity and cruelty, it is impossible to recall these 'innocents'

accurately. A dream of power, to fall into their hands after a new Ten Days That Shook The World staged under their direction, transformed sorry professionals into sleepwalking social highwaymen. If the Communist Front intellectual as a distinct figure produced by the movement was 'innocent', it was in one sense only: the *non sui juris* of pathology.

(3) The most significant falsification of the ex-Communist confessional is the suppression of the account of the struggle that raged on the American Left during the epoch of Communist ascendancy; this omission would be almost enough of itself to prove that Couch Liberalism is a Communist Party spirit that has changed its spots.

Like their master in Moscow, the Communist intellectuals in America detested above all, not capitalism nor even fascism, to both of which the switching Party line taught them to accommodate themselves – their one hatred which knew no amelioration was towards the independent radical. New ideas, modern art and literature, non-conformity in taste, behaviour, morals, produced in them a single venomous recoil. To the antipathy officially demanded by the Party towards its foes on the Left, the sordid Leftish mass added its own spite towards the outsiders who undermined their revolutionary conceit, especially in the days when the Party had traded in revolutionary posing for collective DEFENCE OF THE USSR. Soft to the point of servility to its foes on the Right, the Stalinist Front never varied in its violence against those who struck in any form against its radical pretensions.

Instead of in the common subversiveness of Communists, fellow travellers, liberals and radicals, the reality of the period lay in its battles. Nor were the attacks all from the side of Moscow. I have before me a manifesto of the 'League for Cultural Freedom and Socialism', published in *Partisan Review* in summer, 1939. Signed by thirty-four writers, it denounces the 'so-called cultural organizations under control of the CP' as 'the most active forces of reaction among intellectual circles in the United States. Pretending to represent progressive opinion, these bodies are in effect but apologists for the Kremlin dictatorship, they outlaw all dissenting opinion from the Left,

they poison the intellectual atmosphere with slander.'* At the time this statement was being right about the Soviet Union, Fiedler's 'bullies' were more concerned with sweating as much as they could out of a Federal road-building contract. That some who signed it have by this time adapted their pasts to the Couch Liberal distortion does not alter the fact that the appeals of the free Left to the intellectual conscience cost the Communist Party much. Granted that no permanent victory could have been won by intellectual means alone, Communism in the United States had been rather decisively defeated as an intellectual current long before a single ex-Communist had voided his memory from the witness stand. The Communist who 'passed' into an Ex is himself, very often, the product of this criticism. Only the simple-minded believe Chambers' yarn that it was the light of God glowing through his off-spring's ear, and not an argument repeated in his own by his anti-Communist radical friends, that first revealed to him what was wrong with Communism.

The Confession Era in the United States is about over. It is hard to imagine anyone adding facts likely to prove useful in the current prophylaxis. And beyond the facts each penitent has contributed his bit of himself to the mass protagonist of subversion and vanished into the common life. The attempt to change history has failed, largely perhaps because of the two party system and the common sense and boredom of the public. Mystification has been quarantined in the quarters where it originated, the colony of ex-radical intelligentsia.

An End To Innocence is already out of date. Its political and social morale belongs to the days of McCarthy's putsch, when yesterday's vanguard saw itself blinking in the footlights with a pistol at its head. The moment this physical threat vanished the posture was bound to appear ludicrous.

*The manifesto also attacked the mounting power of conformism and academicism in American art and literature, the censorship of movies by the Catholic Church, heresy hunting by the government, etc., all this during the Roosevelt Administration when, according to the current myth, America was the radicals' Utopia.

Genesis

GENERATIONS are a matter of costume. Their existence is established by a Look. Part of this Look is the rhetorical make-up, the blend of ideas and phrases, by which each generation creates the illusion of its intellectual character.

It is customary to define a generation quantitatively: persons between this birthday and that. But a generation has another dimension besides its linear measure of time. To achieve its Look it may have had to reach back past its chronological birthday to an older image of which it is an imitation or a revival.

Today, one sees on the streets young men in tight black pants and close-fitting jackets and with wavy forelocks of the bicycle-built-for-two era. This common figure, obviously modelled on pictures in the family album, down to the poodle as pet and the aura of hushed parlour or seminary, is apparently that of the new 'quiet', domesticated generation one reads about in the weeklies.

When T. S. Eliot recited his poetry in the radical thirties his 'clerical cut' was part of his comedy of anachronism: it also went well with his reading of Lear's nonsense verses. In those days Eliot's wit was a knife that cut both ways; he advocated The Family Reunion while exposing the paranoia of its relationships. Eliot's prose, like his poetry, contained a good dose of Dada.

Later literary men who copied Eliot's representative-of-culture act missed its two edges and thought the point was to be dull. When I first encountered the gravity of Lionel Trilling

I did not get the joke; it took some time to realize that there wasn't any. Pretty soon, people who could not understand Eliot began to look like Trilling.

Today, The Confidential Clerk is everywhere, and even when he adds whiskers to his get-up no one laughs. With Sidney Hook over-ruling the US Supreme Court for its romanticism about freedom, who would dare? If one ever started. . . . To keep a straight face has become an elementary health precaution.

Aesthetics and Weight

A good deal of the notorious conservatism of the present younger generation is ancestor 'camping'* – that is, a deadpan take-off on life with Grandpa. In the 'camp' the masquerade becomes the real thing. With the return to the album goes a taste for weddings, babies and regular attendance at church and office. Just how much play-acting there is in this, as in every generation-routine, and with the motive of arousing consternation in outsiders, is indicated by enthusiastic participation of the homosexuals in the Reconstructed Family movement; indeed fairies and near-fairies were in the vanguard of the new domesticity – witness the epidemic of marriages among homosexuals.

Part of the comedy of The Solid Look is to scowl at radicalism, romanticism and novelty as illicit. Boredom becomes a merit. In poetry one exhumes the 'forms' and attacks 'the moderns'; in the novel one relates episodes of seduction, political and sexual, overcome or regretted. The ideologist mistakes this charade for conservatism or reaction, which either pains him or arouses his hopes for a stabilization of the social order. But being an ideologist was, as I shall show, the 'camp' of the forepart of the present generation. Now that it has achieved its image its 'ideas' have been absorbed into the rhetoric that goes with playing the family-man part in full generation-consciousness. The younger generation is not hostile to ideas, as some have charged; it believes in cutting all

*The word 'camp' is untranslatable argot: it implies earnest horseplay that at the same time expresses the true character of the 'camper'.

ideas down to size, *its* size, which it declares to be the size of man. It specializes in human incapacity, and puts the knife into the idea of the man of ideas as part of the excitement of announcing one's age and of staging generation conflicts.

Except as a primitive means of telling time, generations are not a serious category. The newcomers in their social-responsibility get-up are no more nor less amusing than the waxworks proletarians in leather jackets in whom some now see the figure of the preceding generation. The opinions of a generation never amount to more than fashion – the regretted 'generation of Fitzgerald' shared few ideas deeper than raccoon coats, hip flasks and Stutz Bearcats. Innovations in thought depend on the labour and insight of individuals not on the preferences of an age-mass; and many 'periods', not necessarily the least articulate, are intellectually represented by a blank.

Nor are the moods and will of a generation decisive for the future, even for its own future. The course of events is decided by the action of forces far deeper and more obscure than the 'issues' fought over by general consent. The generation of Lenin, Trotsky, Luxemburg, Martov, was a revolutionary generation; but it was not a Bolshevik generation. No one analysing its character and its typical thoughts and dreams would have expected Bolshevism to be its chief historical product. Nor, in reverse, could anyone examining the shape of the Communist State imagine such a father for it. One man extracted a seed from his period and made possible its evolution. The activity of Lenin and his idea, by which events were dominated, were not of his generation; nor, on another plane, were those of Joyce or Einstein of theirs.

In the distance of time or of the imagination, the natural effect produced by a generation is one of comedy. Even the heroic collectivities of 1776 or 1848 have a surface of lyrical absurdity. Moreover, their deepest intentions were subject to the irony of history, which changes heroes of the barricades into policemen, lovers into social workers, often without making them aware that the transformation has taken place.

In any case, belonging to a generation is one of the lowest

forms of solidarity. To be in favour of someone, or to act or think like him, because he was born in the same decade or two is inferior to taking out a membership in The League of Red Headed Men.

Thus it is that in nations with long historical experience, the conceits of generations, including the one presently on the stage, are of interest primarily to writers of farces – and to such half-conscious comedians as nostalgic poets and moralists of the Order That Was.

In the United States, however, where news is the final measure of historical reality, the mood of the latest generation is given the weight of the voice of destiny. In addition, history has blessed us with a cult that takes everything seriously, which could indeed be called a 'cult of seriousness', I mean the literary intellectuals. This cult has chosen as its fabulous profession to keep hunting the *Zeitgeist* in order to submit to its command. Perhaps, having without resistance yielded to the social sciences all the claims of literature in myth, psychology, history, morality, American writers have nothing left to talk about but their own group superstitions. Ten years ago, describing the post-Marxist pre-occupation of the intellectual mass, I pointed out that, while its speciality was deploring US 'conformity' and 'mass culture', its generation-consciousness was the particular form of its own conformity and small-mass 'culture':

The area which intellectuals have most recently staked out for themselves as belonging to culture *par excellence* is the common *historical* experience. While down below one still hears about love, crime, ambition, the top of the (mass culture) pyramid is reserved exclusively for the history-conscious small mass. There the talk is of '*the* experience of the 'twenties or of 'the thirties', '*the* experience of the younger generation' or of 'the depression generation' ... To be accepted by the intellectual mass, experience must come wrapped in a time package.' ('The Herd of Independent Minds', *Commentary*, 1948)

New Olds—Old News

Opening an extended series of essays and statements on 'The Young Generation of Intellectuals in the United States' in *The New Leader*, Norman Podhoretz, one of the brightest

of the under-thirties, defined the new generation as a post-Depression, post-War, Cold War species, twenty-one to thirty-one years of age. He characterized this generation as full of a sense of 'responsibility' and 'maturity', and explained that it had got that way through growing up on a pile of butterfly wings torn off themselves by penitent liberals and leftists. It seemed to Podhoretz that youth had a good case for its no-nonsense attitude, but he complained that its members showed a 'fear of experience', a lack of character, knowledge and belief, and were really a 'non-generation'. Podhoretz wound up by expressing the whimsical hope that his contemporaries would refresh themselves with a bit of defiance like taking a midnight swim in the Plaza fountain, a rather adult way of not telling them to go jump in the lake.

Other contributors to *The New Leader* symposium have generally agreed with Podhoretz that there was a new generation with a sober look, in contrast to the Bohemianism-radicalism of the 'generation of the thirties', and that in temperament and ideas the present trend was towards caution and dullness. About half the young writers felt badly about this condition and one spoke of the particular dismay of the Left-wing. The other half – neo-religionists, neo-conservatives and professional enders-of-innocence – found satisfaction in having been divested of socialist and humanitarian delusions; this group might be named the Positives Of The Negative or *The Would-be-Dullards*.

A unique position was that of Mr Anatole Shub of *The New Leader* who passionately denounced as the source of the current apathy the chauvinism and reaction that set in during Roosevelt's wartime administration. Taking a positive political orientation, this contributor was alone in noting that the revolutionary students of Poland and Hungary, with their radical, democratic demands, are also part of the younger generation and that their action may be a sign that the breaking of the spell is in sight on a world scale.

One may, especially today, call any age-group he chooses a 'generation' – among ensigns or ballet dancers a generation is replaced every three or four years. I am not, however, convinced that 'the crucial public experience', Depression, War,

Cold War, or absence from it, is enough to establish a unity of mood and to mark off a generation from its predecessors. Particularly do I doubt that an objective condition can be responsible for shared assumptions among a generation of intellectuals – even the Occupation of France did not produce in that country the uniformity unveiled by *The New Leader*. What is involved here is not alone the *experience* of the present-day youth of being post-Depression but the evolution of an *attitude* from its beginnings in the Depression through the succeeding periods of war and prosperity. Part of one's experience is one's experience of other people's experience of that experience. If Podhoretz is right and this is a 'non-generation' of uninspired intellectuals the cause is to be found in the non-ideas and non-experiences of others by whom these young men were surrounded from birth.*

In short, the 1946–56 group under examination is part of a wider group from which it derives its intellectual physiognomy. It was not of *these* 'responsibles', most of whom were still in high school, that I wrote a decade ago: 'a combination of avoidance of responsibility for individual experience with avoidance of responsibility for social thinking is now known as "responsible" poetry. And, of course, every truly independent mind must believe in "responsible literature", as well as in "alienation", the "failure" of radicalism, the obsolescence of the individual, etc.'

The mistake of *The New Leader* authors is that they speak of two intellectual generations where in reality there exists only one. They discover an ideological conflict, or at least a contrast, between the younger generation and its predecessor. Being intellectuals they naturally feel more at home in a debate than in a burlesque. But though a debate is more dignified, it suffers in this case from the distortion of presenting a grave contest of two personified ideas where in actuality there exists only the act of a single clown who keeps losing his trousers.

*Besides, the Cold War is not comparable to the Depression or to the Second World War: it is not, like them, a physical reality accompanied by certain characteristic experiences and attitudes; from start to finish the Cold War is a struggle in the mental world, hence dominated by ideas which have reference not to hunger, fear, despair, but to influencing and coercing people.

Thus Podhoretz writes:

the celebration of maturity in the postwar years also constituted an assault on the intellectual life of the thirties itself. At any rate, to the young people educated in the late forties and early fifties it seemed that a war was being fought in American culture between two styles of asserting one's seriousness as an intellectual: the old style of 'alienation,' represented by commitment to the ideal of Revolution and an apartment in Greenwich Village on the one hand, and, on the other, the new style of 'maturity'.

Podhoretz is no doubt accurate in reporting that the young intellectuals *think* that their elders were serious revolutionaries and Bohemians. But this does not make it a fact, and Podhoretz should have described not only the opinion but the actuality. One reason the young think as they do is that the older crowd has been telling them for years how Red and 'alienated' they used to be. And because the new intellectuals believe them, they imagine that it was they who cooked up the counter-idea of responsibility and the Family Look. But this is shadow boxing of the silliest sort – it reminds me of Sliding Billy Watson going six rounds against himself.

Nobody becomes dull through discovering the errors of others nor their own. Above all, it is necessary to set our subject straight: the generation we are speaking of is one whose span is not the single decade of post-War America but the Biblical twenty years. To understand the present youth one must view it not as the twenty-one to thirty-one in opposition to the between thirty-one and forty-one but as an extension of the latter group – *the present younger generation is twenty-one to forty-one, or better still twenty-five to forty-five*.

To take a concrete example: Podhoretz is an editor of *Commentary*. But neither he nor his age group founded *Commentary*. Intellectually, *Commentary* came into being as a phenomenon of slowly turning American Marxism, and Podhoretz belongs to the turning generation as a representative of its final turn. He is an ideologist without an ideology and in opposition to ideologies; yet his writing is ideological – not poetry, not fiction, not literary nor philosophical appreciation, not individual insights. It is *position-taking* writing, as *Com-*

mentary's writing has always been; the problems of style and form do not seem to disturb this author, any more than they do the majority of his *New Leader* contemporaries. Podhoretz's age in no way prevents him from fitting well into *Commentary*, to which his intelligence contributes much. It was not necessary that he be in on all the turns of the generation that grew up between 1935 and 1955, and when he feels that he belongs to a 'non-generation' he is attesting that his generation did not begin anything but was caught up with and absorbed by a social organism already ripened.

Today's younger generation of intellectuals consists of the late arrivals to the generation that made its appearance as American 'Marxists' and which has lived its entire life with Marxism (including of course, anti-Marxism) as its central theme and interest. Without Marxism this generation is not only dull – it is *nothing*, it does not exist. (In a typical 'younger' novel, by Peter Mathiessen, the hero goes hunting for Marxism in order to have the experience of disinfecting himself from it!)

If I may be permitted a personal testimony, since the important thing about a generation is that it be *recognized*: when I first encountered this 'Marxist' generation in the mid-thirties it already had its present character; it was, in its own terms, 'responsible' and 'mature' and opposed to personal radicalism and Bohemian life – it is a matter of record that *Partisan Review* was set up by the Communist Party specifically to combat 'Bohemianism in literature'. As a newcomer from the preceding period I experienced this generation as a stranger. I was too young to be solidly anchored 'in the twenties' and when the new tide rose I was swamped like the rest (woe to him who is not swamped). Like everyone else, I became involved in Marxism, but from the start my Marxism was out of date. I was interested in Marx for the sake of something else – in the clichés of 'my' generation, I found in his writings a new image of the drama of the individual and of the mass, as I saw in Lenin a new kind of hero, a sort of political M. Teste. Every word of Marx I read made the master seem more interested in the deities I had brought with me than in my contemporaries' Marxism. This did not help me to understand them nor their

vision of themselves. Yet we were using the same vocabulary – this is an illustration of why generations belong to comedy.

What made 'my generation' was not age alone but a history of work under the touch of a spirit which the thirties banished –a spirit whose native habitat was international Paris (where none of us need have been) and to which national-above-national Moscow (where few of the 'Marxists' wanted to be) was not so much a place as an argument that could not be ignored. As this argument lost its force, as the 'Marxists' themselves made separating from it, and later attacking it, their speciality, the generation whose entire intellectual capital consisted in the Muscovite bonds it was liquidating was bound to seem *pointless*. As the literary leaders of the former Left flopped over, they found it increasingly easy to come to terms with older members of 'our' generation, especially the more conservative ones. But not with the few who, like myself, were chronologically, as well as temperamentally, on the edge between the two generations and actually strangers to both.

I recount this bit of autobiography in order to identify, from a point just outside of it, the generation of American intellectuals whose history of futility is the real subject of *The New Leader* discussion. Also, younger members of the present generation may be interested in the experience of being 'on edge', since if my time calculations are correct, that is where they are most likely to find themselves.

To return to our sheep: it is the representative intellectuals of the past twenty years, and not just the young men on tip-toe, who fit Podhoretz's description of the partisans of 'adult living' and of 'firm commitments to careers of a fairly modest kind' (they are also committed to the word 'commitment'). For every Chambers in the mask of the Underground Man there was a Hiss in the mask of the Responsible. That under each mask lay the other mask was established when the masks were exchanged and Hiss was convicted of personifying the Underground by the testimony of a Responsible Chambers, whose 'firm commitment' to the ideology of world conspiracy had been switched to farm, babies, God and job. That the Red and the officeholder were proven to be the same is the sole intellectual revelation of the Cold War period.

This bent towards careerism of modern Left intellectuals as a social caste is worldwide. Here is testimony concerning 'The Left Wing in Egypt' by Walter Z. Laqueur (*The New Leader*, 10 June 1957):

This new [petty bourgeois] 'intelligentsia' confines its reading and discussion almost entirely to Marx, Lenin, and various of their more recent expositors. These Communist convictions are often somewhat superficial, and the students and petty officials [are] essentially concerned with getting a foothold in some faction of the party in power, thus attaining a social position one rung above the one they now hold.

The quietistic non-ideas of the younger generation represent not defiance of an opposing philosophy but the debris of a collective mind. The comedy in which this mind has starred has to do with the rise of the 'Depression rebels' through a succession of national crises to 'normalcy' and success. Mistaking themselves, under the prodding of Third International cultural programmes, for the equivalents of the castes who had seized control in Russia, Germany, Italy and former colonial countries, the American intellectuals of the Depression fell into the delusion that their day of power had arrived. Earlier American intellectuals had engaged in assaults on the American businessman and his representatives in Washington: the new élite was less concerned with social criticism than with the imminent rewards of banding together. The fact that a new togetherness not new ideas was its aim accounts for the murderous style of its factional fights and its vile treatment of dissident individuals. This swing towards collective consent carried the generation of the mid-thirties away from the radical individualism of the generation of O'Neill, Cummings, Marin into whatever social role presented itself.

'It is not the "I" but the "we",' declares Mr William R. Yates, twenty-seven, already 'formerly-of-Hollywood' and a script consultant to CBS's *Studio One* 'that one hears most often on the lips of the young intellectuals. As family men, as "company men", as technicians, educators, publicists, the young always seem to think of themselves as part of a whole, as citizens of a society.'

By the time of the Spanish Civil War, the imported notion

of an American intelligentsia reigning as a caste had already been proven a dream by the power of Catholicism and big business in the State Department, while the Moscow Trials supplied a midnight shiver to warn of what might happen if the dream came true. Instead of laying hands on the State the intellectuals had qualified for jobs. The leather jacket had been replaced by the Brooks Brothers suit and the Depression ego was left without an image of itself – or with a double image. Confronted with a blank mirror, or with one that had two faces in it, the gentlemen of the Left could not slough off the obsession of being somebody; the effect was to make them hysterically antipathetic to whatever possessed its own physiognomy. The outstanding figures in modern art and literature were abused as 'mere individualists' unable to 'solve the problem of our time', while mass leaders and political ideas were attacked as 'anti-human'. With Gide, Valéry, Picasso, Trotsky, Surrealism, Socialism, Existentialism, 'disposed of' by the non-writers of the pre-non-generation, the age of the anti-hero dawned. Orwell of *1984*, with its frigid rationality and paranoiacally lifeless prose, rose as the ideal author, while Sidney Hook's precautionary logic became the measure of political wisdom.

The hangover of the power trance was made more depressing by the Cold War and the terror raised by Congressional investigators. 'The end of innocence' meant, basically, an abusive good-bye to Karl Marx by shivering jobholders. Not that anyone should have risked his job for an idea of which the job had revealed itself to be the essence. But why gestures of despair at the fact that with the Depression ended and an idea no longer needed to get a job, young men simply get jobs and don't have any ideas?

The Open Road of Im-Possibility

The comedy is finished. And now comes bowing from behind the curtain Mr Daniel Bell to pacify the younger generation with the dirge that this is 'the end of an age', when all intellectuals are in an 'impasse', a time 'which has seen the end of ideology' and of the ideologist who 'wants to live at some extreme, and who criticizes the ordinary man for failing to

live at the level of grandeur' – oh, it's all right, croons Bell, to 'try to live heroically if there is a genuine possibility that the next moment will be, actually, a "transforming moment" when salvation or revolution, or genuine passion can be achieved. But such chiliastic moments are illusions [of course no one was ever really saved, no revolution ever took place, and as for "genuine passion"]. . . . And what is left is the un-heroic, day-to-day routines of living.'

And who in the audience is to jump up – certainly not a relic of a still earlier generation – to point out that Mr Bell himself, who knows all about possibility and its non-existence, seems to be, if not 'living at some extreme', at least thinking in terms of two. For between 'the transforming moment' which is an 'illusion' and 'the day-to-day routines' which are the reality, a great deal takes place that is quite worthy of atten-tion, heroic and ordinary. For instance, the falsification of history both comic and malicious, even in the face of living witnesses, that goes on all the time and is both a routine and a transformation. But who is to jump up, since there is 'a lack of issues'? Except that you yourself are an issue.

A generation is fashion: but there is more to history than costume and jargon. The people of an era must either carry the burden of change assigned to their time or die under its weight in the wilderness. Besides the issue of truth as to what has hap-pened there is the issue as to what can happen, and as to what cannot. The goal of the intellectuals' movement towards the social niche has been happiness in terms of middle-class con-ceptions of the family, work, the nation, religion. In the rush to lay hold of these solid things, it has rarely occurred to the neo-bourgeois intellectual that what he gets may not be en-tirely for him to decide. Middle-class values and institutions (the 'day-to-day routines of living') have themselves gone through a succession of crises; the class has become progres-sively 'Bohemianized' by population shifts, depression, the absorption of family-size enterprises, the growth of the State, contact with Communism and Fascism, and the exposed posi-tion of the U.S. in world culture. The new prestige of art, psychology, exurban manners, in short, of the intellectuals

themselves, is a reflection of this phenomenon. As usual, the intellectual herd is rushing backwards towards a mirage and as usual under the banner of Forward to Reality.

By force of its unreality, both psychological and social, the Family-Man-and-Respectability 'camp' results in cruelty and self destruction, like all farce transferred to the actual world. The costume is put on easily enough, but the plot has the last word. The slogans of 'free love' and 'the liberation of women' were not invented merely to supply people of an earlier generation with 'radical values'. As they were slogans they were inexact; yet their failure does not mean that the family no longer needs to be revolutionized and that people can 'go back to' it if they choose. In the decade of belief in domesticity, some of the nastiest and most pitiless divorces have disrupted the moralistic serenity of the happiness boys, and not of the oldest either. As to the mental health which is so central to the new orderliness, current statistics on commitments (that word again!), alcoholism, drug addiction and juvenile delinquency sufficiently describe the situation. As Trotsky retorted to Burnham: you may not be interested in dialectics but dialectics is interested in you.

Luckily, the young intellectuals who have undertaken to be the voice of their age do not represent the whole of the younger generation but primarily its literary element. Young painters and sculptors share a mood quite different from that of the *paterfamilias* of the universities, the quarterlies and the editorial offices; they neither look nor feel dull nor are they excessively 'mature'. It may be that many of them neglected either to go to college or to look for signals to the *Partisan* or *Hudson Review*. These unfortunates, misled by the example of some throwbacks to the creative tradition preceding Communist-anti-Communist realism, did not succeed in becoming painters without learning how to paint, a problem which in writing has been mastered by most of the official younger intellectuals. As a result the past ten years, while witnessing the decline and shame of American literature, have seen the most vigorous and original movement in art in the history of this nation. If it weren't for those flat-headed clerks I keep running into on the street, I could be induced to believe that the y. g.

of intellectuals is a fantasy of a Summer Workshop In Literary Criticism.

Naturally you don't develop a style by contemplating your maturity and its implications. Throughout the life of the literary generation under discussion, 'positionism' has been a substitute for art as for thought. Attempts were even made to place ability to write under suspicion – in the famous debate between Trostky and Burnham mentioned above, the latter accused his opponent of winning arguments through imagery and eloquence rather than through a sober line-up of propositions (another instance in which any generation but this would have died laughing). Literary style was held to be a frivolous evasion of sound political thinking. Yet how comes it that the decline of White House prose from FDR through Truman to Ike corresponds exactly to the deterioration of political intelligence in the same ménage?

The battle-cry which the current movement carries on its white flag is: LET US FIT INTO AMERICAN LIFE. In terms of our metaphor, it is a matter of getting one's picture into the family album. Depression rebels, children of immigrants, former Social Democrats, native radicals, all are drawn to the same moustache cups. Yet the young man in scant dark pants seems to spring from none of these categories. Can it be that *everybody* is looking for a way to fit in? If so, doesn't that imply that nobody fits?

Perhaps it is not possible to fit into American Life. American Life is a billboard; individual life in the U.S. includes something nameless that takes place in the weeds behind it. In America everything is possibility – or it is sham. You cannot *fit* into American life except as a 'camp'. If American intellectuals accepted Mr Bell's endism and agreed that possibility is an illusion, and reality 'the routines of living', their choice would have to be either the 'camp' unto death or their traditional solution: expatriation.

THIS collection* of theoretical, historical, statistical, cultural anthropological, depth-analytical, polemical, prophetical articles on TV, the movies, pulp fiction, advertising art, etc., more than exhausts its subject. I should like to believe that it will now be considered closed for some time to come. '*On peut finir avec la sculture*,' Giacometti once said to me. If it is possible to be done with an art – and this is an age when artists keep trying to finish theirs off – it ought likewise to be possible to make an end of talk about comic books and science fables.

I confess that one of the reasons I hope that the wares of the cultural supermarket will henceforth be left for their proper customers is that I find something annoying about the mentality of those who keep handling the goods while denying any appetite for them. True, some of my best friends are mass-culture analysts. Naturally, I am not referring to any of them. Most have taken only one or two shots at the matter, and I know none who has not had better things to say on some other topic. The people I am complaining about are the mass-art specialists, particularly the profound ones, those who cannot switch to Channel Four or roll over with the corpse in a red chemise without beholding hidden patterns of the soul and society of contemporary man.

As if there weren't already too much talent and intellect in America steadily draining into the *dreck* of the mass media. Must the mite of the PhD and the literary critic be tossed in too? With so much *bought* interest in bad art, there would

* *Mass Culture*, compiled by Bernard Rosenberg and David Manning.

hardly seem any need for volunteers. Particularly when one considers the shrinking quantity of thought being devoted to anything worth while.

The common argument of the mass-culture intellectuals that they have come not to bathe in the waters but to register the degree of its pollution does not impress me. I believe they play in this stuff because they like it, including those who dislike what they like. I never heard of one who to meet his duty to study best-sellers or Tin Pan Alley tore himself away from Walden Pond or a cork-lined isolation cell.

Besides, whatever their aim, and often it's not so easy to figure out, the chief effect of writings like those of Leites, Riesman, Rolo and others is *to add to kitsch an intellectual dimension*.

Every discovery of significance in Li'l Abner or Mickey Spillane helps to destroy the distinction between that spurious mental and aesthetic substance known as 'kitsch' and art, good or bad. One of the grotesqueries of present-day American life is the amount of reasoning that goes into displaying the wisdom secreted in bad movies while proving that modern art is meaningless. Yet it is nothing else than the intellectualization of kitsch, in which the universities, foundations, museums play their part, that makes the concert of popular media into such a tremendous social force against the individual in this country, as in the Soviet Union. If only popular culture were left to the populace!

Certain social scientists have a great deal to answer for in this respect. They have put into practice the notion that a bad art work cleverly interpreted according to some obscure Method is more rewarding than a masterpiece wrapped in silence. And since the interpretation is everything, why pin it to a novel or poem when more people are likely to have seen *The Prince and the Showgirl*? Cultural Anthropology pays better than literary criticism, even than New Criticism.

Will anyone deny that to these people their own insights are superior to those of art? Or that their attitude towards the artist is a blend of philistinism, condescension and malice?

Social science apart, will anyone deny also that in recent years mass-culture analysts in the literary world have been

ceaselessly distracting to themselves – and to the junk they deal with – the attention that ought to go to writing, painting and music? Yet it is typical that one of these town criers of kitsch should proclaim as the urgent issue of our time the need of the individual to 'hold his own against the spreading ooze of Mass Culture'.

Although this topic is so greedy, there is one aspect of it that has received little, if any, attention. I refer to kitsch criticism of kitsch. Writing books about what's wrong, or what's right, with Hollywood or Madison Avenue has become as solid a profession as working for the movies or an advertising agency. To study kitsch critics of kitsch might be more important than to study kitsch itself, since false arguments about these false products relate to the timbre of those intellectuals who are not yet, or imagine they are not, in the service of mass manipulation.

Some modes of kitsch criticism of kitsch:

criticism of kitsch that ducks the question of the quality of the object it is examining – 'the swampy ground of aesthetic dispute', as one expert puts it;

criticism of kitsch that wishes to treat each work as a work of art which succeeded or failed, as art succeeds or fails; ignoring the fact that, given the social and psychological conditions under which mass art is produced today, a coherent expression of any kind in it is all but impossible and is rarely seriously intended to begin with;

social criticism of kitsch that has the air of emanating from a lover of the arts in despair at being overwhelmed by an inescapable flood of newspapers, radio programmes, comic books, etc.;

cultural anthropology, professional and amateur.

'The counterconcept to popular culture is art,' says Leo Lowenthal.

To oppose kitsch makes one appear automatically a champion of the arts. Thus by his exposures of absurdities of *Time-Life*, movies, popular novels, Dwight MacDonald becomes a bloodbrother of De Tocqueville, Nietszche, Ortega. Qualified counterconceptually, he expresses his views on contemporary painting and poetic diction in the *New Yorker*.

It turns out, unhappily, that the counterconcept is unreal.

MacDonald's taste for kitsch is largely negative, but it is genuine, at least genuine enough to yield him the time to become familiar with it. Modern art, however, revolts him; it gives him as much incentive to get to know it as would the gases in a condemned mine.

In practice the counterconcept to kitsch is more kitsch. When MacDonald speaks against kitsch he seems to be speaking from the point of view of art; when he speaks about art it is plain his ideas are kitsch.

What is true about MacDonald is true about most of the writers on mass culture. Popular art is their meat, whether as a clue to current social relations, as an object of moral protest, as an occasion for self-expression, or just for the grinder. No doubt they believe that the true material of their psychic existence is poetry, paintings, concertos. Such self-delusion can be enormously stultifying. Though every intellectual regards himself as an animated counterconcept to it, the discussion of popular art in America is thrown out of shape by the vacuum of positive interest in art. As against the symbol searchers, on the one hand, and the wailing women of culture, on the other, I'll take a TV actress any day.

There is only one way to quarantine kitsch: by being too busy with art. One so occupied is protected by the principle of indifference – exemplified by Edmund Wilson's testimony in *Mass Culture*, one of the few by literary personalities, which states simply that detective stories stink, that those who read them regularly and with enthusiasm are probably in no better condition and that he, Wilson, will debate no further on their qualities.

Ortega is consistent: he not only dislikes mass art, he dislikes the masses themselves. They gave him a sense of being crowded. Personally, while I admire Ortega's wit, I dislike him more than I do crowds for his way of getting his body into his arguments. Had he not been disputing with the masses the right to possess the most prominent places, he could have found plenty of room.

An aesthete by implication, the critic of popular culture tends to be trapped into considering himself an aristocrat.

There is no surer way of making oneself ridiculous. Several *Mass-Culture* authors sound as aggrieved as King Alfonso by The Industrial Revolution. One might as well take walks on Fifth Avenue leading a pair of greyhounds.

'The counterconcept to popular culture is art.'

The statement is false. Art has no official attitude towards 'poetic crap' (Rimbaud). Whatever can be said of kitsch with regard to 'its distortion of reality' can be said in equal measure about art. Nor does art tend to occupy a higher moral plane – kitsch is much more likely to exclude personal malice, for example, which accounts for so many great passages in poetry, painting, music.

When kitsch first began to spread in European cities, the liveliest poets found it cute – read Mallarmé's ads. By now there is too much of it around for it to be a mode of the intellectually exotic. As a snobbery the craziness of advertising art is as passé as rent parties in Harlem or reading thrillers. Nevertheless genuine artists like Stuart Davis and William de Kooning continue to make good use of billboard type or the lips that sell rouge.

Kitsch is the daily art of our time, as the vase or the hymn was for earlier generations. For the sensibility it has that arbitrariness and importance which works take on when they are no longer noticeable elements of the environment. In America kitsch is Nature. The Rocky Mountains have resembled fake art for a century.

There is no counterconcept to kitsch. Its antagonist is not an idea but reality. To do away with kitsch it is necessary to change the landscape, as it was necessary to change the landscape of Sardinia in order to get rid of the malarial mosquito.

To affect the landscape is the only legitimate reason for investigating the processes of popular art. In other words, politics is the only legitimate reason. To study kitsch as propaganda is legitimate – e.g., analysis of the treatment of minorities in slick fiction – since the aim of the study is not knowledge alone but action, to dissolve into a new reality the conditions that make for the 'old crap'.

Life and kitsch have become inseparable. Genuine art in our time has made this point again and again – in Cubist collages, the prophylactics of Neo-Plasticism, Surrealist poetry. Using kitsch is one of art's juiciest devices, and a comic revenge for the looting of art by kitsch. Art drinks the corn of the popular, takes it in limited doses as a poison, as a vaccine. It deals with life in the same way.

Art also attempts to hurl itself out of both life and popular art, to enter its own realm, that of creation liberated from things.

But art never makes the mistake of regarding itself as a counterconcept.

Academicians insist on a separation and an opposition, on the counterconcept to kitsch of an idealistic art. The result is, of course, kitsch. But every fabricator of kitsch looks down on other people's kitsch.

That kitsch and life are grown together into one monstrous limb may very well be at the bottom of the new delusion that the secrets of existence can now be read on the movie screen.

Mass art is a phenomenon of the world of art and can be understood only in relation to conditions in that world. Mass art is the product of creative talent put into the service of

(a) art that has established rules;

(b) art that has a predictable audience, predictable effects, predictable rewards.

Kitsch is art that follows established rules at a time when all rules in art are put into question by each artist. As a result, the production of kitsch is manageable at a time when works of art succeed in coming into being only through tragedy, irony or a cast of the dice.

Kitsch is art that has an audience at a time when art throws itself against a blank wall and reaches the public only after it has bounced off and exploded into a rubble of critical platitudes.

Kitsch is thus art produced in obedience to the basic assumptions of the Art of the Ages: the assumption that traditional

forms can be put to new uses through technical means; the assumption that these forms retain an intrinsic power to move people. Both these assumptions are correct.

With regard to the norms of art there is nothing wrong with kitsch, whether represented by Leonard Bernstein or the draughtsman of Little Orphan Annie. Whatever is wrong is wrong with art.

People don't need works of art any more for entertainment – there are too many commodities more directly designed for that purpose. As Cummings said thirty years ago, poetry competes with elephants and motor cars. Thus if art becomes an extension of daily life it loses itself; it becomes a commodity among commodities, kitsch.

But if art sharply distinguishes itself from the automobile ride or from reading the newspaper, if it seeks to embody in its medium a unique psychic tension, it becomes a disturbance and even a risk, a thing labelled FOR CERTAIN MOMENTS ONLY, and by this fact dissociated from the experience of millions who, regardless of their 'level of culture', have never passed through such moments; and beyond these, even from the artist himself in his ways of passing time – everyone knows that today artists turn for pleasure not to art but to kitsch.

Art is not the sport of starving hermits. It implies an audience, if only as a source of easy money and applause. Yet for the reasons given, the best art of our time restricts its appeal to other artists, a group that has neither money nor social glamour to bestow and whose members are for the most part bitter and miserly in handclapping.

Or it appeals to introverted adolescents, to people in crises of metamorphosis, a small-town girl who has met an intellectual, a husband forced to give up drinking, a business man who feels spiritually falsified, all these being, like the audience of artists, more attentive to themselves than to the work.

In any case, there is no audience for contemporary art and no luxury for artists. Both attention and cash go to kitsch, which earns them by believing that art and human nature remain the same throughout the ages.

Kitsch is right about art, but art continues with its aim of

changing the landscape, art norms or no art norms, audience or no audience.

Art succeeds, but the situation of art is hopeless. For half a century it has been forced to surrender one position after another. Poetry yields to kitsch its traditional forms, retreats to free verse, abandons that too when copywriters begin to chant in the new style about refrigerators. If the spirit of poetry had no other resource than the poem it would long ago have signed a lifetime contract with *Omnibus*.

There are in the USA today probably fewer than one hundred persons fully supporting themselves through the creation of literature, painting, music – probably far fewer than one hundred. Yet who can count the number of those who are living well off the literature and arts industry?

Kitsch has captured all the arts in the USA. The art world is full of kitsch, literary magazines brim over therewith. When painter X or playwright Y begins to turn out X's and Y's for his readied audience – kitsch. One of the best American poets has produced little else for years – in thirty seconds I could name five painters in the same state. In each case, no question of dishonesty, of 'selling-out', but of muscular slackness associated with finding an audience responsive to certain norms.

Art will continue its manoeuvrings of retreat between beauty and anti-art, between reality and aesthetic counterfeit, revolution and nostalgia. More and more the condition of art turns into its own affair and resistant to the generalizations of those who would fit it into their system of functions. In the present organization of society only kitsch can have a social reason for being.

AMERICA masks its terrors behind patterns of fact. Here the intolerable discloses its presence not in the grimaces of comedy or tragedy but in the bland citations of the scientific report. Since the War, no novel or play has given body to the larger disturbances of the American consciousness. Literature, one hears, is dead, or too enfeebled to risk arduous adventures. Nevertheless, documents keep appearing that touch upon apprehensions equal to any in the history of men: computations of the daily incidence of outlawed sex in America's bedrooms; records of scientific sadism practised by governments and their programmes to transform the will of individuals; estimates by atomic technicians of the flimsiness of the earth and of the natural shape of the human body. When phenomena of this order are explored in a work of the imagination, its author tends to be exiled to the colony of 'morbid intellectuals'. Given the form of the report or survey, and authorized by the rhetoric of the professions, the most alarming topics overcome the handicap of their profundity and enter into the conversation of solid men of affairs.

Among the grand metaphysical themes of this decade, the one that has proved perhaps most fascinating and persistent has been that of 'alienation' – the loss by the individual of personal identity through the operation of social processes. The tone of the post-war imagination was set by Orwell's *1984*; since the appearance of that work, 'the dehumanized collective that so haunts our thoughts' (as Mr William H. Whyte, Jr. calls it in *The Organization Man*) has been a topic for the best-seller lists.

Orwell's melodrama of the pulverized ego was a work of fiction. But Orwell was a Briton; besides 1984 could be read as a description of life in Stalin's Russia or in a future Labour Party England, rather than of the destiny of America. Of US storytellers who essayed to raise the same spectre, none achieved large public impact. Americans awoke to the menace of robotization when it passed from the fiction-writer's yarn to the testimony of the sociologist and cultural anthropologist. Riesman's *The Lonely Crowd*, with its 'other-directed' hero-victims of automobile showrooms and PTA meetings, left no doubt that the familiar feeling of being some-one else was not a mere after-effect of seeing the wrong movie. Spectorsky's *The Exurbanites*, Whyte's *The Organiza-tion Man*, Mills's *White Collar*, Packard's *The Hidden Per-suaders* filled in important details of personnel, locale and method. Like The Man With The Bomb That Can Blow Up The World, The Creature That Lost Himself ceased to be a reflection of the dream-maker's art, or a literary construction of the philosophical moralist, and emerged as a statistical probability from the file-cards of the social scientist.

It goes without saying that the Other-Directed Man, the Exurbanite, the Organization Man, is a *type*, that is to say, the personification of a behaviour system on the order of, say, Sinclair Lewis's Babbitt. In this respect the difference between the sociologist and the novelist reduces itself to the fact that Riesman explains that he is writing about 'social characters' and devotes his book to analysing what they do, while Lewis trots Babbitt out on the stage and has him do it.

The type or character is deficient in individuality *by defini-tion*. Said Strindberg: 'The word "character" ... became the middle-class expression for the automaton. An individual who had once for all become fixed in his natural disposition, or had adapted himself to some definite role in life – who, in fact, had ceased to grow – was called a character ... This middle-class conception of the immobility of the soul was transferred to the stage, where the middle class has always ruled.'

Since the immobility or eternal fixedness of the present-day American social type – let us nickname him The Orgman –

is presented as something new, in contrast to the dynamism and inwardness of the Inner-Directed Man (Riesman) or the Protestant Ethic Person (Whyte) of the nineteenth century, let us keep in mind Strindberg's point that the image of the person who is identical with his social role has been with us for centuries.

Automata of manners are a feature of traditional literature, as the true automaton, the Golem, Homunculus, Frankenstein, is a familiar figure of mythology and folklore. Most interesting with regard to the type presented by the new American sociology in his relation to the 'mechanical man' image conceived by last-century writers as associated with the effects upon human beings of the new machine culture, Poe, in 'The Man Who Was Made Up', imagined a person put together from fabricated parts; while Marx built his political philosophy upon the misery and triumph of that human 'product of modern industry', the proletariat.

In the current writings, the type that displaces the human person also originates in the productive and distributive machinery of society. The Orgman is further identified with the older literature of industrial alienation by the part of science in his drama. In Marx the key force in historical progress is, of course, science; and it is the scientist of revolution who releases the proletariat upon the world; in *1984* the scientist reappears as the personality-crushing interrogator. Says *The Organization Man*: 'The first denominator is scientism'; and goes on to demonstrate the presence in all American institutions of the traditional creator of the mannikin, the 'mad scientist', now wearing the guise of the personnel expert, the motivational researcher or some other 'soul engineer'.

Blood brother to the inhuman 'double', the Mr Hyde, of romantic literature, on the one hand, and to the proletarian of revolutionary socialism, on the other, The Orgman belongs to the latest episode in the saga of the conquest of society by hordes of faceless *directed* men.

Yet the new literature is neither romantic nor revolutionary, and in this lie its most striking characteristics. One no longer hears the metallic lockstep coming closer, like the rising of swarms of beetles or crabs. The enemy of this decade does not

come from below. His is neither the face of the ogre over the edge, nor of the ghost behind the window pane. In the muted melodrama of the current sociology, the inhuman does not *invade*. It sits in the living room twisting the TV dial or takes the family for a ride in the two-tone hard-top. It is you.

Recoiling from the outerworld of society's monsters, outcasts and victims, the analysts of contemporary America centre their interest on the majority that benefits from the existing social process. With this shift of attention the spectre has shifted too. The alienated man has left the company town for the suburb; the factory for the office, the drafting room, the lecture hall. The presence within him of the socially constructed Other is, by the testimony of each of our authors, the mark of 'the new middle class' man. It is to the absorption of this alter-ego that all his education and training are directed. Says Riesman: 'The mass media ask the child to see the world as "the" child – that is, the other child – sees it.' To be inhabited by the abstract social person is what is currently meant by the terms 'normal' and 'socially adjusted'.

The charge that all our social behaviour stands as a power over and against us *is a more extreme accusation of existing American society than that of the preceding radicalism.* Implicating *everyone*, without distinction as to social class or function, in a single deepening process of dehumanization, such works as *The Lonely Crowd, The Organization Man, The Hidden Persuaders,* communicate in atmosphere, if not in stated concept, the sinister overtones of a developing totalitarianism from which there is no escape. In this literature with its subdued manners of scientific analysis Orwell keeps springing up like a red devil. *The Hidden Persuaders* features Big Brother on the jacket and promises the reader 'a slightly chilly feeling along the spine'; an effect which the blurb for Whyte's volume has already delivered through billing its hero as the man who 'not only works for the Organization: he belongs to it'. The smiling credit manager you spoke to this morning is a piece of company apparatus like the filing case from which he extracts the card that is you; his human appearance is a disguise and his real name isn't Brown but Agent F-362.

With Marx the conversion of the individual's 'living time' into lifeless commodities was restricted to the routine of the wage worker. In the current studies no one who participates in any capacity in the system of production and distribution can escape the vampire that drains him of himself. Differences in class functions have ceased to matter. Even the division between labour and leisure has lost its meaning; for the psychic mortification of the individual takes place not only in and through his work but by means of his participation in any form, public or private, of social life, from church-going, to cocktail parties, to his relations with his wife and children. Whyte and Mills put the major emphasis on the job as the ground of estrangement; Spectorsky gives mode of employment and style of leisure about equal play, seeing one as the extension (laboratory?) of the other; Riesman regards the externally controlled psyche as a phenomenon of 'the consumer age' – and is supported by the evidence of *The Hidden Persuaders* concerning supermarket penetration-assaults and the cold war against the customer by means of the new psycho-sales weapons. All our authors are at one in conceiving the flattening of personality in America as a universal effect of our interrelated economic and social practices.

What the Orgman-critics expose is not a flaw in society but the injurious realities of its normal everyday life. These, however, are presented in a perspective that denudes them of radical implications. Here 'scientific objectivity' has become the disguise of a philosophy of fatalism. The emergence of the Orgman is conceived in terms far more deterministic than those of the 'historical materialists'. Neither Riesman's 'age of consumption' nor Whyte's 'Organization' was brought into being by the choice, nor even the need, of anyone, whether individual, class, or nation. The 'other-directed society' of the first is a manifestation of the population-curve; the new corporate 'collectivism' of the second, of an immanent process of expansion and stratification. The vocabularies chosen by Riesman and Whyte of themselves exclude human intervention, in the future as in the past: you cannot re-direct an other-directed period, any more than you can refill an Orgman with 'Protestant Ethic'. Even if you could, there would

be no point in doing so, since other-direction and the ubiquity of the Organization are necessities of our time.

In any case, the histrionic effect of the new criticism is unmistakeable: the bland deadpan of the Objective Observer has definitely replaced the scowl of the radical accuser. For him such words as 'capitalist', 'class conflict', 'profits', 'depression' are at once too bulky and needlessly exciting. Since they draw from the same storehouse of material and cultural consumers' goods, all Americans have become 'capitalists'; since they are changed into directed beings by their work and social consumption, all have become 'proletarianized'. On both counts, there is no cause for conflict and a unanimity of interest prevails. All of us, Whyte thinks, will have to revolt. But whatever basis there was for Marx's conception of a metaphysico-political uprising of human machine parts against a minority of opulent personalities has vanished in the universal estrangement.

In the new Organization America there are no fundamental issues, though some old-fashioned people may not yet have gotten rid of the habit of taking sides. To 'moralize the flow of words', says Riesman, through which events are apprehended today is a tendency of 'the inner-directed person who remains still extant in this period' – which is a marvellously ironical way of saying that you know what is happening only through what you're told about it in the mass media, and that if you care one way or another you merely define yourself as a relic. The deadpan, apparently, is a requisite not only of the analyst of society but of all of us. If Riesman's irony goes unnoticed, as Whyte complains his has, it is because his language is too consistently detached from his subject matter to admit any sense of contrast: Orgprose, too, is deadpan.

Evoking the sinister concept of man as a tool and as an object, the new writing does so in an oddly disembodied and unpainful way. Its tone is one of injury but of injury unsuffered. It would seem that among the 'groups', particularly the better-paid ones, that have replaced the classes in Orgamerica, the substitution of a corporate identity for one's own is not the unmixed deprivation it might have been for the twelve-hour-a-day factory hand or for the citizen of the slave

state. Before the Orgman can feel put upon, it is only fair that he consider the advantages gained. 'It is not,' explains Whyte, 'the evils of the organization that puzzle him, but its very beneficence.' Strange literature which, assembling the proof of society's subversion of both the will and the intelligence of its members, cries out, like the man in the joke, 'But good. But good'.

When the fear of the unreal becomes mixed with an idyllic dependence on it, a kind of mythic euphoria ensues which is related to the essence of the comic. Chinese folklore is full of the pranks of demons who have shed their awfulness and sit on window-sills and above doorways minding one's business like so many other-directed neighbours. These everyday fiends may be as spiteful on occasion as one of Whyte's integration-specialists, but their troublemaking only adds gaiety to the way the 'system' to which they belong achieves its generous aims. The tale of the Orgman has as much in common with dream farce as with the Orwellian torture phantasy. If its hero suffers, it is in the drugged world of *A Midsummer Night's Dream* laden with bodily pleasures and tremors, where, in the words of *The Organization Man*, 'the demands for his surrender are constant and powerful, and the more he has come to like the organization the more difficult does he find it to resist these demands or even to recognize them'.

For both radicalism and conservatism, history is a struggle of winners and losers. In the new American scene, everyone has won a fairytale luxury and lost himself. The drama of history has been replaced by a pantomime in which, freed of individual or mass conflicts, bewildered, adjusted beings respond as in a narcosis to mysterious signs, whispers, hints and shocks, which each receives on his Riesman 'radar mechanism'. The scientific wand-wielder responsible for these psychological pinches and tweaks which inject dream anxieties into their physical serenity is a kind of affable Puck; for even the scientist, since he is necessary, is no longer a real villain; the evil lies rather in his abstract double, 'scientism'. Riesman and Whyte construct their shadowplay in such a way as to leave no point of resistance. As in Whyte's description quoted above, any struggle against surrender on the part of the indi-

vidual constitutes a wrestle in a dream. Neither Whyte nor Riesman indicates any direction in which the American person can realize himself in the actual world.

Yet disregarding the nature of the type or 'character' as automaton, each holds out the hope that the alter-ego he is describing may some day develop into a human individual. This empty happy-ending is excellent as finale in a farce like *The Three Penny Opera*; as a substitute for protest or for tragic pathos in a portrayal of actual life, such sudden optimism arouses the suspicion of an attempt at ingratiation. Whyte looks forward to a time when 'men partially liberated might be tantalized into demanding more' – no doubt by means of mass-persuasion techniques. As for Riesman, he can lift his consumer type out of the trap of 'belongingness' only by attaching to him the timefuse of a self-transforming process: 'these developments [the mass distribution of art and literature] suggest to me that the process of taste-exchanging holds the promise of transcending itself and becoming something quite different, and of signally contributing to the development of autonomy in other-directed men'. As if one could go from the abstract to the concrete, the automaton to the organism. Our sociologists' remedy for alienation is not 'scientism' – it is sorcery.

Extremist but neither radical nor conservative, the Organization criticism is inspired not by a passion for social correction but by nostalgia. A sigh over the lost person mars the phantasy of American unanimity which has supplanted the ideological Passion Plays of Marxian condemnation and conflict. Whyte's memoir on his training in the Vicks Vaporub rugged individualist sales force of 'the old days' (the late thirties) is the most eloquent and touching passage in this entire literature. The Age of the Giants – alas, gone forever. With Vicks' Richardson extinct, every human degradation may be logically anticipated. Today, the Orgman, the 'dominant member of society', still lives among the relics of older types. Tomorrow he will tread the stage alone, in conflict only with himself.

It is the business type of yesterday whom the new social

criticism has generalized into its 'inner-directed' and 'Protestant Ethic' abstraction, and in the name of which it fires its barrages against present-day tendencies. If it takes some daring to bury the boss, it takes less if one also bewails him in public. Especially in a situation where he has much to gain by playing dead. In Whyte's indictment of the human exactions of The Corporation, one hears the voice of the Founder deploring 'the drift towards socialization'.

Loosed from action, for which it can see no aim, the post-radical criticism often exaggerates its complaints, producing a worse impression of conditions than is warranted by the facts, at the same time that it seeks remedies in the wrong direction. For example, Mills, the most emotionally authentic of these writers, undervalues the personal and social expression of the white-collar worker on the job, with an effect of melancholy that seems unreal when one looks at actual men and women coming out of an office building. On the other hand, the salvation through improvement of taste proposed by Riesman, or through a psychic resistance based on private life (far more impoverished for the clerk than his job) suggested by Whyte are, as we have seen, equally unreal.

But there is more to the conception of the Orgman than regret for an older social type. As the representative of the new post-War employed intelligentsia, the post-radical critic suffers also a nostalgia for himself as an independent individual. For his former abstract sympathy with a nominal working class, the intellectual of this decade has substituted an examination in the mirror of his own social double as insider of The Organization and The Community. It is what he sees there that has caused him to project a morbid image of society compared with which the old 'class struggle' America seems not only naïve but as relatively healthy as a war with rifles and cannons.

For in regard to the misery of alienation, who is a greater victim of what Whyte calls the split 'between the individual as he is and the role he is called upon to play' than the member of the intellectual caste newly enlisted *en masse* in carrying out society's functions? As writer, artist, social scientist, he is one with his talents and his education for creative work; in playing

his part in the service of the organization he must eliminate any thought of functioning for himself. Through his personal inventiveness he has in the past fifteen years achieved prosperity and social prestige, yet he is the most dependent of wage earners and the most anxiously conscious of his dependence – *The Exurbanites* chronicles this dependence and anxiety to the last instalment dollar. (Applying itself to the narrower spectrum of the commercialized intellectuals, *The Exurbanites* is the most realistic of the works we have been considering.)

The intellectual employee also accepts a more total identification with his role than other workers, in that the editorial director, the designer, the copywriter, etc., sells himself more completely in terms of both psychic energy expended and number of hours worked. With him the division between work and leisure, discipline and freedom, has truly been erased. If the free artist or the founder of a great enterprise builds his life exclusively out of the substance of his work, today's intellectual unbuilds his life in order to live his job.*

Besides being the prime victim and exemplar of self-loss in contemporary society, the 'organized' professional cannot escape a conviction of guilt for his part in depriving others of their individuality. He has consented to use his capacities as a tool and to approve in practice the proposition recorded by Whyte that 'all the great ideas have already been discovered'. His skills tend to relate to human management, e.g., writing, image-making, programme-forming; even if his speciality is in engineering or the physical sciences, the results of his work directly augment the force by which society is controlled. The intellectual cannot function as Organization Man without also functioning as Organization-Man moulder; as human object he must also affect others as objects; as manipulated act as manipulator. Thus he cannot help but feel himself to be a

*The rule quoted by Whyte for corporation executives generally, 'You promote the guy who takes his problem home with him,' becomes for the intellectual, 'You hire the guy who takes his problem to bed with him'. His job has a creative side in which his preconscious must also collaborate. Take this into account in computing his average salary, and the difference between the wage-earner of the suburb and of the company town becomes largely a matter of overtime pay. At $2.50 an hour the totally employed intellectual would earn more than $20,000 a year.

betrayer of humanity as of his own mind. Helpless to change anything, he is yet the chief culprit of the alienation drama, the driven 'scientist', who directs the undermining of the raw individual, whether as motivational expert, inventor of personnel tests, or as preacher of despairing acceptance.

Self-displacement through one's acts is the innermost problem of life in America as of that in all civilized countries. The Social Type has always been among us, of course, despite Riesman's effort to distinguish today's other-directed man from his nineteenth-century counterpart. Tolstoy's Ivan Ilych, who decorated his house entirely according to his own original ideas only to have it turn out exactly like all other houses of his class, is as good an example of automatic 'radared' taste-exchanging (Riesman) as can be found in Fairfield County. Tolstoy explicitly insisted that Ilych was a socially made-up man, an 'object' guided by public opinion, an example of 'dead' living.

In the United States, nineteenth-century literature, whether in the popular stage comedies of manners or in the symbolism of the romantics, centres on society's human abstractions. We mentioned above Poe's hero who owed to industry his movable parts. A contemporary of this invention was the ubiquitous Salesman-Preacher, whom Melville, writing in a less unctuous age than ours, named The Confidence Man. Like Whyte, Spectorsky and Packard, Melville saw in this professional who supplied his countrymen with things, ideas and feeling, the outstanding specimen of man as social artifice. As his complement, he set up the brooding inner-directed Indian Fighter, paranoiac Ahab of the prairies; while from the silent recesses of the office files, he drew forth the white-collared tomb deity, Bartleby.

What is new in America is not the socially reflexive person but the presence of a self-conscious intellectual caste whose disillusionment has induced its members to volunteer for the part. The predicament in which these individuals find themselves is what casts a bar sinister over their image of America. The fear-augury that the Orgman will become everyone in a quiet, unopposable totalitarianism is not a conclusion based

on social analysis but a projection of the fate they have chosen for themselves. The American landscape has by no means been re-made by the 'Social Ethic' compression machine into an electrified Eden set out on porcelain grass. Except in the new suburbs, the physical condition of America's cities, towns and villages is of itself proof enough that decay, shiftlessness, egotism and other forms of popular expressionism are more than holding their own against other-direction. Granted that the growth of the supercorporation and the absorption and standardization of small business has changed the independent operator into an agent, at the same time that mechanization has been turning the workman into a technician; granted that Whyte's notation that 'the collectivization so visible in the corporation has affected almost every field of work' is indisputable; and that today Orgmen reproduce themselves like fruit flies in whatever is organized, whether it be a political party or a museum of advanced art; given this groundwork for the conquest of America by this 'type', still the contention that the nation is, or even might be, subordinated to such a master is at least as ludicrous as it is alarming. The increasing concentration of control and the standardization of work present well-known alternatives which we need not discuss here; but for the individual, the last voice in the issue of being or not being himself is still his own.

The inhabitant of the sacred groves has, however, surrendered all choices. Having accepted self-alienation in trade for social place, the post-radical intellectual can see nothing ahead but other-direction and a corporately styled personality. For him the Orgworld has closed for good. Within these limits the deploring of 'conformity' is simply an expression of self-pity. The strategy of fighting the organization through secret resistance behind the outer-shaped mask (Whyte) is, by the measure of the ancient intellectual tradition of denunciation or self-exile, only a dreary professional's ruse for holding on to the best of both worlds. That such a proposal should seem relevant is another proof that the Orgman is, with necessary additions and disguise, none else than the new intellectual talking about himself. Certainly the deft management of the corporate Look which solves things for Whyte would be of no

help to the farmer or to the working man, nor would the boss need to make use of it. The 'what to do about it' part of the studies of Whyte and Riesman are clearly sermons for their milieu rather than challenges to history in the name of mankind.

The critics of the new America are disheartened by a revolution won – their revolution, which can go no farther than the ending of the underground life of the American intellectual mass through economic recognition of the services it has to offer. With his own success achieved the only issue the intellectual can see as remaining for society is 'personality'. Somehow, this seems unattainable in 'the dehumanized collective' in the building of which he is taking a leading part. The result is depression – and it is by the power of the depression it generates, in contrast to the smugness of the old-time boosting, that the present sociology is a force against a more radical and realistic understanding of American life.

Index

Renaissance and Renascences in Western Art
Erwin Panofsky

In one of the most important studies of the Italian Renaissance ever published, Professor Panofsky first examines what the idea of a 'revival' or 'rebirth' of civilization meant to the artists and thinkers of the Renaissance. After discussing earlier medieval 'renascences', such as the Carolingian revival and the 'renaissance' of the twelfth century, he moves on to consider the essence of the Italian Renaissance as it developed in the art and literature of the fourteenth and fifteenth centuries. He looks closely at the invention of perspective, the relationship between the arts of Italy and of Northern Europe, and the contribution of the Antique to the form and content of Renaissance art.

'For 40 years Erwin Panofsky has given art history what some of his favourite Renaissance artists gave their colleagues – perspective and proportion. No conscientious art historian today remains untouched by his ideas . . . '

James S. Ackerman

'There is some hope for the future of our civilization as long as its cause is being upheld by scholars of Panofsky's calibre.'

Paul Oskar Kristeller

Crime and Personality
H. J. Eysenck

Revised edition with an additional chapter.

During the past 50 years, writers and researchers have stressed environmental causes of crime – broken homes, unsatisfactory family relations, poverty – without explaining why the great majority of children coming from such under-privileged backgrounds did not in fact turn to a life of crime. Professor Eysenck, by contrast, concentrates on the personality of the criminal, and stresses the importance of heredity. He examines just how heredity can determine personality differences, and how it can predispose a person to develop or not to develop restraints which act as a 'conscience'.

'There can be no doubt of the importance of his new book on the nature and treatment of criminal behaviour.'

NEW STATESMAN

'The clarity of the author's style is a model for criminologists, and his book is controversial and witty.'

THE TIMES

'Dr Eysenck is justly celebrated for his enviable ability to expound difficult concepts in simple language intelligible to the layman, and this book is no exception.'

LISTENER

The Politics of Ecstasy
Timothy Leary

Dr Leary, 'the high priest of the psychedelic', was dismissed in 1963 from the faculty of Harvard University where he was a lecturer in clinical psychology, when it was learned that he had been experimenting on himself, his associates and hundreds of volunteer subjects with measured doses of psilocybin, the chemical derivative of the sacred mushrooms. Still harassed by what he calls 'the forces of middle-aged, middle-class authority', Dr Leary continues to enforce his bid that 'anyone who wants to have a psychedelic experience and is willing to prepare for it . . . should be allowed to have a crack at it . . .' This startlingly candid collection of essays in defence of ecstasy are the documents of his own spiritual search and the fantastic entrance to the psychedelic world.

Love and Death in the American Novel
Leslie Fiedler

Love and Death in the American Novel views in depth both American literature and American character from the time of the revolution to the present. From it there emerges Professor Fiedler's once scandalous – now increasingly accepted – judgment that American literature is incapable of dealing with adult sexuality and is pathologically obsessed with death.

'One of the great, essential books on the American imagination.'

Richard Kostelanetz

'Dr Fiedler's witty, exasperating, energetic, penetrating book will prove indispensable . . . a high level of scholarship and intelligence.'

SPECTATOR

'Something of a classic . . . witty and arresting . . . He has contrived to make the American heritage less wholesome, but far more interesting than once seemed likely.'

ENCOUNTER

Bomb Culture
Jeff Nuttall

'Fragment of autobiography? Anarchist manifesto? Slice of contemporary cultural history? Manual for young guerillas in the generation war? The Underground's epitaph by one who was in at its birth? Jeff Nuttall's book is all these and more ... his book is a letter from a man who desperately wants to share his terrible healing vision in the hope that we may profitably pool our madnesses and our sanities. He is a man I should like as a friend.'

Peter Fryer in NEW SOCIETY

'*Bomb Culture* is an abscess that lances itself. An extreme book, unreasonable but not irrational. Abrasive, contemptuous, attitudinising, ignorant and yet brilliant. ... A book which you must read, as soon as possible.'

Dennis Potter in THE TIMES

' ... a book which burns off the page, a book which is like a heap of searing photographs from the battlefronts, both physical and psychic, a book which sings and dances and won't lie still.'

Michael Kustow in SANITY

Paladin